Ingeborg Zotz – Fascination Drawing

© 2014 Ingeborg Zotz

ISBN: 9781095423356
Imprint: Independently published

Editor – Merilyn Shields

Design and Typesetting – Ingeborg Zotz

Ingeborg Zotz

Fascination Drawing

It starts with a dot

Many thanks

Art is fun but it means a lot of work.

While I was working on this book I often thought about this saying by the Bavarian comedian Karl Valentin.

It has taken a long time to complete the book since I first had the idea. This difficult period of time could only be managed with the generous support of my family.

Eberhard, my husband, helped with encouragement and especially with the design and layout.

My daughter Jutta and my son Thomas checked my manuscript to see if my words made sense and Jutta translated it with enthusiasm into English.

Merilyn Shields helped a lot with the editing and had many good suggestions for making the text more fluent and understandable.

A big THANK YOU to you all!

Contents

Introduction – Welcome to a small universe vi
1 A dot marks the start 1
2 The line 15
3 Forms and outlines 39
4 Space and perspective 65
5 Landscapes 93
6 Light and shadow 109
7 Patterns are everywhere 123
About the author 156

Introduction – Welcome to a small universe!

This book is written for people who:

- Want to draw but can't get up the courage to do it
- Are curious, adventurous and spirited
- Want to understand the rules for drawing
- Would like to create something new
- Seek new experiences

It is fascinating to be able to illustrate an idea with a few resolute lines, capture a gesture or sketch a landscape.

If you would like to draw but are unsure about how to get started, this book is for you.

Once you get serious about drawing and want to get your act together, a question arises:

How do you draw correctly?

Soon you will feel unsure about your efforts and become worried about making a mistake.

But if you take time to observe children, and you will notice that they will have a go at something without worrying about the how and what. They do things spontaneously because they are curious and they think it is fun.

The actual process of doing is the driving force. When you draw your first line, just observe the process without judging or evaluating.

Simply take pleasure in the sensation of the pen gliding over the paper.

You are familiar with the term 'motivation'. Motivation can arise from a motif, from an experience and through sensation. It is the impulse that triggers the desire to create something.

Drawing is a uniquely human activity

Some people start doodling when they are on the phone. This involves rather instinctive hand movements that result in spontaneous shapes and patterns. These shapes happen to be the basic elements of drawing.

Drawing however is mainly a conscious and intentional representation of attentively observed scenarios.

It enables you to depict an area, a landscape, scene or object. Everything that is conveyed this way must be translated into a visual language. This can only be achieved by way of abstraction of real life things.

Thus a straight line becomes a horizon, a mast or a direction, depending on how this line is graphically presented.

Drawing creates symbols. The invention of signs and symbols allowed humans to develop a world of communication tools.

These symbols and signs stand for real life objects, concepts or impressions.

Symbols are older than the written script that developed from them. They aid communication and understanding. They help make sense of the world.

Signs are able to express things. A good example is the ! or the ?. What do they convey visually?

In the ! a straight line shows decisiveness and clarity. The full stop completes the sentence and closes it off. The soft and curvy shape of the ? characterizes a vague or unresolved issue.

These are the types of attributes and means of expression that can be used in drawing with lines.

As soon as you have familiarized yourself with them you will be ready to draw freely and bring these elements into play.

I want to demonstrate how dots and lines can playfully turn into a drawing. You will no longer see a drawing as simply an illustration, rather you will recognize its elements and composition.

You will witness the birth of a new universe. Very small particles, such as dots, will comprise this new beginning.

Once these dots connect to each other they become lines. These lines can be straight or curved. Each one has its own character.

Just draw with dots at first. The dots will become lines that transform into a rhythm, a shape or a structure. Begin in a playful manner and see what happens.

Think of drawing as playing a game. Every game has rules. The better the player knows the rules, the better the chance of winning. We never know the outcome of a game in advance. Each game is exciting and full of surprises.

> **Important:**
> Throughout the book you will find boxes like this 'Important Box'.
>
> These boxes contain and explain the rules that create certain effects in drawing

1
A dot marks the start

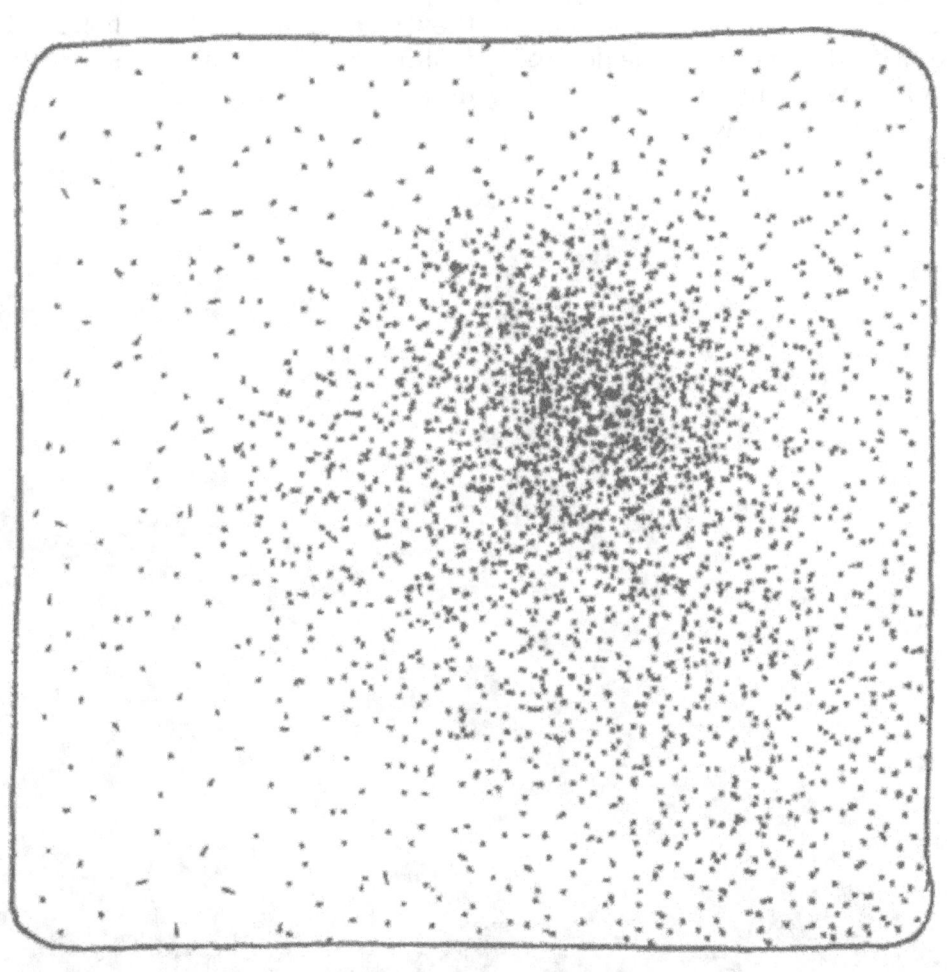

A dot marks the start

Our story begins on a blank piece of paper. This is a boring and unattractive white expanse. It is an empty and untouched space, like a little universe. Into this space falls a tiny black dot. The dot has no dimension and on its own has no meaning, but it has brought life into the empty space and attracts your attention.

As with the Big Bang, the dot explodes and an infinity of dots is created. They are everywhere.

They drift into the empty space, on their own or in groups like small clouds. Here the universe of drawing begins.

Imagine that this picture of clouds below is made up of little dots. Where the clouds are denser they appear darker. Where the dots disperse they become lighter. They float in this space. Where they are very close they seem almost black; they form a mass. They behave in a similar manner as the stars that make up the Milky Way.

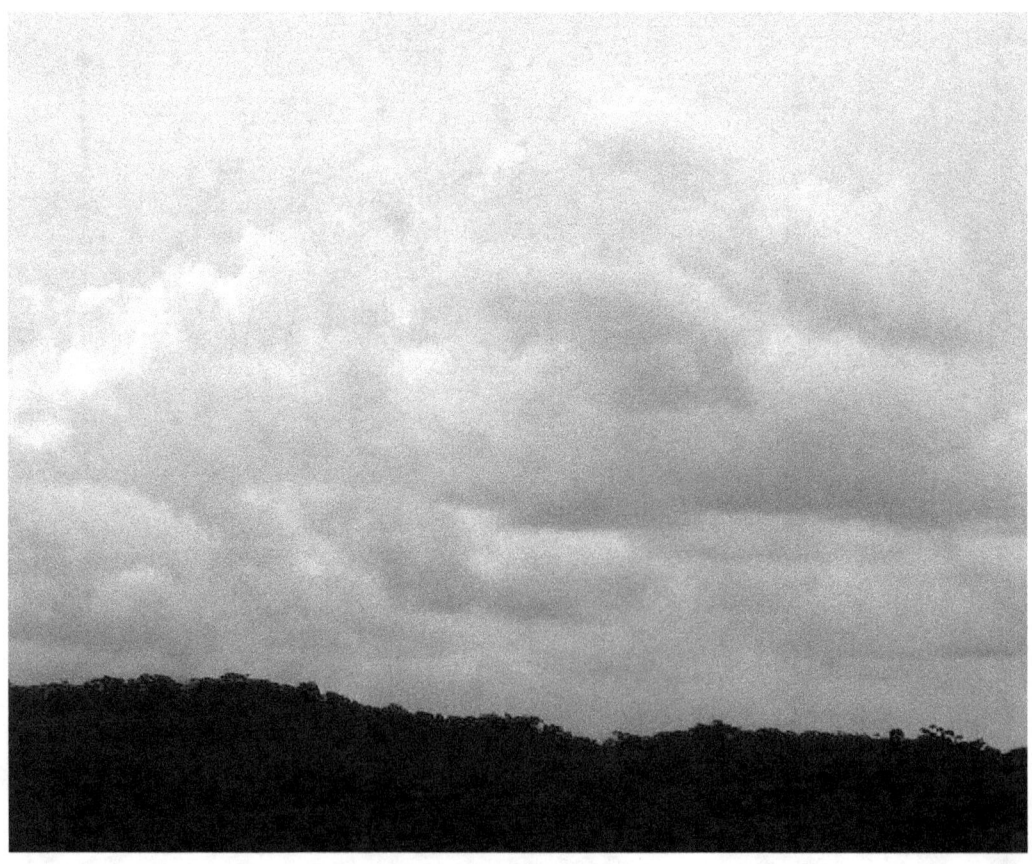

Everything revolves around the dot

The smallest unit a drawing can begin with is a dot. It does not represent anything; it can adapt and does not take up much space. Only when used in conjunction with other dots or the shapes they form does it become meaningful.

Small beginnings

If you are one of those people who think they can't draw a straight line, then start with a dot instead. Begin by just drawing dots. In turn these dots become lines, shapes or patterns, depending on the rhythm you use when you put them on the paper.

Stay playful when drawing dots; experiment and see what happens. It is like a game, exciting and full of surprises and you will get better as you practise and learn the rules.

For your first drawings use a black 0.2 felt-tip marker and an A4 size sheet of good quality drawing paper. The black colour of the marker gives you the maximum contrast on white paper and there is no need or opportunity to use a rubber to make corrections. This will give you more confidence. Start with a drawing the size of about a 5 cm square or larger.

Put a frame in the form of a single black line drawn freehand (that is, without a ruler) around your drawing. This provides the border and contains all the dots.

To get better control, don't hold the pen as if you were going to write something. Instead, hold it at a steeper angle and keep the hand off the paper. This way you can use your whole arm and control a large radius for free movement over the surface of the paper.

If you stand up straight it becomes even easier because you can see your drawing take shape from a greater distance and can observe it taking shape.

As you let more and more dots accumulate, let them move closer to each other. The place becomes darker and seems to gain depth [1].

If you concentrate the dots at the edge of the drawing, the centre seems to be optically closer [2].

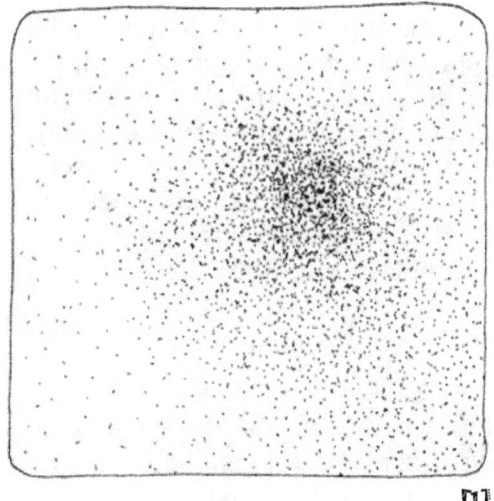

[1]

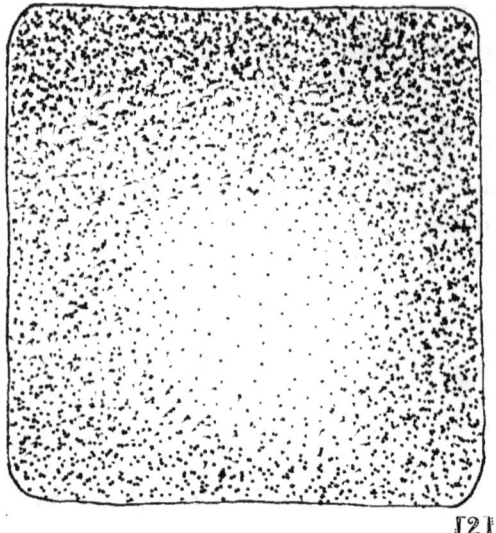
[2]

Your first drawing

Although these dot drawings are quite simple, they still provide many opportunities for discovering new things. For instance, you know that the further you are away from an object the smaller it appears.

Look at your dot drawing: could it represent a crowd of people? Alternatively, imagine the dots are light and the background dark. Now they are the lights of a city viewed from above. They could also be specks of dust dancing in the sunlight or tiny air bubbles in the water [2].

Dots can be even more

So far we have distributed dots similar to the way salt comes out of a saltshaker. We can also put them on paper in an orderly fashion.

Try putting them down on the paper in rows, not worrying about the odd one that escapes. With practice you will get faster and more accurate. As the old saying goes, practice makes perfect!

In the illustrations below you will see that the dotted lines float next to each other in the available space. Continuously they build new formations. They are also useful for creating ornaments [3].

Submerge yourself in the creative process and just let the dots wander where it feels they should go – right, left or straight and then back again. Invent the picture as you go along.

With a bit of practice you will soon be able to have good control over the dots and bring movement into the drawing through the shapes you create [4].

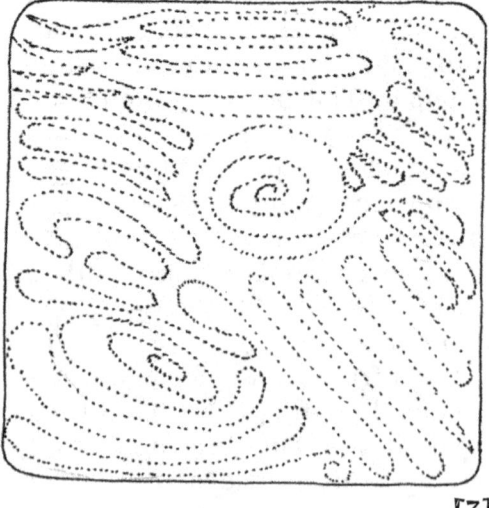
[3]

A dot marks the start

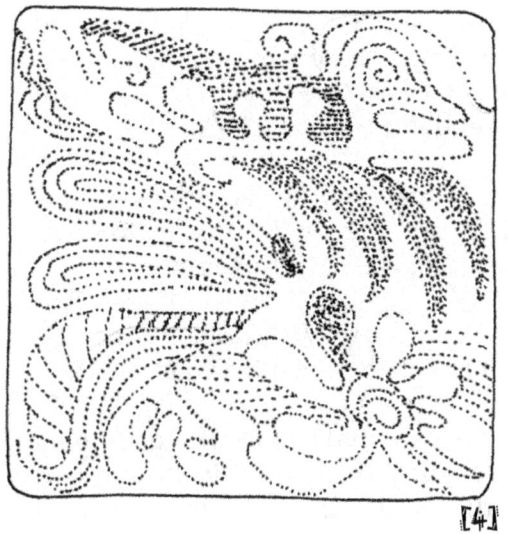
[4]

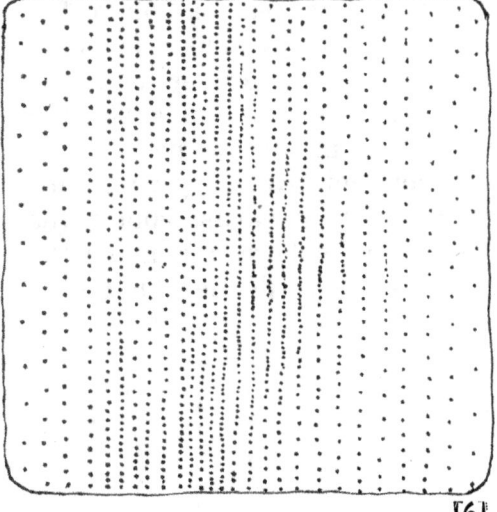
[6]

In the example below the dots come together in the top third of the picture and create depth [5].

The other example shows what happens when you practise drawing the dots far apart or bringing them close together [6].

Important:
The closer things shift together
the darker the tone
and the greater the depth.

[5]

Now try to create a sphere [7]. There is no need to use a compass for the outline. Because dots are very flexible and adaptable, you can easily fix up any uneven parts.

When you are happy with your outline, move inwards. Follow the curve of the sphere and make the dots denser towards the edge [8].

This creates dotted lines. To make the shadow darker, repeat the dotted lines, this time in the opposite direction [9].

Remember to keep the pen upright to help with the movement and accuracy of your hand.

These two art works by Aboriginal artists can inspire you.

Aboriginals mostly use dots in their paintings. Sticks or grass stalks and earth colours are used to turn their whole world into dot language. If you fly above the Australian landscape you can get an insight into their paintings.

[7]

[8]

[9]

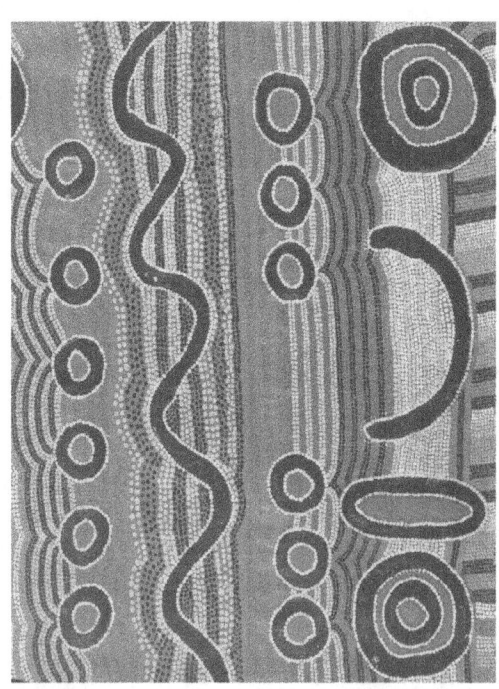

Howard Morphy: Aboriginal Art. Phaidon Verlag, New York 1998

A dot marks the start

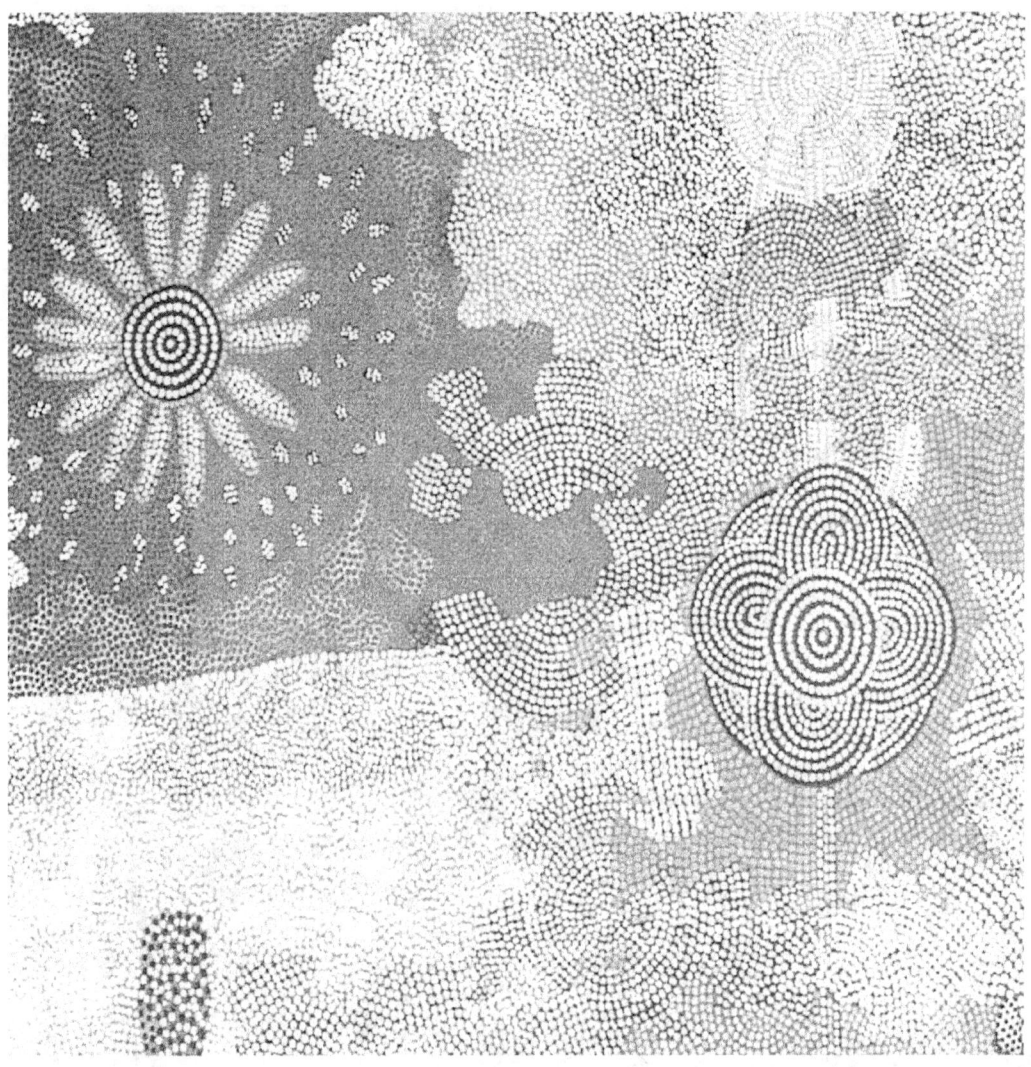

Howard Morphy: Aboriginal Art. Phaidon Verlag, New York 1998

Dots in straight order

Now position your dots in straight and even lines and always seven in a group. Change direction for each new group. Let these groups intercept and cross each other [10].

Then make a similar pattern using lines [11]. The dotted drawing looks like a woven fabric and the lined one like matchsticks that have been scattered.

Dotted depictions always retain a certain softness and transparency. Some artists turn this into their personal style, such as in the drawing by the artist Michael Prechtl. He used coloured pencils for this drawing.

The painter George Seurat became well known for his mosaic-like paintings. He used brilliant dots of colour that seem to merge into a larger picture when observed from a distance. This type of painting is known as 'pointillism'.

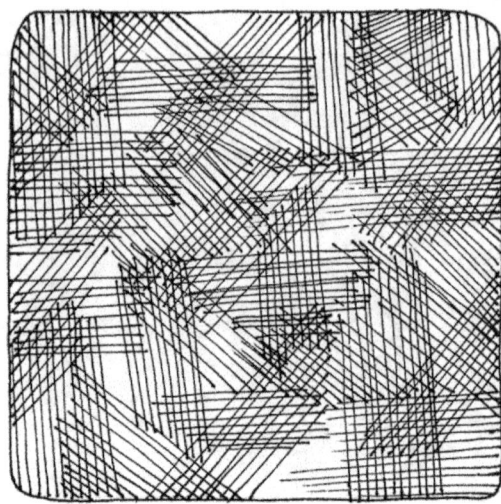
[11]

[10]

George Seurat, Selfportrait

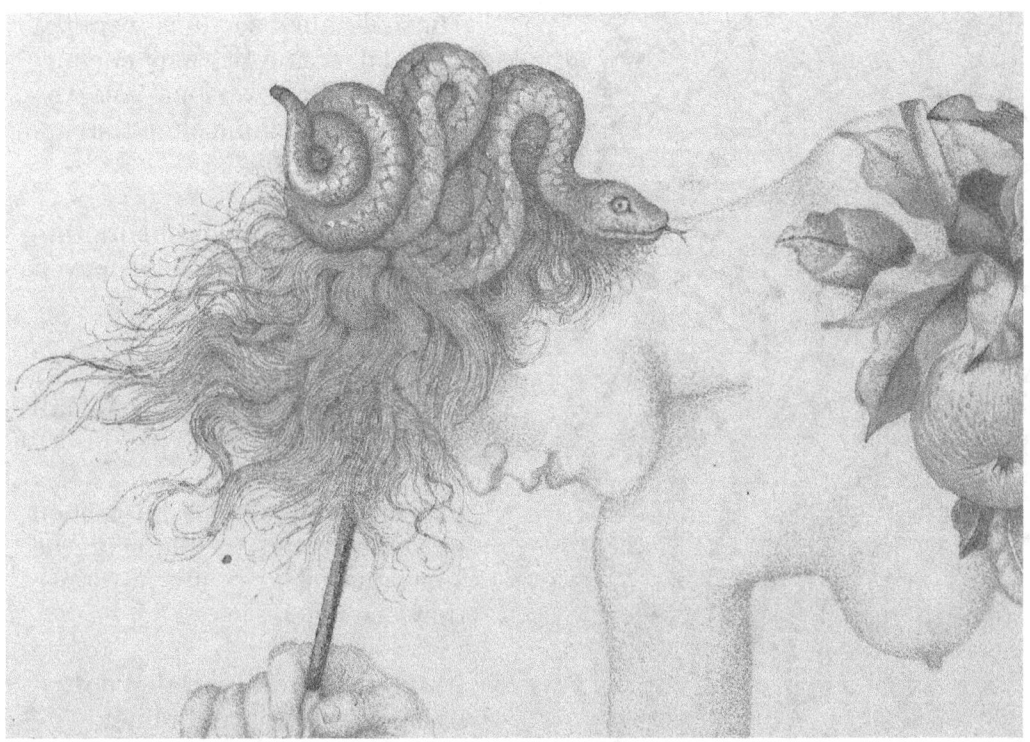

Michael Mathias Prechtl: Denkmalerei. C.J. Bucher, Munic/Lucerne 1986.

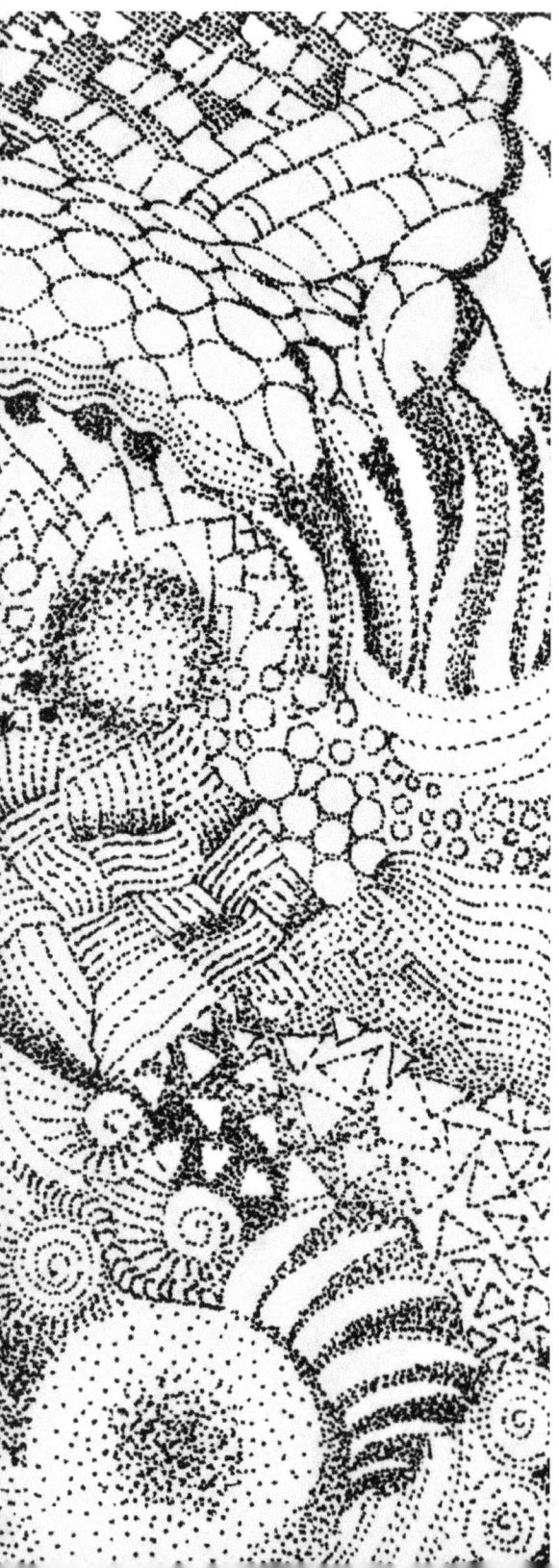

These detailed sections from the bigger dot drawing [12] may encourage you to collect various patterns and use them to build doted structures like this:

- [12a] Here the circles shrink into ovals and therefore seem curved towards the back.

- [12b] The spirals here have star shaped circumferences in small and large dots.

- [12c] Triangle shapes have been kept clear and the dots in the surrounding area are so dense they are black.

- [12d] Here several parallel dotted lines weave over and under.

Remember the rule I mentioned previously: the closer things shift together the darker the tone and the greater the depth. The big dot picture [12] was worked using this rule.

Small and large patterns take turns. If you also vary light formations with dense and dark ones you get a good light-dark contrast into your drawing. This can manifest itself as a meandering movement through the picture.

[12]

A dot marks the start

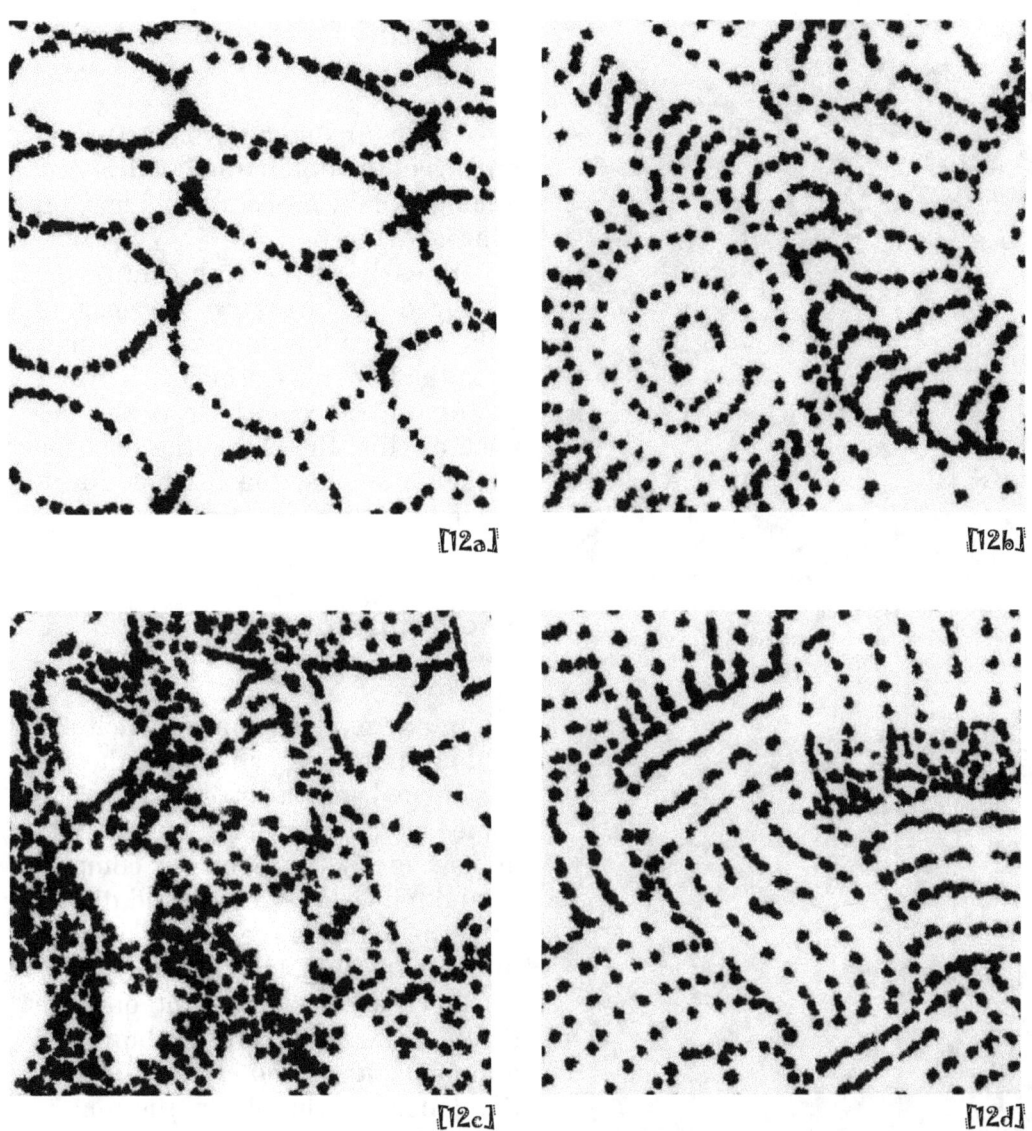

[12a] [12b]
[12c] [12d]

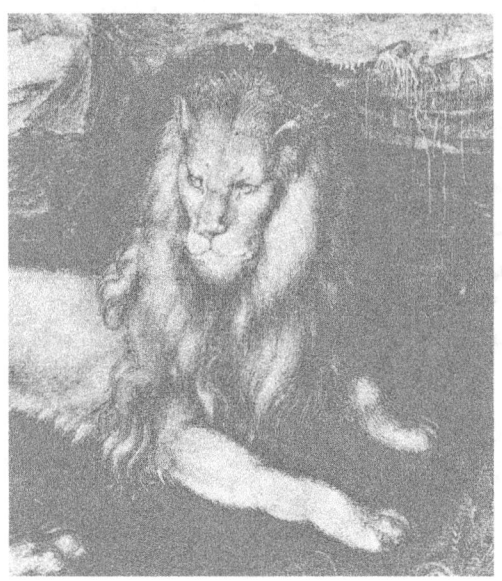

Albrecht Dürer (1431-1528),
Das gesamte graphische Werk, Handzeichnungen, Roger and Bernhard (Muenchen, 1971)

Picture of a pixelated screen

Interesting facts about the dot

There are some wonderful examples of the dot method of drawing amongst the works of the old master, Albrecht Dürer.

As early as the 15th century he managed to introduce a sense of light and shadow into his etchings, as in the lion, for example.

Again, the clue here is the important rule: the closer the dots the darker it seems; the further apart, the lighter.

The dot becomes a pixel

In our modern times, which are so dominated by technology, the dot has turned into a 'pixel'. This term comes from the graphic images that appear, for instance, on our computer and television screens and digital cameras and it is the term now used in the print industry.

To create a colour print, only the three primary colours, yellow, red and blue, are used. Depending on the density of the pixels, the tone is either lighter or darker.

When used in conjunction with each other a multitude of different colours are created. Combining yellow and blue makes green, red and yellow makes orange, and red and blue make purple. All three togeth-

er, depending on the quantities, can create an amazing array of tones.

While artists have used these methods of combining a number of different colour plates in lithography and colour etchings for a long time, today once a dot has become a pixel its home is also in the world of electronics. As the smallest unit it conveys a variety of information for computer monitors and television screens. We use these machines every day without realizing the technological advances they involve.

A dot can also be referred to as a point or a mark. We all have different points of views and standpoints, but we need to come to the point!

Spots mostly come about inadvertently; they may look similar but they are never the same.

They can boost our imagination when we try to give them meaning and can morph into a multitude of objects.

It is said that Leonardo da Vinci drew inspiration for his battle scenes from the study of blotchy, mouldy and discoloured walls.

Do you recall making pictures by dripping blotches of paint onto paper and then folding and unfolding it to create a random pattern like the one in the picture [13]?

The spot is a different character
. .

So far we have talked about dots in the world of drawing, but in the world of painting, spots are much more likely to occur. The difference is that the spot or blotch is bigger than the dot and has uneven edges.

If a spot appears in the wrong place we call it a 'blotch'. Often we get annoyed with spots, but when viewed in a different light they can lead to curious formations and can be quite stimulating. For instance, when dots move very close together they can form a spot with an uneven outline.

[13]

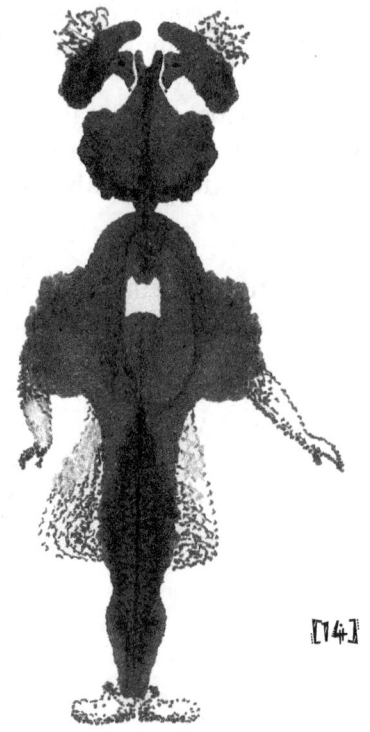

[14]

You could embellish one of these blotch pictures with dots to create a figure [14].

A variety of different marks and spots are found on rocks, bark, sand and leaves. Because they give us opportunities to interpret and implement them in different ways, they represent an important and valuable basis for artists to use in their work. Be inspired by this to be creative. Dots form lines. These leads to shapes.

The next chapter will show you the amazing abstract invention of the line, the basis of all drawing and writing.

2
The line

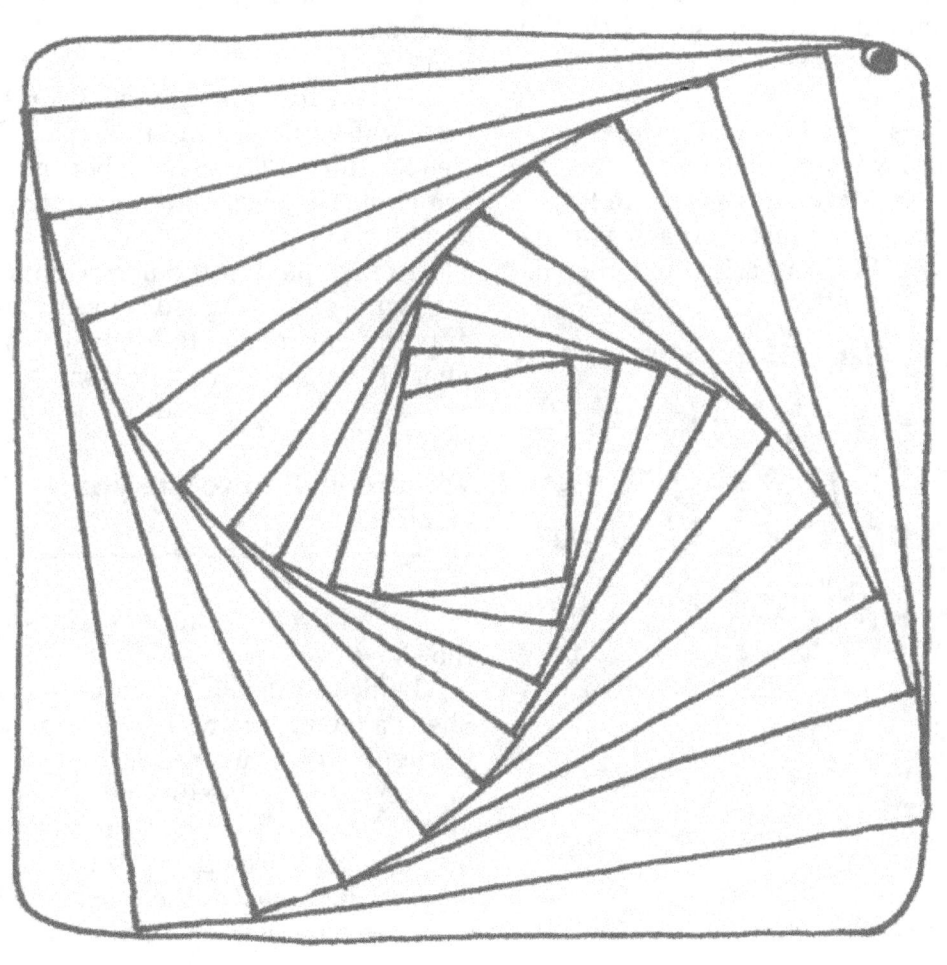

The line

The concept of the line is a human invention which helps to create a new world. This is the world of communication. Throughout history lines became marks and then symbols with various meanings that are closely linked to language. This in turn enabled the development of script, which provides another way of communicating along with the use of the spoken word.

These two images [1a - 1b] convey the same message. The first image is a translation of the second. An Egyptian recipe against stomach pain is depicted first in script and then is translated into hieroglyphs. This illustrates how a complete transformation of the symbols has taken place.

Because images such as these were the original form in which the world was depicted, the lines used to create them retain a powerful message. Their special characteristics cause various different and individual reactions in the viewer. Here the lines have been given two opposing personalities.

The straight line provides direction, while the curving line symbolizes flexibility. These lines become a drawing. They are actors on a stage of white paper.

To take part in the performance you will need a good quality A4 drawing pad and a 0.2 felt-tip pen. There is no need for an eraser.

You are invited to the line circus

Let's introduce the two stars of the show.

Ladies first: her name is Fiona. She is a curvy line with a breathtaking figure, slim and elastic. She loves to dance and is flexible and adaptable. She feels very close to nature but she has a weakness in that she is unpredictable. On the other hand, she is able to move in all directions.

The straight line is called Frank. He is determined and straightfor-

ward. Sometimes he is a bit edgy, but he is trustworthy, fair and square. He loves building sites and mathematics and likes getting together with like-minded people, Because he is a specialist in angles, whether right, acute or obtuse, he is a master builder. Frank builds illusionary spaces and commands perspective. Because of his upstanding personality, he is an expert in geometry and architecture.

In our circus, Fiona and Frank don't just appear as solo acts. Their combined program is dynamic and it is exciting to see what they can achieve when they combine forces.

The straight line - Frank and his crew enter the arena

Let's imagine first the fanfare and then the red curtain lifting. Next the welcoming committee lines up. They all stand up as straight as they possibly can – the lines are drawn freehand, without the ruler [2].

When you look closely you see that the lines are not equidistant from each other. This is done on purpose. Remember the rule we discussed in the introduction: the closer the lines, the deeper and darker the effect. Although all the lines here stand in a straight row, it seems as though the lines standing closer together are further away. What adds to that effect is the fact that the lines are not all the same height, and so a wave movement is created. OK, I admit, it does also look a bit like a rickety old fence, but you will see the point I am trying to make!

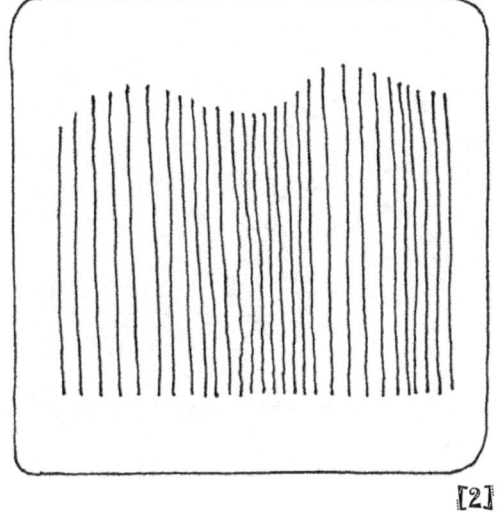

[2]

The picture changes when we move the actors into the horizontal position – now the shape of an antique vase emerges [3].

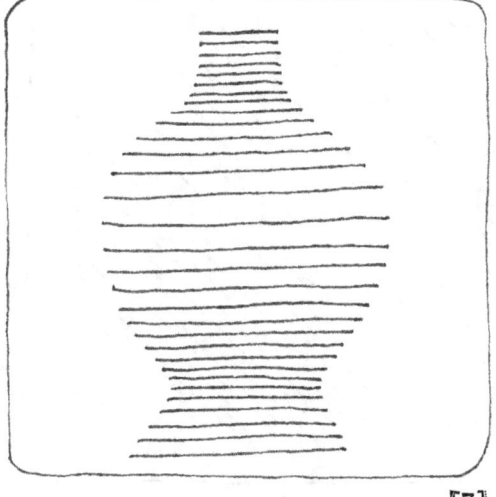

[3]

Because horizontal lines come across as calm and stable, they form a firm basis on which to build. Therefore, they can also form the foundation for drawing a landscape [4].

In the next illustration we have a completely different effect created by straight lines coming to the fore [5]. These are diagonals, also with varying distances. Because of being set at an angle they seem a lot more dynamic. They appear to be in motion. It is also interesting to observe that when the lines are drawn from the bottom left to the top right they seem to ascend [5] and when drawn from top left to bottom right they seem to descend [6].

The reason that Example [5] looks as though it is ascending is that when we write we naturally move from left to right and, without control, our hand will naturally move higher on the paper as we go. A traffic sign which indicates a descending road depicts that with a line running from top left to bottom right [6].

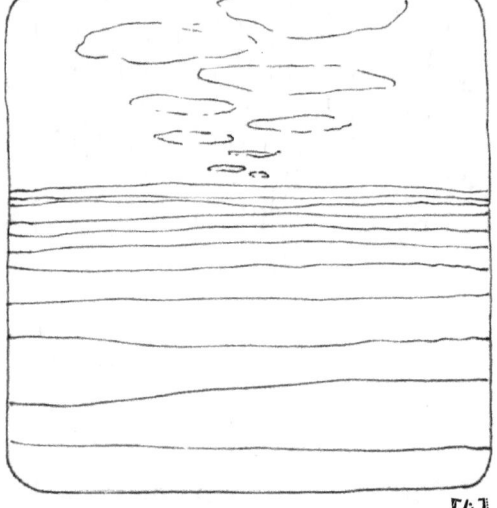

[4]

[5]

[6]

Now Frank wants to involve the audience. He is playing a geometry game with angles. He, as a straight line, is getting together with a horizontal line to form a right angle [7]. To test the strength of the construction he asks a member of the audience to participate. They find that it's a nice place to sit, very harmonious, and so the right angle passes the test.

Next we have an obtuse angle. The candidate sits down. Yes, it is relaxing but the candidate feels a bit exposed, as if he is sitting in a recliner. It is not a very convincing pose [8]. This angle appears weak and fragile.

The last angle is an acute angle [9]. This causes the candidate quite some concern. He does not know what to do with it. He can't sit or stand on it. Maybe he could crawl into it. When you look at it closely it resembles an arrow, aggressive, tense, showing a direction. It is a shape that seems to want to move forward and lead the way.

[7]

[9]

[8]

> **Important:**
> Straight lines can go in three different directions – horizontal, vertical and diagonal.
>
> A total different kind is the curved line.

To find out about the effect of angles for yourself, copy the examples below. First, look at the effect of the right angle [10]. You will be surprised at how much concentration it takes to reproduce this illustration. You can draw all sizes of right angles pointing either horizontally or vertically. You will see that right angles create a very calm and orderly overall effect.

When you compare the right angle drawing to the following two drawings you see how much more aggressive and agitated these shapes seem [11-12]. It is useful to be aware of which tools you can use to gain certain effects.

[11]

[12]

[10]

[13]

[14]

Frank and his colleagues build one more pattern. They create one angle after another, without any regard for which type it is, right, obtuse or acute [13]. It looks like a maze, constantly changing direction. It reminds us of Native American Indian art.

But we can go further. If we add another line, the two-dimensional shapes suddenly become three-dimensional [14]. These shapes look like polished crystalline structures. Again, it is the dynamic diagonals that are able to achieve this effect. Try it for yourself.

We can't imagine our world without right angles. They form the basis for all built things. Four right angles make a square. Now see how dynamic they can be when placed on the diagonal [15]. When you draw this example you start with six parallel lines in the middle of the picture. This way you can expand in all directions. Add the next lined square going in the opposite direction. It ends up looking like a woven surface.

[15]

These little games involving combinations of straight lines and angles mostly resemble patterns and remain flat [16], but there is in fact much more we can achieve with them, as we will learn in one of the later chapters.

While a square does have a harmonious look about it, it can be a little boring. Frank knows this. That is why he uses a trick and divides up the squares. The resulting right-angled triangles are interesting and can be arranged in a multitude of ways. You can create a mosaic with them [17].

You can also use acute angles to make triangles in different sizes. For instance, they make beautiful tile arrangements [18].

These types of patterns have been around for a long time and in art history are called the 'geometric' style. They were often used to decorate vessels in early civilizations [19]. It is not quite clear why geometric patterns were used. Today we call art forms that use these patterns 'constructive' art.

[16]

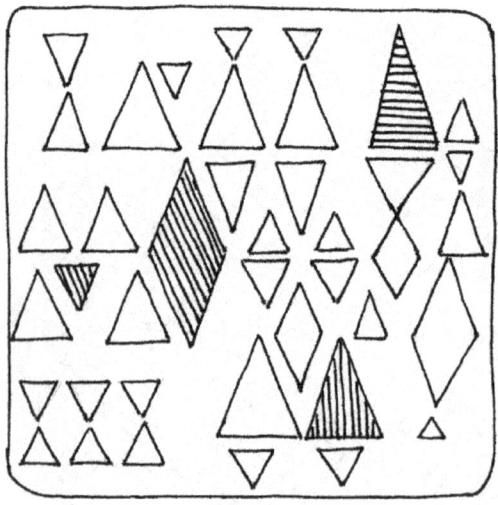

[17]

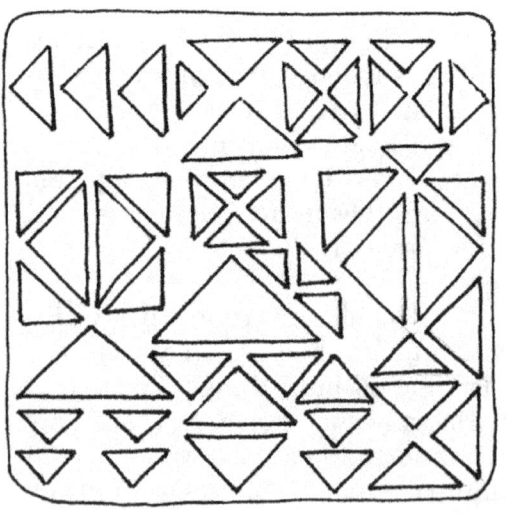

[18]

Now the straight lines start to move

Do you remember the best way to draw a straight line freehand? Hold your pen upright and set it on the paper at your desired starting point. Then focus your eyes on the place where you want the line to end, or its direction. Now move the pen towards this point without hesitation, keeping your eyes focused on the place where you want the line to finish. This ensures a practically straight line. Of course using a ruler will get an even straighter result, but the slight unevenness brings life into the line.

Frank now demonstrates how a straight line can turn around in a circle [20]. The black line that surrounds all the little drawings is like the arena or the stage of the show. From one corner we move nearly parallel to the other side. The small angle shift is important.

Once Frank has reached the other side, it is child's play. He continues with lines at a similar distance to the frame and keeps going around and around. Every added line will meet the next line with a small angle shift. This way he creates curved lines and ends with a square in the middle.

These fanlike structures look quite complex but are created by simply manoeuvring the angle of the line. The room in the second picture is created in a similar fashion [21].

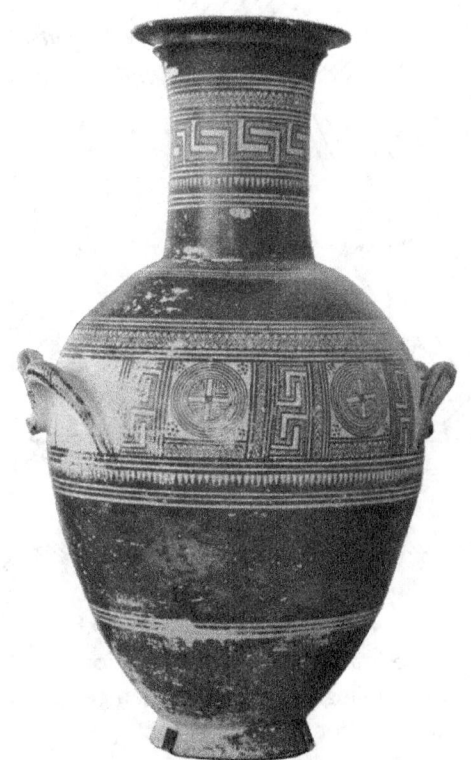

Geometric patterns on an antique vase [19]

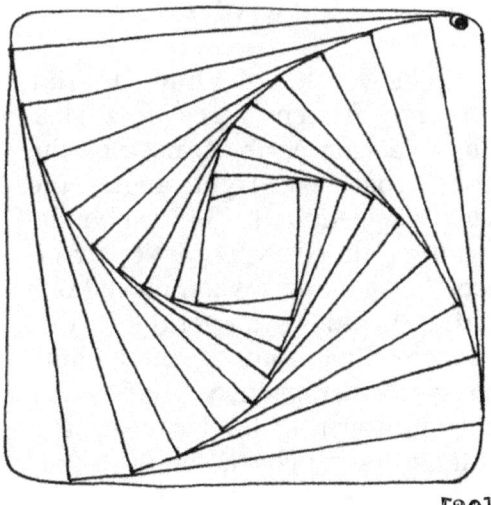

[20]

[21]

[22]

We all know what a wave looks like. It has shape and rhythm, such as that created by spectators when they stand up in the stadium to motivate their team. Frank's audience is so impressed that it spontaneously does the wave by standing up and sitting down again. Frank feels empowered. Thus, you can see that straight lines can create movement in a very elegant way [22-23].

So now you are quite familiar with the different types of angles. You have seen performances by the three types: the right angle, the acute angle and the obtuse angle. En masse they create particular effects. For instance, when placed one behind the other, you get the feeling if a three-dimensional space without the use of perspective. They create the impression of landscapes, each with a different character.

[23]

Important:
Even without the diagonal, which is so important for the creation of a feeling of depth, you can get a 3-D effect by grouping shapes behind each other.

In the land of right angles it is easy to climb around [24], but the mountains formed by obtuse angles are more difficult to navigate [25], while acute angles make the landscape look downright inhospitable [26]. You can see how different shapes can either feel inviting or uninviting.

No matter what kinds of shapes you use, as soon as they are shifted into each other and progressively get smaller towards one side you get the feeling of depth and three-dimensionality.

It is very interesting to note that this way of depicting depth was used for centuries in art before constructed perspective was invented during the Renaissance.

The impression of depth is created when the viewer unconsciously adds the missing parts of the shapes. This is all an illusion of course and quite amazing when you take into account that all this happens on a two-dimensional piece of paper.

[25]

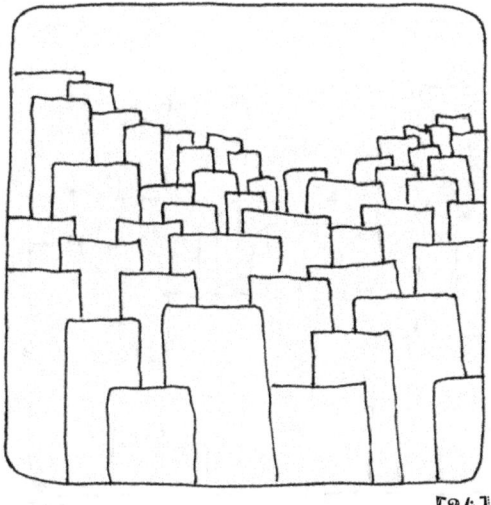

[24]

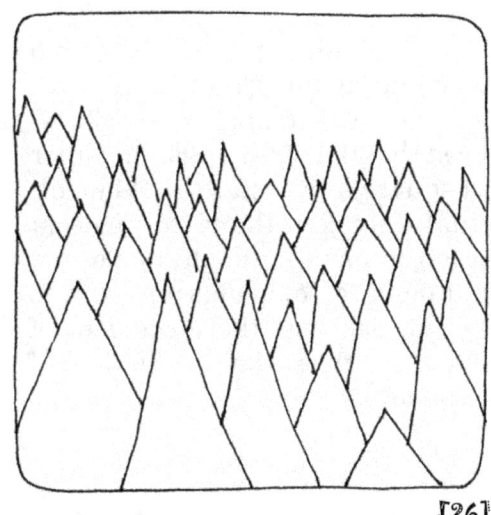

[26]

Frank starts building

For their next trick Frank and his performing friends show you how to turn a flat ground into a graph [27a, 27b, 27c]. Vertical lines of differing heights are standing at the ready. A point gets marked in the optical middle of each line. Then the remaining segments are divided in the same way.

Now each vertical has three dividing points along it, or four segments of equal length. Next, horizontal lines join the points along the vertical lines to join the segments.

While the lower section of this construction seems to be nearly flat, the top section has turned into the skyline of skyscrapers.

It is good to know how to divide heights evenly without the use of a ruler. This is useful when you want to sketch a streetscape or city-view.

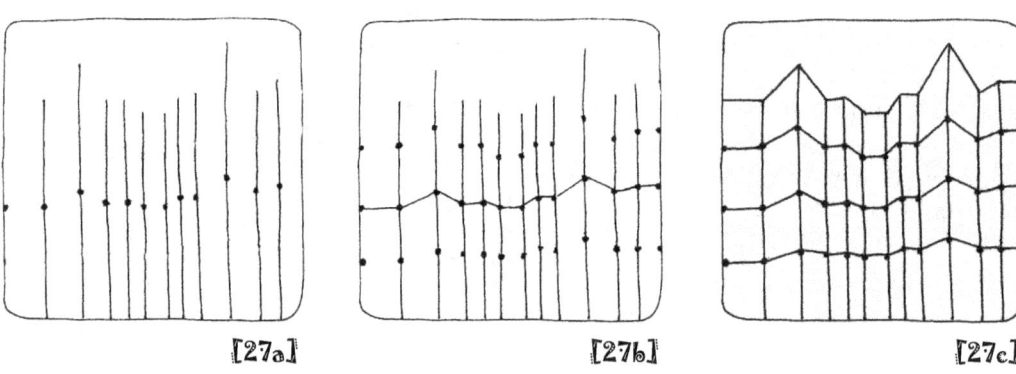

[27a] [27b] [27c]

Our building project gets into full swing again when we reintroduce the use of angles. We know how stable the right angle is, either as a square or a rectangle. When diagonal lines join the right angle at the top to form an acute angle, the buildings are complete; the town is finished. See how the placement of the cubes gives the perception of depth [28].

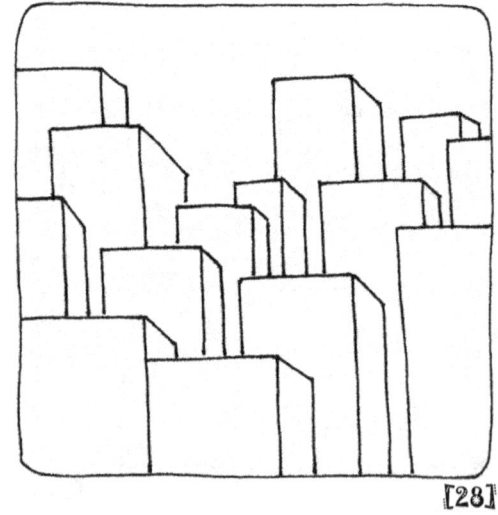

[28]

Now Frank uses a clever trick to link his performance of the straight line to Fiona's curvy line act [29].

Again, lots of vertical lines stand straight and tall next to each other. But No 7 has the hiccups and is a little crooked. Not to disrupt the overall picture, No 8 leans in the same direction on purpose. The following lines do the same.

Thus, the little hiccup becomes a big bubble. Because the size of the stage is very restricted, in order to be able to stand straight again the remaining performers are squeezed together trying to straighten themselves out.

Finally, they are able to stand straight again and move apart as they get further from the bubble. You will see that the last five actors are nearly completely straight again.

Frank explains to the audience that they have just witnessed a great innovation. But what he really means is that a small accidental event is not necessarily a mistake and can develop into a new idea.

The curtain closes, the first Act, the Act of the straight lines, is over.

It is now time for interval. This gives us a chance to think about our circus friend, Frank, one more time. As a straight line he only knows three directions, horizontal, vertical and diagonal. But he can also become an outline. An outline becomes a shape that conveys information and has a name – for example, a square or an isosceles triangle.

[29]

The curved line

With curvy Fiona it is a different story. As a wavy or curved line she has no particular direction. Her movements are decidedly variable – this is her strength. It is not only the path she takes that is significant, but the emotional response she evokes in the viewer. This is why it is so important to draw your curved lines in a special way – with a lot of momentum!

you think about making a mistake the better you will be able to draw. Lines need a lot of space and also a certain tempo. The slower you draw, the less convincing the line will be. Think about people doodling while talking on the phone. During this subconscious process these curves are a lot of fun to do and they end up having rhythm [31].

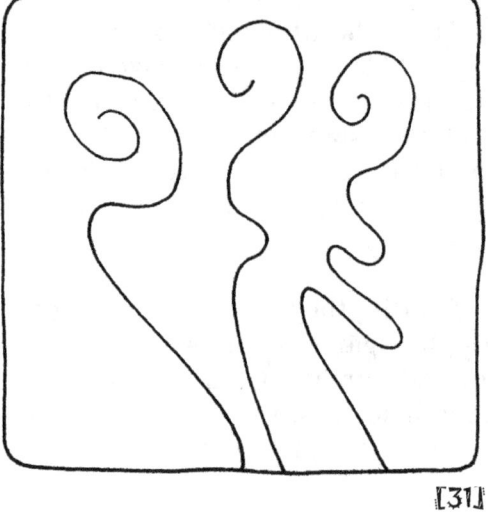

[31]

[30]

Fiona in action

After interval the performance continues. Now it is Fiona's show. At first you only see a dot exactly in the middle of the stage. From there Fiona starts a wild dance of turns and rotations, circular motions, back to the start and outwards again. It is as though she is ice-skating, leaving grooves behind in the ice. It could also remind you of a ball of yarn that is hopelessly tangled [32].

Unfortunately, it is very common for budding artists to use lots of short little lines when drawing. But by doing this it is not possible to get energy into the lines. They seem listless and lacking in vigour [30].

Mostly these short little lines are used as a precaution against making a mistake. In fact, the less

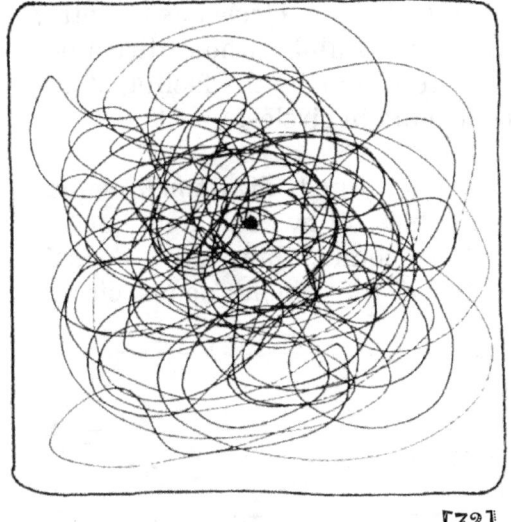

[32]

This looks very elegant. It is a wonderful exercise to help you become more fluent and assured, and it also stimulates the imagination. Turn your creation upside down. It could resemble a figure, plant or animal.

Now Fiona sets the whole stage into motion [34 - 35]. Starting at the edge the lines run across, nearly parallel and swing at the same time. By varying the distance between them they become a wave motion.

This is the way the topography of the land is shown on maps.

Anyway, letting Fiona get carried away is fun and you will enjoy the carefree feeling you get from letting go while you are drawing.

Now let's try just one round of curving over the surface of the paper with one start and one finish [33].

[33]

[34]

[35]

We all know that the letter S is a snaking line. See how many you can fit into an area. You will notice the ornamental character they express and you'll experience the three-dimensional effect they create when they are spaced at different intervals and in varying sizes [35].

While repeating these exercises, be careful to ensure that the lines do not cross each other the way they did when you drew the ball of wool. When repeated horizontally the snaking S-shape lines look like rivers, like flower petals when forming a circle and like decorative ribbons moving vertically [36 - 37].

As a circle, Fiona the curved line reaches her perfect state. The circle is a shape without beginning or end and that is why it has become a symbol of infinity.

But while the circle has a centre, it is restless and without direction. I'm sure you know the feeling of going around in circles!

Well-trained draftsmen sometimes show off by drawing a perfect circle freehand. However, it doesn't matter if your spontaneous circles

[36]

[37]

are a bit egg-shaped and not perfectly round. Start with lots of circles, some smaller some larger, and vary the density of placement; it looks a bit like a bubble bath. The same thing happens as with the dots: the closer they are the darker it looks [38].

[38]

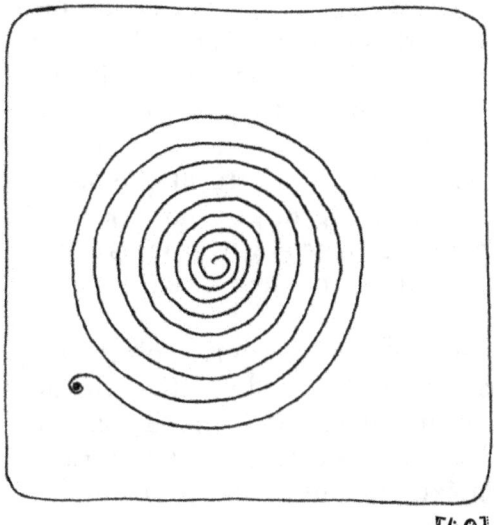

[40]

Imagine that the frame surrounding our pictures now becomes a vessel. Fill it with pebbles. The pebbles are of different sizes. Fit in more pebbles behind to fill the gaps. Be careful to imagine the hidden parts of the shape as you fill the gaps, otherwise the lines don't join up in a logical fashion. When we draw we always imagine the hidden parts [39].

After forming all these circles, Fiona returns to the centre of the stage. From there she starts moving and the audience experiences something unexpected. Fiona forms circles again but they merge seemingly into each other while keeping the same distance apart. She creates a spiral [40].

[39]

The spiral shape played a role very early on in art. Not only is it a symbol of infinity and eternity, it also has a hypnotic effect on the viewer. This is because the viewer is made to focus on the centre at the same time as taking in the movement of the circles. This is why it is used for eyes that express fear or agitation.

When you draw such spirals, try starting in the middle, although you may find it easier to begin on the outside and work your way in. Concentration is very important.

Next Fiona starts playing with planets, the sun, moon and stars, spherical heavenly bodies forming small and large spheres. When they orbit around each other their movements look like ovals or ellipses [41].

Through these forms a three-dimensional image emerges: the circle is squashed and its diameter is changed. And so the oval shape is created. The oval is a very common shape in the natural world. You can find it in nature – eggs, birds, flowers, trees, a plum, and a face.

[41]

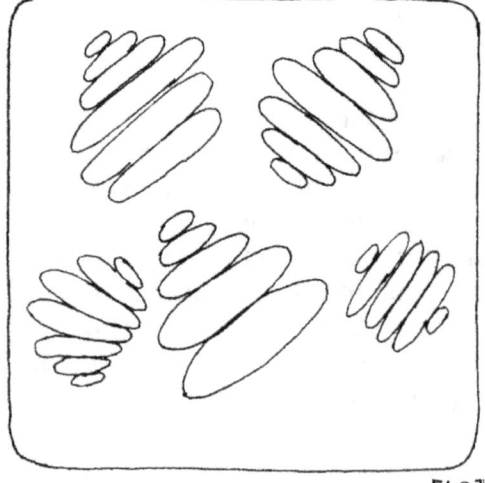

[42]

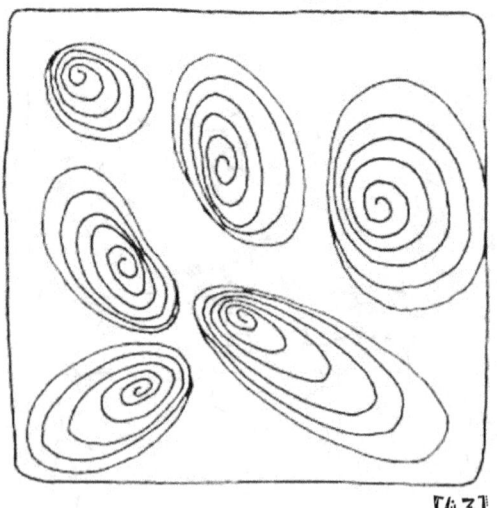

[43]

You can see the three-dimensional effect that is created when Fiona forms a lot of ovals, joined together but becoming smaller and denser towards the top of the picture. These patterns of ovals and shapes become distorted spirals that remind us of shells and oval objects [42-43]. A well-known example that has been created from these kinds of circles is the symbol of the atom [44].

Curvy and straight – Frank and Fiona's combined program

It is said that opposites attract each other – for example, curves and straight lines. It follows then that the expression of a form can be enhanced by combining the two. For this reason, the third part of the line circus is performed by Frank and Fiona as a team.

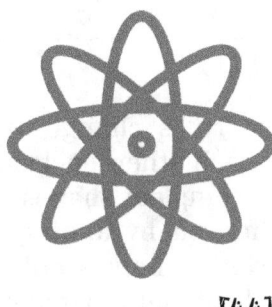

[44]

To end her show Fiona creates a dizzying spiral out of ovals [45].

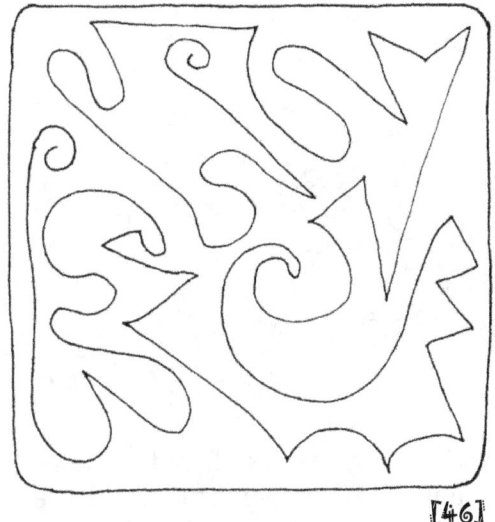

[46]

They combine their talents to create new movements. Frank's straight line is followed by Fiona's curve; then comes an acute angle by Frank, and Fiona adds a semicircle. It is like the rhythm of a dance, two steps straight, a turn to the left, then straight again and around in a circle. Imagine it as the drawing of a tango. In the example you can see

[45] how this might appear on paper [46].

[47]

[49]

Now the rules change and the lines touch each other, enclosing areas to form complete shapes. These can be enhanced by adding cross-hatching. Notice how similar this looks to a lead light window in a church or a glass mosaic. The areas are connected via a network or loose framework [49].

[48]

Have a go yourself, but remember not to lift the pen until you have completed the shape. It's all about the rhythm!

This interplay of lines has another important characteristic. The lines do not touch or cross each other. This gives rhythm to the line but there is no closed shape, which means that the drawing stays light and open. While you are drawing these lines try to imagine, for example, a plant. Your mind can lead your hand and help you to create what your mind is thinking [47 - 48]).

[50]

[51]

Practise this change from curve to straight line as much as possible using spontaneous hand movements that are uncontrolled and playful [51]. Accentuate some parts by colouring them dark in order to enhance the new shapes even more.

Frank and Fiona have become a couple. They complement each other. They stand together, a mixture of momentum and direction [52]. Give them your own interpretation by drawing them next to each other and also behind each other.

Once more Fiona and Frank begin to dance. This time their movements cross each other and intercept and all these swaying movements result in a variety of new shapes. The new shapes are created because the lines are overlapping each other [50].

[52]

[53]

Now they are at the end of their performance, Frank and Fiona have an encore for their audience. By combining parts of all the different acts of their performance they have created a picture. Very imaginative mixes of all the variations of the show make a pattern with no repeats [53 - 54]

The pictures are an interplay of lines that fuel the imagination. With that picture in their minds, the audience leaves the circus.

Your personal circus act

Have you ever been to the circus and quietly wished that you could glide through the air like the acrobats? In our line circus you can make your wish come true.

> **Overview: what lines can do**
>
> They can be just lines, straight or curved.
>
> Combined they can form things like an angle.
>
> If you close them they become a shape like a square or a circle.
>
> They can represent movement when they point in a diagonal direction.
>
> They can give the illusion of three-dimensional space.
>
> They can be used to shape physical forms.

All you need is pen and paper and some of the fascination you felt when watching the circus. It is the act of drawing that is important, not what you draw. The fun of doing is what brings the reward. Set your pen to paper, move your hand and then observe what is happening. If you don't focus on a particular outcome but just move your hand, you will stay relaxed. Your hand will surprise you because it can do anything.

We all have our own personal handwriting; our signatures in particular are unique. How did we learn this? At school, through the practice of making certain marks consisting of lines that go up and down, some straight and some curved. It is taken for granted that we are all able to do this. We don't even think about how to write an 'a' or a 'b'. The movements we make when writing have become a part of us. When we write it is about the message we want to convey, not about how we do it. It is the same with drawing.

In the first chapter we began with the dot. That's where you can also begin. Take up some of the suggestions and recreate them, first small, then really large. Draw while listening to music and let the pen follow along with the melody. Find your own ways of playing with the countless possibilities that lines provide. You will never run out of new ways of combining them.

[54]

An opportunity to practise

These four empty picture frames are for you to practise. The example on top shows you how this former empty space looks after a spontaneous drawing is inserted.

Imagine what it could look like if you add colour to the shapes.

3
Forms and outlines

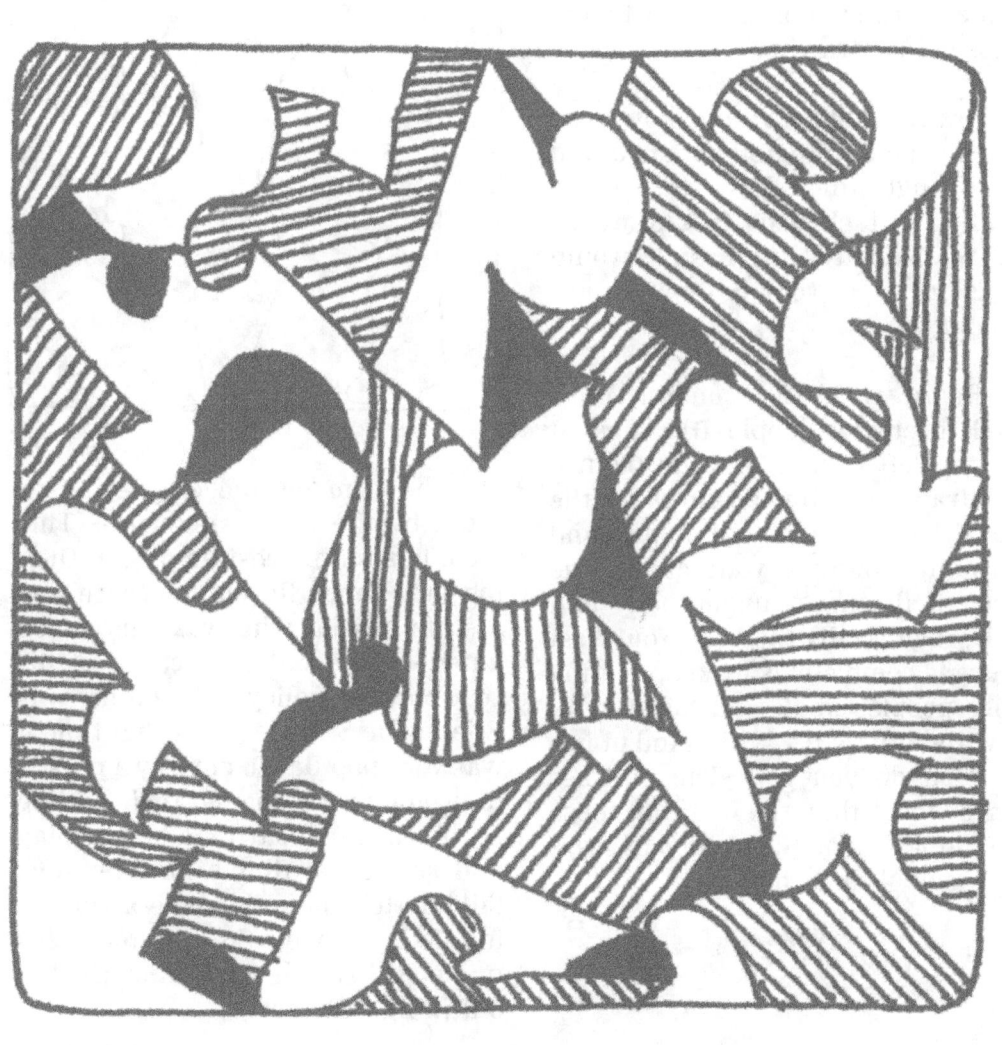

The world is made of more than just objects

Forms and outlines

We are surrounded by objects hat we can touch and name. Other things we can experience or feel the effects of – for instance the wind, sunshine, darkness, or movement and speed. We also experience feelings and sensations that can be expressed in a drawing.

Frank and Fiona have shown you how a shape is created using curved and straight lines. Now you will be wanting to tackle the task of drawing realistically. But first it would be useful to try your hand at an abstract form.

Begin with the contour of a small group of people [1]. Start at the top left corner of your picture and draw a continuous curve for the top of the head, the nose, mouth and the chin. Continue your curvy line through the neck, upper body and belly, then finally the legs. Your first figure is complete! Now keep adding more people, small and large, with or without hats [1]. What kind of impression do you get? The outlines convey more than the fact that these are human forms. They also express the mood of the group.

Thus, lines are much more than just a picture, they also evoke feelings. The outlines of the five people in the drawing below indicate that they are either waiting for something, or they are observing something because they are standing upright and close together. Only the dog is impatient.

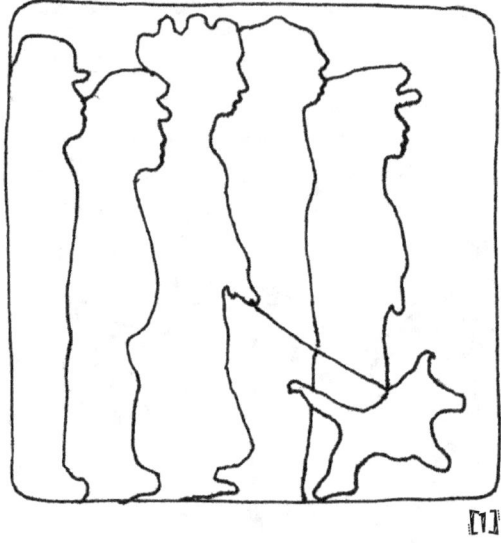

[1]

The term 'outline' can be substituted by the term 'silhouette'. This term has an interesting origin. During the French Revolution there was a state official who was very much hated by the public because of his cost-cutting policy. His name was Etienne de Silhouette. At that time it was very popular to portray a person in profile by cutting out their outline in black cardboard. It was cheap and so was available for everyone. Silhouette's name became a symbol for saving money. So even today his name still stands for this method of outlining a shape.

Forms and Outlines

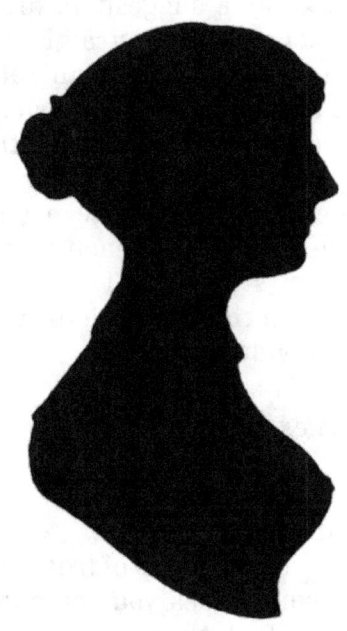

The silhouette of Jane Austen

Shapes and creating a sense of space

This principal also applies to abstract forms. Varying and curving lines are expressive. Abstract forms can gain an identity if, for example, we give them an eye. We could also turn the drawing upside down to discover new meanings.

Now hold the pen lightly and let it glide over the paper in a relaxed way. Change direction and alternate between curved and straight lines. This is a lot of fun. With the inclusion of an eye a shape can become a beak or a head. In this way you are creating caricatures [2].

Abstract shapes are created spontaneously. Our imagination interprets them.

An outline is like the fingerprint of an object. It defines the object and its relation to other objects. By default we always look towards the centre of an object to identify it. Although the surrounding area is very important for a harmonious composition in a drawing, it is not something we particularly notice. The reason for this is that in life we often need to identify things quickly to maximize our survival and alert us to danger – for example, when a car drives speeding towards us.

The expression of an object depends on its contour. It can be elegant or clumsy, mighty or weak. Even a simple drawing can be improved through a beautiful outline.

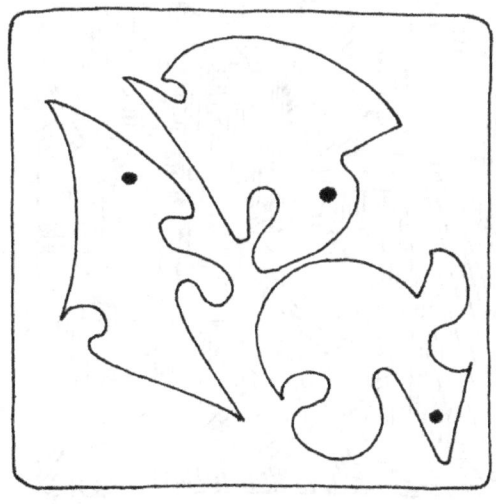

[2]

If you draw the forms right next to each other without a gap, you create a puzzle [3]. The outlines clearly separate the figures from each other. Include some black and striped shapes to add contrast.

You will be surprised how many variations you can create if you draw lots of these figures.

[3]

Frank has a suggestion: draw a puzzle picture using straight lines only, without giving them an outline [4]. Use a pencil to plan the shapes. Then draw black lines to fill in those shapes, changing direction for each one. The result is a pattern where the shapes merge into each other as in a woven structure. The focus is now more on the whole picture than on the individual shapes.

The next example shows a group of trees, each with its own outline – similar to the group of people in the first example.

Draw such a group of trees, maybe even some trees you see outside somewhere [5a]. Now turn the drawing upside down [5b]. It is less clear now what the drawing represents. When you turn the drawing only 90 degrees, it looks more like leaves growing out of a stem [5c].

Thus, you can see that the direction of the depicted form says a lot about what it is meant to represent.

Because we are so focused on the inside of a particular shape, it is hard to concentrate on what the space around a form looks like. The colour, surface texture, as well as the light and shadow of an object also distract the eye.

The area around the objects is called the 'negative space'. This space is very important for a successful composition. Remember that a picture consists of more than all of its parts. Only when the objects in a picture have a relation to their sur-

[4]

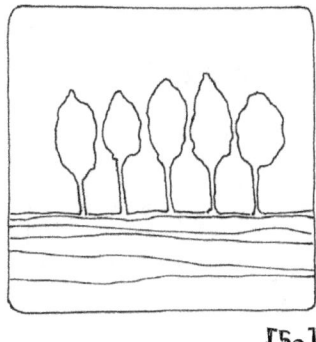
[5a]

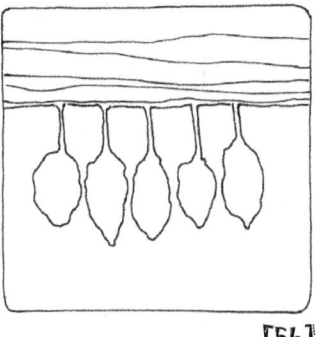
[5b]

[5c]

roundings will you achieve a drawing that has the right balance of tension and harmony.

Still life drawings are an excellent way of practising these principles because fruits and vases don't move!

For your first still life drawing, make an effort to concentrate on the space around the objects. Put a pattern on the tablecloth and the wallpaper. That way the objects move into the background and look more at home in their surroundings [6a, 6b, 6c, 6d].

> **Important:**
>
> Geometric forms are built and constructed.
>
> Organic forms grow and develop.
>
> Abstract forms develop from our imagination, fantasy and associations.
>
> We interpret them or turn them into symbols.

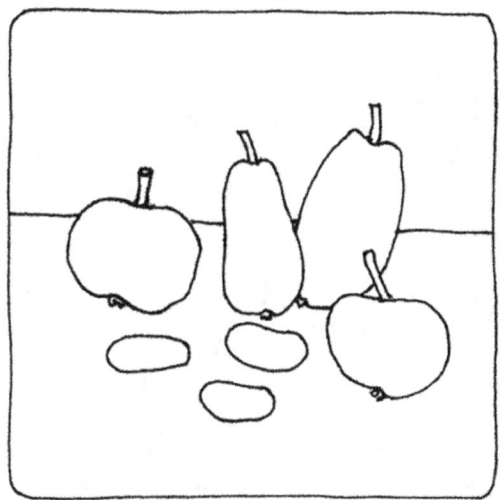
[6a]

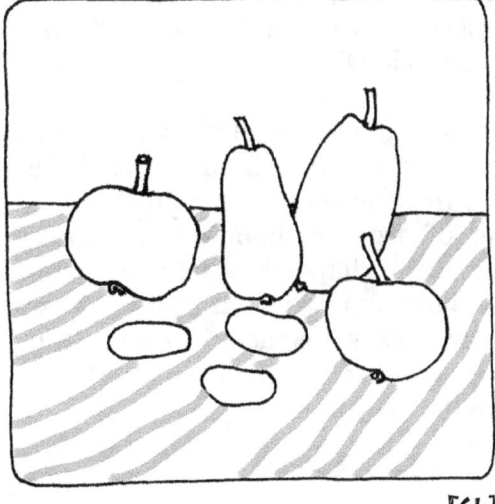
[6b]

[6c]

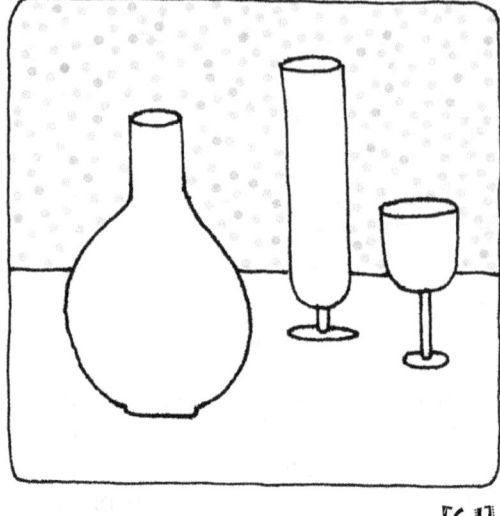

[6d]

Forms for building and shaping

The next illustration shows the elements of Leonardo da Vinci's portrayal of Vitruvian Man.

The meaning of this picture is that the human form in the centre is at home in a world that is both constructed and organic. You can see that Frank appears in Leonardo da Vinci's picture as a square and Fiona as a circle [7].

All manmade objects are constructed but the natural world we live in consists of an infinite number of organic shapes. When looking at the shapes around you, try to see how many are natural and how many are constructed. Those that are constructed will probably be in the majority.

In the previous chapter, Fiona the curve and Frank the line showed the contours of many shapes. Now they use these shapes to build and grow things. The aim of their drawings in this chapter is to develop your spatial awareness.

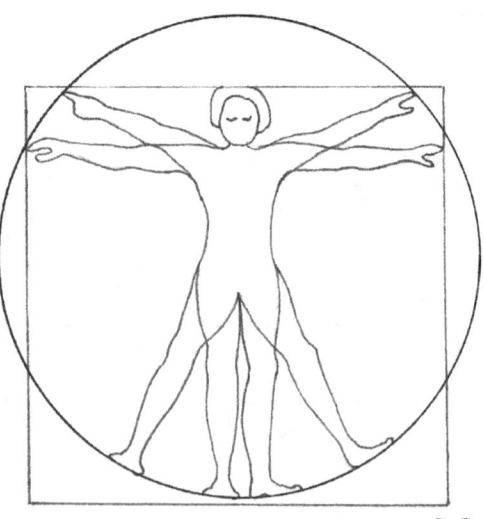

[7]

You will learn to see a lot more through the use of a combination of horizontal, vertical and diagonal lines. These are shapes, not architectural drawings.

All this becomes a lot easier when we take a playful approach. Look at it as an exploration of space. But remember that it is important to embrace 'mistakes' as a valuable learning tool.

Geometric shapes are mostly invented by humans through their imagination.

While the sun and moon appear to be circles, other geometric shapes such as cubes, cylinders and diamond shapes are much harder to find in nature. Therefore, we don't have firsthand experience of them, although under the microscope we can discover a multitude of geometric structures.

As far as Frank is concerned, the square is a classic for construction. With six identical sides and some angles it becomes a cube. Elongated it turns into a square prism. Then if we cut a square we get triangles, a rhombus or pyramids [8 - 9].

This leads to endless possibilities. For instance, geometric shapes can be cut up and used to construct little robots. Have a go! It could be that you will discover cubism, as Picasso and many others did [10].

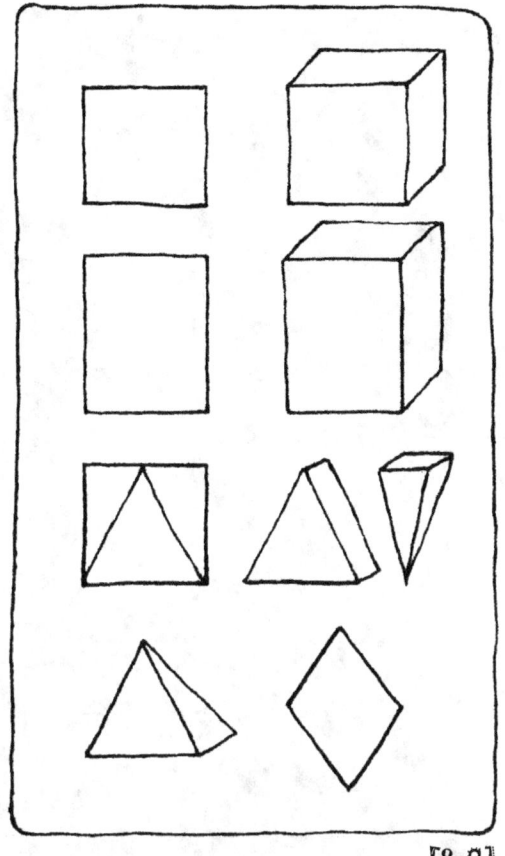

[8-9]

[10]

45

Ingeborg Zotz – Fascination Drawing

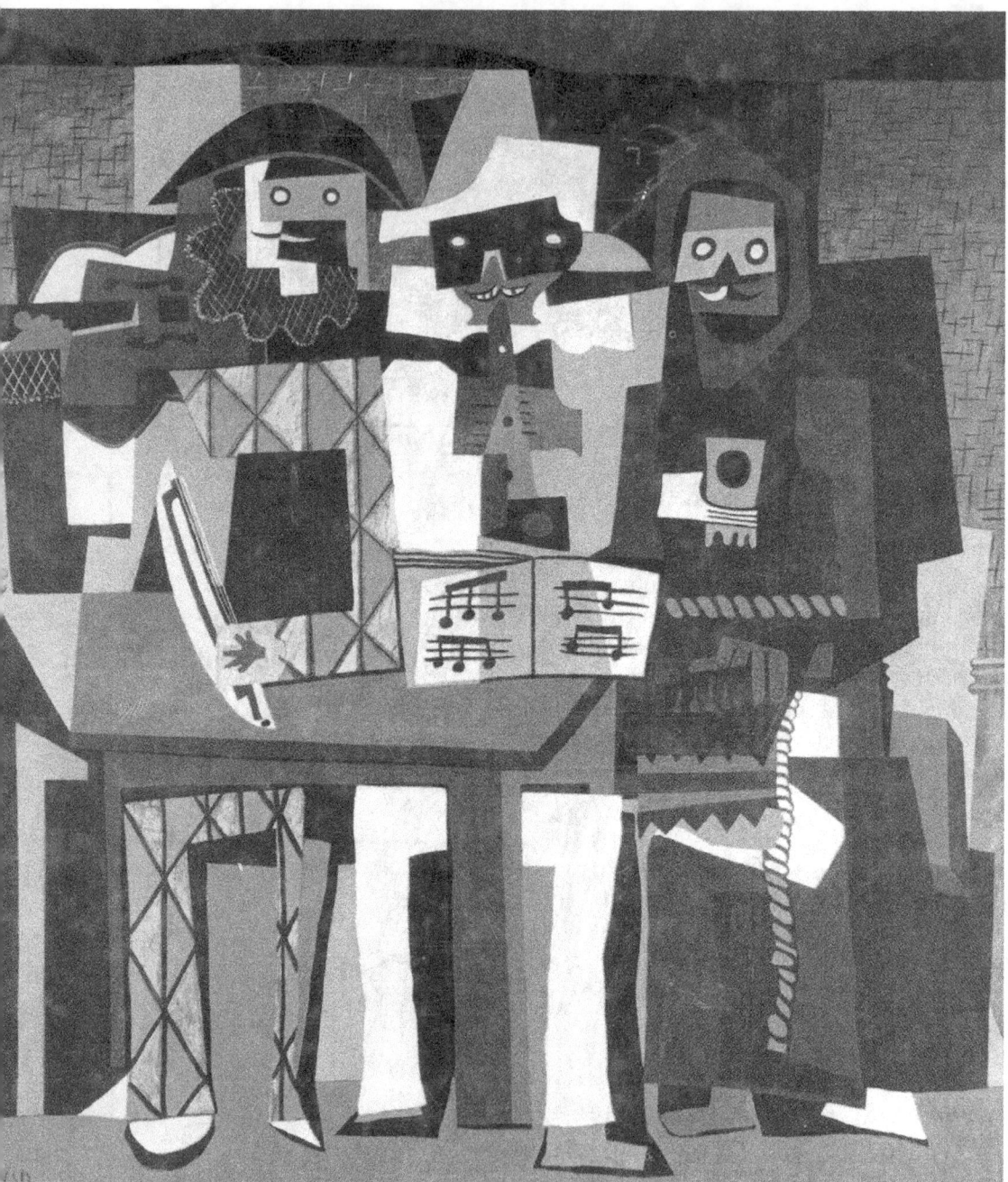

Pablo Picasso, The Three Musicians, 1921

Now divide a square into nine small squares. This gives you a scaffold for the construction of a small town in which you can build whatever you please [11a]. Keep on dividing [11b] the newly created areas and add dark elements for contrast [11c].

Note, however, that although we have sloping lines there is no depth to the picture yet. To get something to look three-dimensional you need at least two parallel sloping lines.

[11b]

[11a]

[11c]

Next Frank shows you all the different effects you can get with his games.

First he uses the square and a rectangle to develop a two-dimensional pattern. At first it looks like a tiled floor, varied but flat [12]. The same shapes are used to build a shelf. Frank just adds short flat diagonals which connect with the sides and the base [13].

[12]

[13]

[14]

Now use a pencil to compose a sketch yourself. Then add the three short sloping lines per square and join the parallel to the straight lines.

When you are happy with your composition you can use black ink to go over the pencil marks [13]. You have made a shelf [14]!

Make sure that only the verticals of the boxes are coloured in. The darker parts represent the shadows of the shelf. If it appears to be sloping a little bit, don't worry, this can happen the first time you draw without a ruler.

Next colour the insides in different greys or colours and you will see that the shelf now has depth as well as height and width [14].

In the last chapter we learned that stacking rectangles behind each other gives them a three-dimensional appearance. Build your stack of rectangles from bottom to top, starting with small rectangles that get larger [15]. Now turn them into cubes by adding short sloping lines that connect with the parallel lines [16].

[15]

[16]

In the next example the sloping lines point downwards – this gives the impression that you are looking at skyscrapers [17].

Now see what happens when the direction of the diagonals is not uniform throughout: from one point of view you are looking up into the shapes; from another you are looking down onto the top box [18]. For the viewer this is rather confusing.

Thus you can see that the impact of diagonals is so significant that it can make us question where we are in relation to the environment around us.

In the first example below, the small blocks appear to be in the foreground because there are large ones behind [19].

Turn the picture upside down and you get an entirely different impression – it appears that everything is dangling from the ceiling [20].

If, on the other hand, we have large cubes in the foreground and the small ones behind, they seem to be getting taller in the background [21].

[17]

[18]

[19]

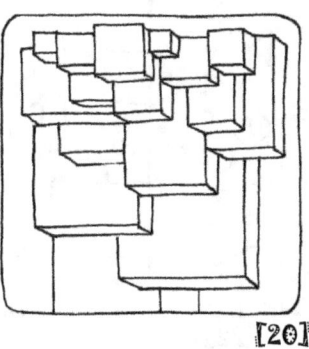

[20]

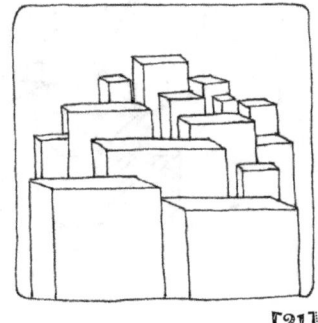

[21]

> **Important:**
>
> We have an inner sense of gravity – small is up and large is down.
>
> Large and small bring life into the picture.
>
> The sloping lines create a sense of depth.

With this technical know-how you can now easily build your own structures. As in the example below [22], it is best to start with a solid square, in this case shaded with diagonal lines.

Taking this as a starting point, continue in all directions with lines. Some are horizontal, some vertical and some sloping. It is best not to copy the example but to attempt your own composition. It is easy to do. Just keep building your own structure, only referring back to the example if absolutely necessary. Soon you will find that you have created a real architectural wonder! You will get a sense of space in your creation [23].

Creating a sense of space

For his next trick, Frank the angle expert constructs an abstract space on a flat piece of paper. This is how he does it. Mark a number of dots on the paper. Then draw a straight line downwards from each dot.

Next join all the dots with diagonal lines. This will create a lot of different angles and the resulting shapes become three-dimensional. It is easier to use a pencil for the initial sketch. When it looks right, go over it with black ink [24].

In the next example we have only trapezoids and angles. Start with one angled shape and continue adding more shapes overlapping each other. You can call them floating shards of glass [25].

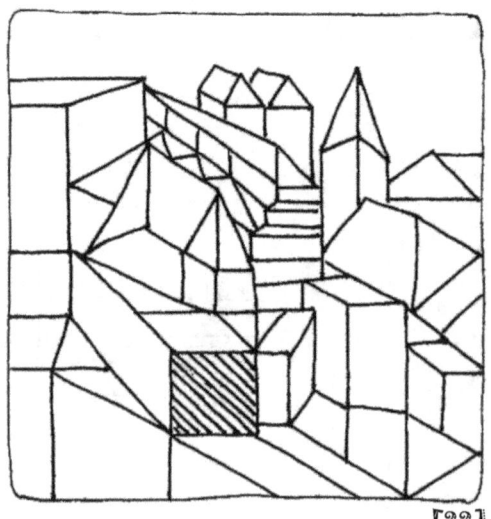

[22]

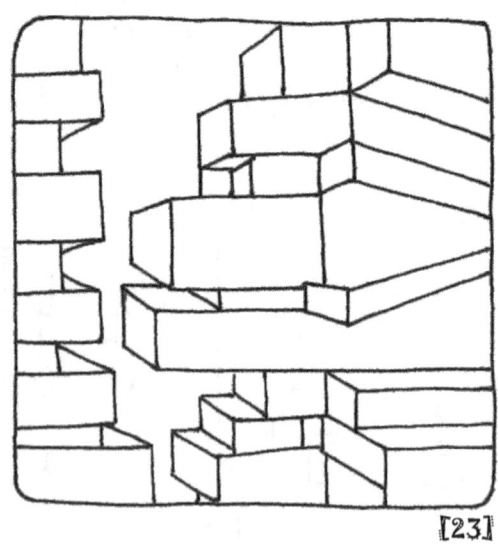

[23]

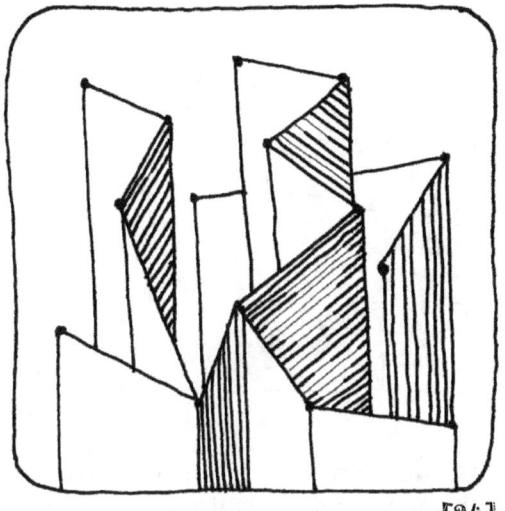

[24]

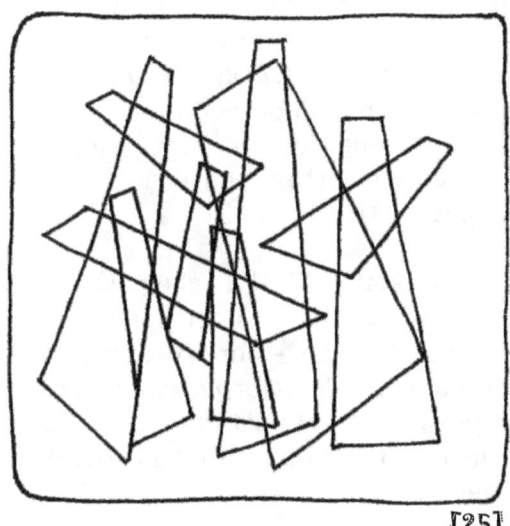

[25]

sense of depth by using angles effectively.

With a few rectangles and squares you can build this illusive glasshouse. Start drawing first one rectangle into the space and give it an other one right underneath. Connect the ends with each other and you get a box.

Now continue building more shapes across the first. By doing so you get lots of new forms caused by the crossing lines. If you use transparent paper for some of these shapes you can show the interesting way in which they overlap each other [26].

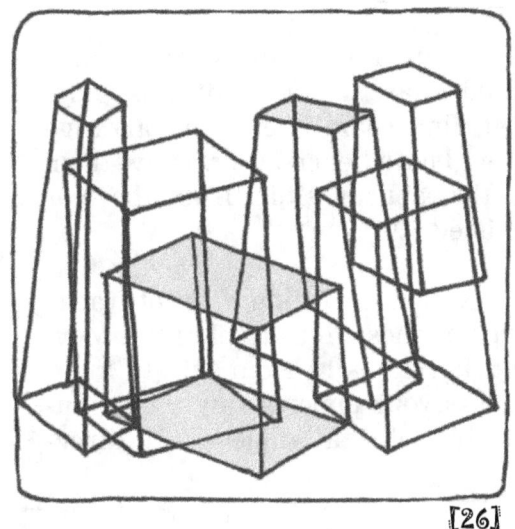

[26]

Because so many lines are crossing each other it is not easy to understand which line belongs to which shape. But they create a sense of depth in a two-dimensional area. While the overlapping of the shapes does not represent reality, it shows off the beauty of the geometric shapes.

Thus, as this and all the other examples show, you can achieve a

Frank knows that a drawing can be just a snapshot of an object in motion. With squares he shows how this would look in slow motion. When he makes two opposite angles acute and the other two obtuse, his square or rectangle can fly.

 [27]

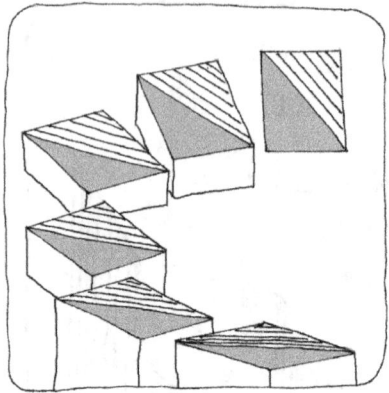 [28]

Everything looks distorted and the objects seem to become airborne [27], particularly when Frank adds vertical lines and the shapes seem to turn into flying boxes [28].

Another of Frank's tricks is to build a box snake. To do this yourself, find some cubes and arrange them behind each other. Draw them as they appear, either from above or twisted [29].

Now try creating a set of tracks such as those in example [30]. Moving horizontally from left to right across your paper, draw a continuous line of right angles in all directions, up, down and across, using both short and long lines. By adding sloping parallel lines to all corner points, you create a structure that looks like tracks or gutters. In a similar fashion you can create stairs, except that the right angles are more even and descend down the page [31].

The artist M C Escher was a master of drawing such optical illusions of space – for example, in the picture *Metamorphosis*, where shapes change almost imperceptibly from one to another that is totally different.

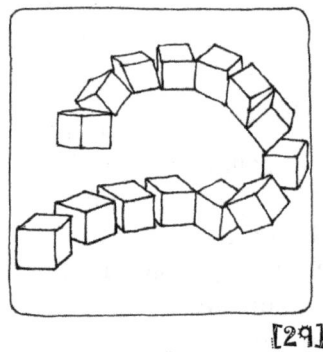 [29]

 [30]

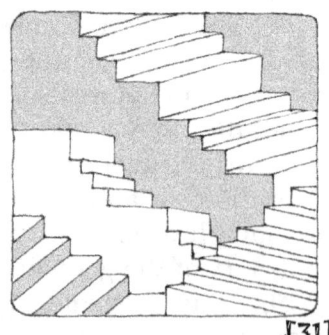 [31]

Forms and Outlines

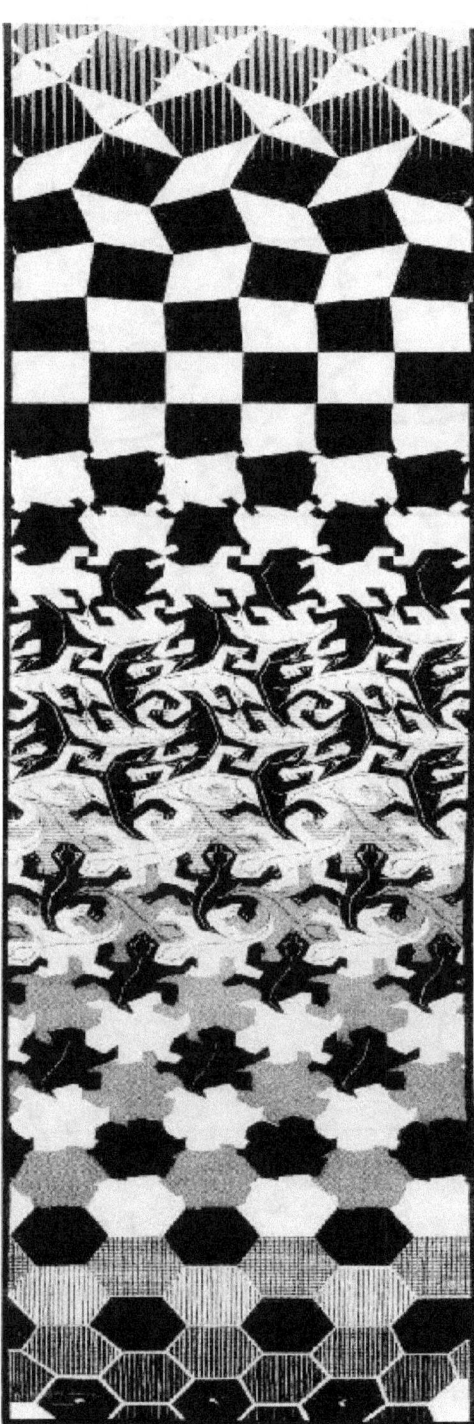

M C Escher, Metamorphosis, Graphik und Zeichnungen, Taschen Verlag, Köln 2006

All sorts of things can become a picture

Rather than throwing out your shopping bags and boxes, set up a collection of them on the floor so that you can look inside them. Next draw the outlines using the techniques we have discussed above. Even bags and boxes can make an attractive picture, especially if you design logos for their fronts [32].

You must be tired from all that building. Perhaps you need to sit down and take a rest. That's no problem for Frank – with the use of some smaller and larger parallelograms, four legs for each and a backrest, Frank creates a set of chairs [33].

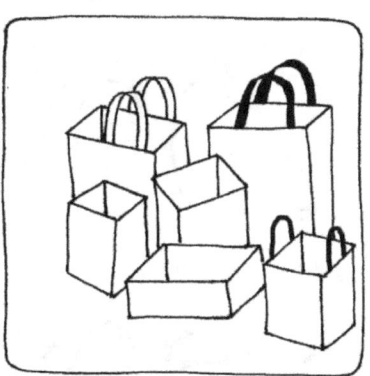

[32]

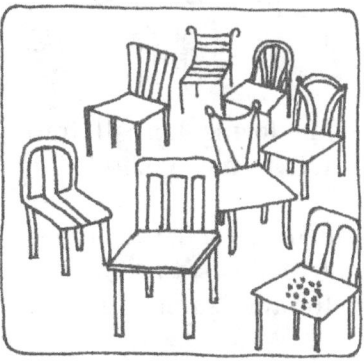

[33]

Round and curved things, and the discovery of the circle

In the middle of a field a farmer has tied his goat to a stick with a piece of rope. The hungry animal eats all the grass it can reach. The farmer watches an outline emerge in the long grass. Was this perhaps a step along the way to the discovery of the wheel?

The circle, or parts thereof, is also used in the construction of buildings. Fiona, the curved line, however, does not just build, she creates. In the three-dimensional environment the circle becomes an oval or a cylinder and semicircles become archways or domes joined together [34].

[35a]

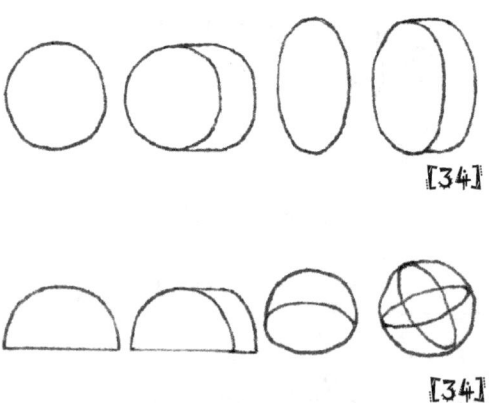

[34]

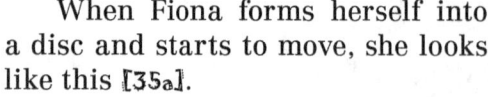

[34]

[35b]

When Fiona forms herself into a disc and starts to move, she looks like this [35a].

To transform herself into pipes all she needs to do is to combine with Frank to add some straight lines [35b].

In nature there is a mingling of lots of different shapes. It all depends on the viewpoint from which you see things. For instance, when you look down onto a daisy it looks round, but viewed at eye level it appears to have an oval shape.

Take a tour through a garden and observe how many different variations of oval forms you can identify. Observing nature very closely helps us to gain insight into its amazing diversity.

By using just a single shape – the oval – Fiona can create an entire flower garden. Not only are the flower heads and petals oval, even leaves are often elongated oval shapes [36a - 36b].

By using a more elongated and pointed oval shape, Fiona can also create a leaf arrangement. Have you ever observed how a florist creates a flower arrangement? He or she starts with just a single leaf. In Fiona's picture it is the small white one that stands upright in the middle of the picture.

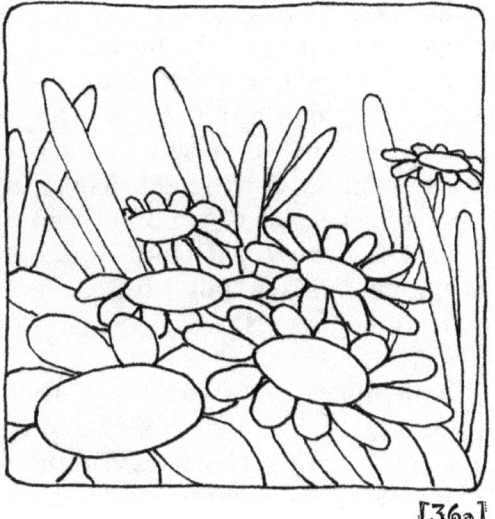

[36a]

[36b]

[37]

All the other leaves, large and small, are grouped around this. Stripes and spots make them even more attractive [37]. Remember that leaves exist in an almost infinite variety of shapes and colours.

However, while a trained person can recognize a plant by its leaf, it is not necessary to draw true to nature. We are not aiming at a botanical drawing, but we do want to use Fiona's dynamic, flowing approach.

To achieve a loose and relaxed style, try to draw a pot plant in one continuous line without lifting the pen from the paper [38a].

Remember to go with the flow of spontaneity. You will see that in the second picture the background is black [38b]. This contrasts to the first drawing and shows the negative space around it. Can you see the different effect this has on the appearance of the picture?

Our perception is that the white section, the pot plant, is a lot less clear or sharp. You are not drawn to look at it as intensely. Later you will learn the advantages of drawing attention to the background of an object in a picture.

Eggs, plums, nuts, pine cones, trees, stones, faces and, of course, leaves, all have a more or less oval shape. They are all subjects that you can draw. At first, concentrate on the basic outline of the objects. The more you observe things, the sooner you will discover the difference between the form of a plum and an egg-shape.

[38a]

[38b]

Forms and Outlines

[39a]

[39b]

To continue our oval theme, a helix and a spiral can both be depicted by very dynamic ovals, and shell-like shapes are also made up of ovals [39a, 39b].

In building our little universe of drawing we first moved from the dot to the line. Then we used these to discover basic shapes, which can be turned into new things. These basic shapes repeat themselves again and again. By now you will be quite familiar with them.

Fiona and Frank combine and invite you to their party

As a circle or disk, Fiona appears flat. But this changes as soon as we introduce curving patterns. We then get the sense that we are looking at spheres – small and large, they are bouncing across the picture. Add some strings and they become balloons [40a, 40b, 40c].

Continue the series by inventing your own flying objects.

The party continues with flying hats and lampshades [41a, 41b].

Fiona's flat disks can become other things as well. The lines help to give them the illusion of body and depth.

[40a]

[40b]

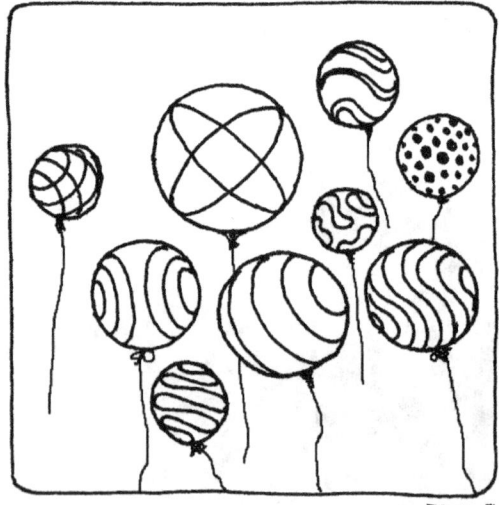
[40c]

Forms and Outlines

[41a]

Notice how the disks change their appearance depending on whether they are observed from the front or from above [42a, 42b].

If our aim is to create the illusion of a three-dimensional space in the two-dimensional environment of the drawing paper, the magic wand we need is the diagonal line.

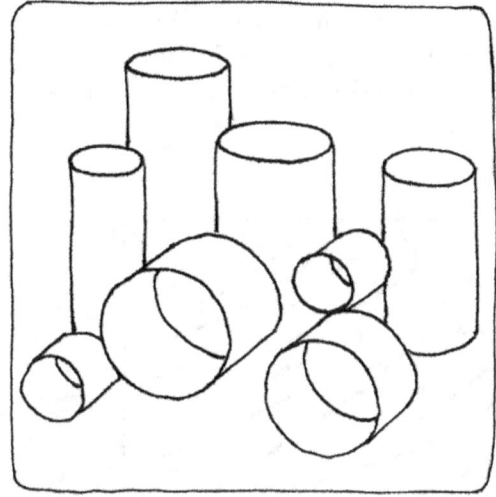

[42a]

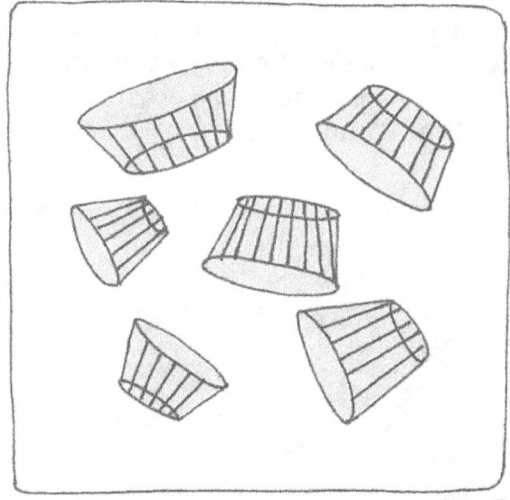

[41b]

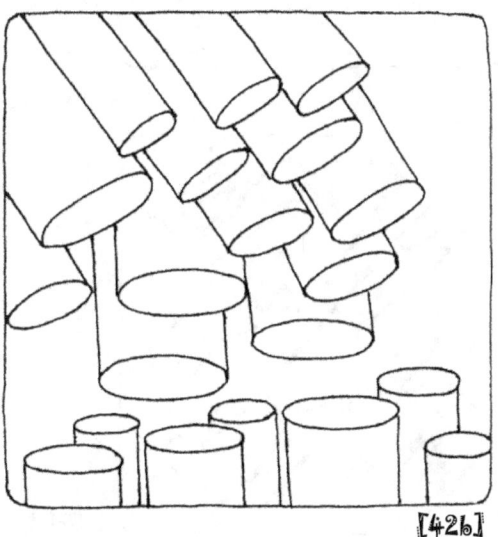

[42b]

For example, note that when Fiona draws a curving line across the paper, every curve has an outermost edge.

This is where Frank starts his diagonal line. Frank's diagonal lines close the shapes.

When all the diagonal lines are inserted, the picture looks like folds of paper or a ribbon [43].

If you combine the curving lines with straight ones, the effect is rather more abstract [44]. Here again the diagonal is used to give a sense of depth.

Now Fiona shows us an optical illusion based just on these sloping lines. First she groups lots of small circles around a centre. Then she connects everything to this centre with straight lines.

The result is a whole lot of tubes that look spherical because the diagonals give us such a strong sense of depth [45].

As an exercise, draw some floral shapes and spread them randomly across the paper. Diagonal lines can then be added to connect the shapes and make them dynamic.

Next add some black and white details to provide contrast. Ornamental designs such as this are often used for fabric [46].

In a later chapter we will talk about landscape. Here is a little foretaste. The scene has been created by both Frank and Fiona.

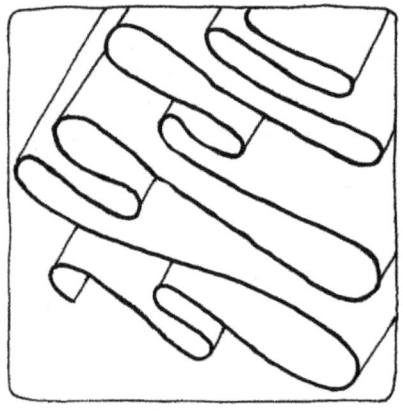

[43]

[44]

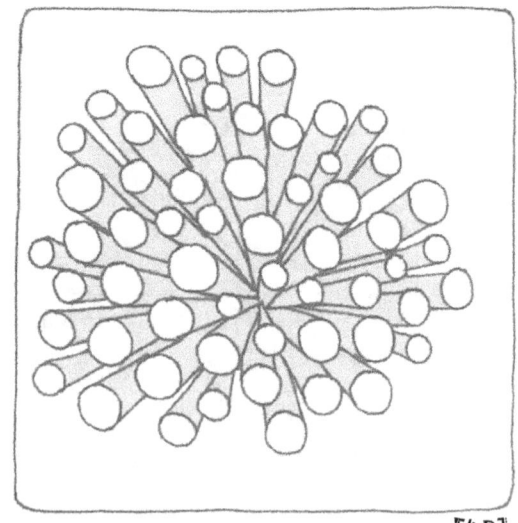

[45]

Forms and Outlines

[46]

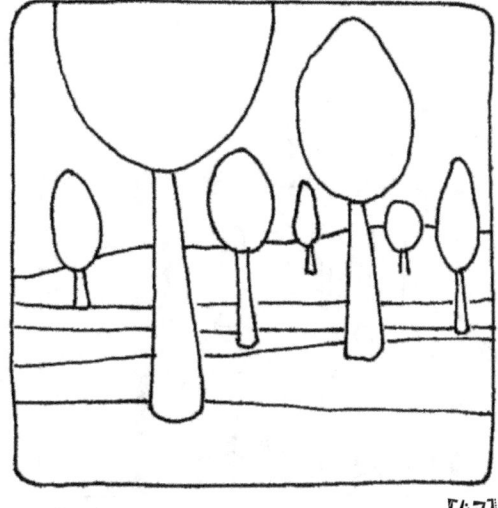
[47]

Because Frank's horizontal lines get closer together towards the horizon, the picture looks three-dimensional, while Fiona's oval tree shapes in different sizes add to the effect [47].

For their next trick, Frank and Fiona are playing with building blocks. The resulting picture contains all the forms you are already familiar with as well as some arches and domes contributed by Fiona. Together they have made a little town.

Now it is your turn. Start from the bottom up, adding diagonal lines to horizontal lines as you go and then continuing with the verticals. This is a game you can play as often as you like [48].

In the next example, six horizontal lines divide our picture into different-sized segments. Walls and gates appear in the first, third and fifth parts. Diagonals are added to the other sections to create roof lines, which become more and more sloping from the centre of the picture outwards. The second and third sections of the building seem to create a circle. That is because diagonals are very powerful in influencing what we perceive [49].

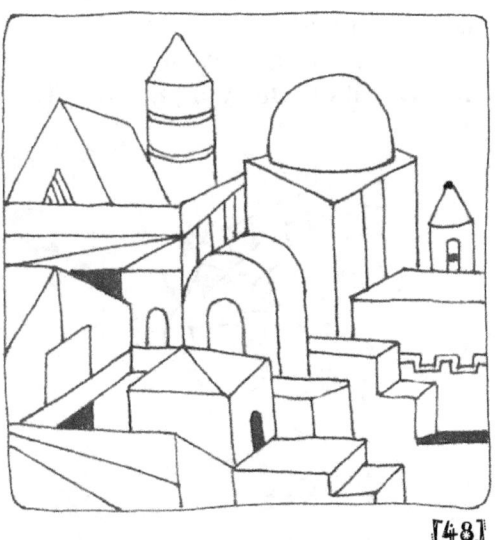
[48]

61

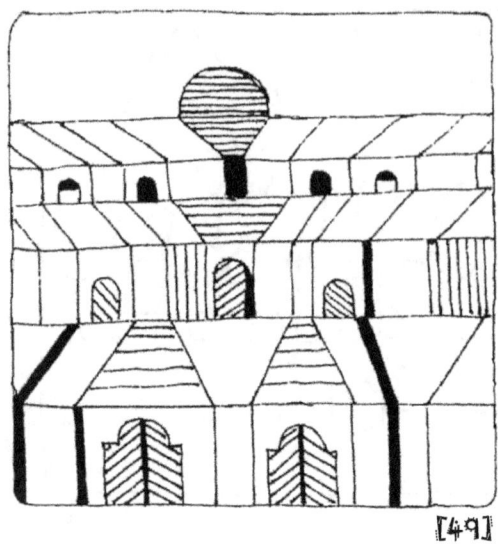
[49]

Representing nature

A drawn object always has a different character to its actual counterpart. We are not drawing nature but our impression of nature. We think words, but we imagine pictures. Images also dominate our dreams.

An object that we observe affects and influences us. To be able to represent it in a drawing we have to discover its underlying nature. To draw a picture of something is not to reproduce it. It is an exploration – sensing and discovering its true nature. Because objects talk to us and influence us, we end up being drawn to those that have the most to say to us as individuals. Objects surround us on a daily basis. They connect us to memories. Buildings and landscapes that impress us become favourite subjects for our artworks.

While objects are items that we recognize and have names for, there are also objects that only exist in our imagination – like the poor man in the illustration [50] being overwhelmed with having to deal with too much information.

The two large drawings [51 – 52] illustrate most of the material covered in this chapter. They will remind you of all the important rules once again:

- Big means in front.
- Things get smaller towards the back and top as well as closer together.
- Ascending lines draw you into the picture.
- All objects in the sky become smaller towards the horizon.
- Depth is created by stacking things behind each other. The bigger an object in the foreground the more distant the other objects seem.

All this leads us to the next chapter: three-dimensional space and perspective.

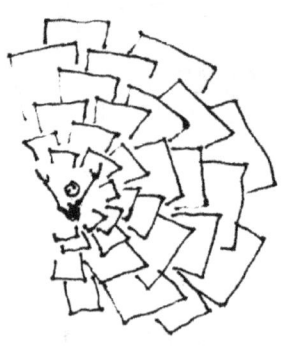
[50]

Man dealing with an overload of information

Forms and Outlines

[51-52]

Ingeborg Zotz – Fascination Drawing

Two frames for you to practise

4
Space and perspective

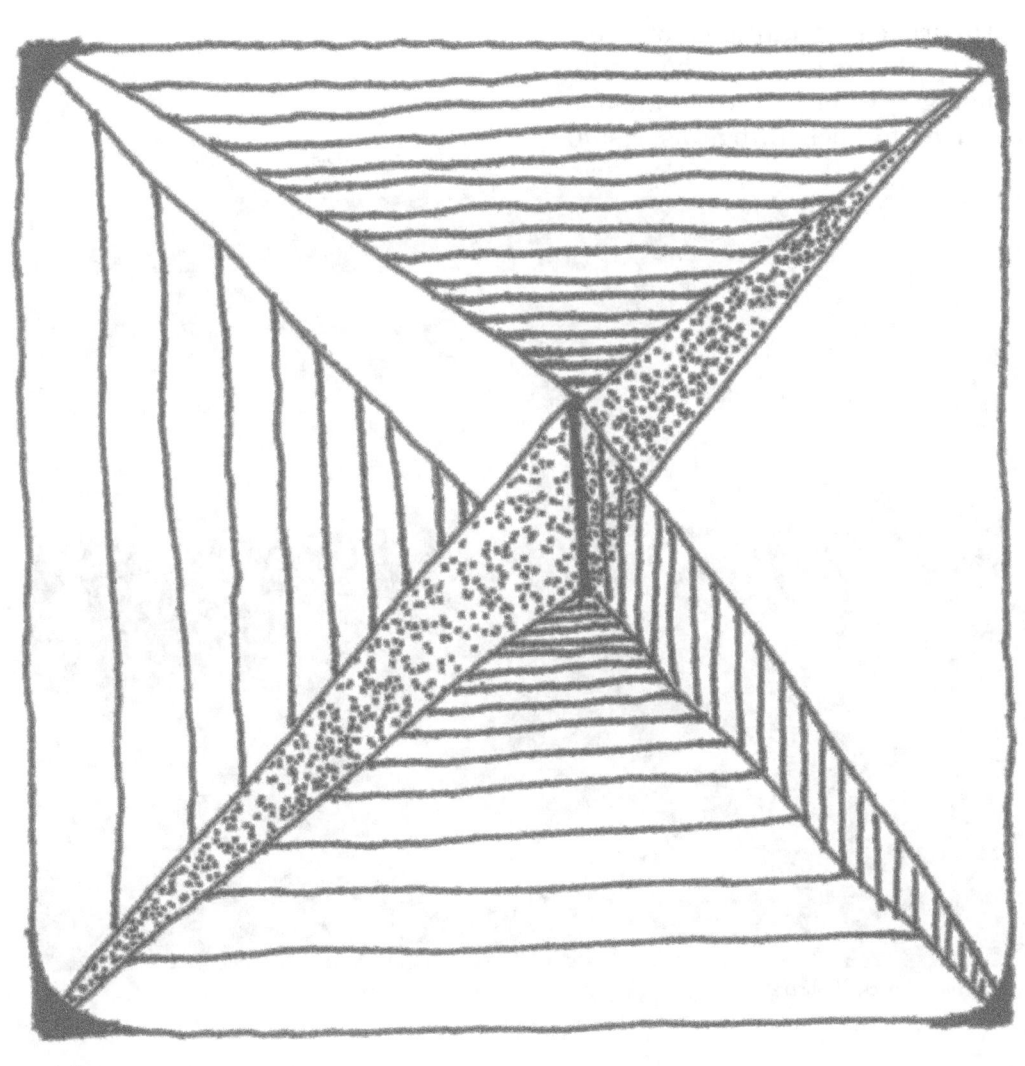

Perspective leads us into the distance

Everybody knows what 'perspective' means. Just think of the famous example of the train tracks that meet at the horizon, or when you drive along a straight stretch of road that gets smaller and smaller in the distance but does not end. The photo below shows this point, called the 'vanishing point'.

Theoretical definitions of 'perspective', however, can be quite confusing when they include references to such things as visual rays and vanishing points. This is not much help to the beginning artist, but with the help of Frank and some simple observations we can make these things become a lot clearer.

Frank knows that as a straight line he has only one dimension, but with the help of some of his colleagues he can magically create the second and third dimensions on a two-dimensional piece of paper [1]. Clearly, of course, it is an illusion.

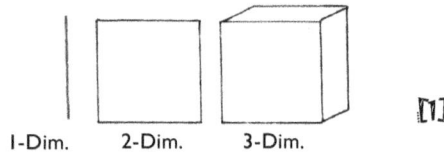

1-Dim. 2-Dim. 3-Dim.

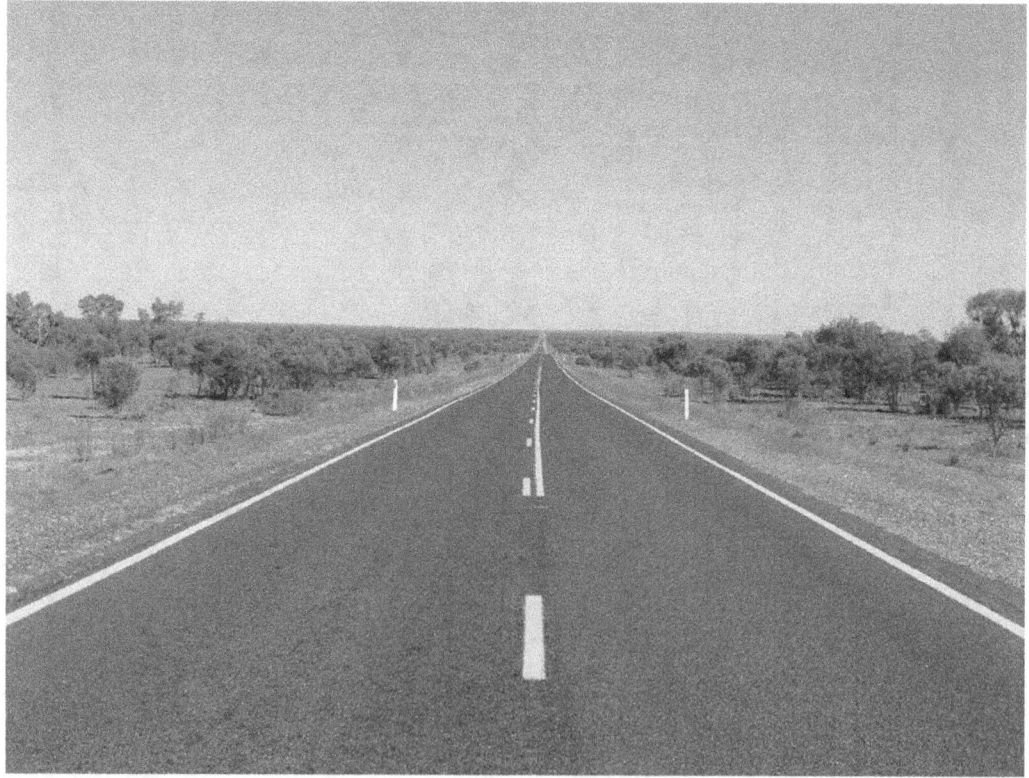

A road in the outback of Australia

How to create the impression of the third dimension

When drawing out in the wilderness the conscious need for perspective is less because it is obvious that the big things are in the foreground and all other objects are located behind each other, becoming smaller towards the horizon [2].

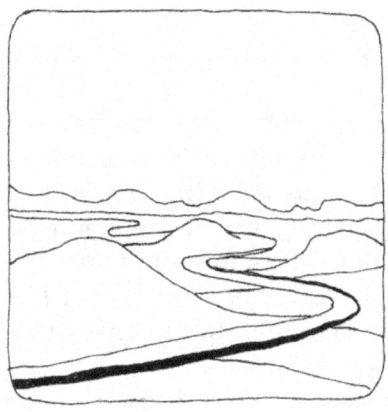

[2]

A river running through a range of mountains

A short history

The term 'perspective' had its origins in the Latin word 'perspicere', which means 'to look into the distance'. Perspective was developed by human activity. People build houses, roads, bridges, fields, fences, walls and so on. They also plant trees in straight lines.

In Chapter 3 we referred to a very famous drawing by Leonardo Da Vinci, Vitruvian Man. It shows a man reaching out into a square as well as into a circle [3].

See what happens when he stands on the square shown in the third dimension or having the circle changed into a sphere around him. He has now conquered a new world – space!

With the use of perspective the figures in examples [4] and [5] illustrate the illusion of spatial awareness.

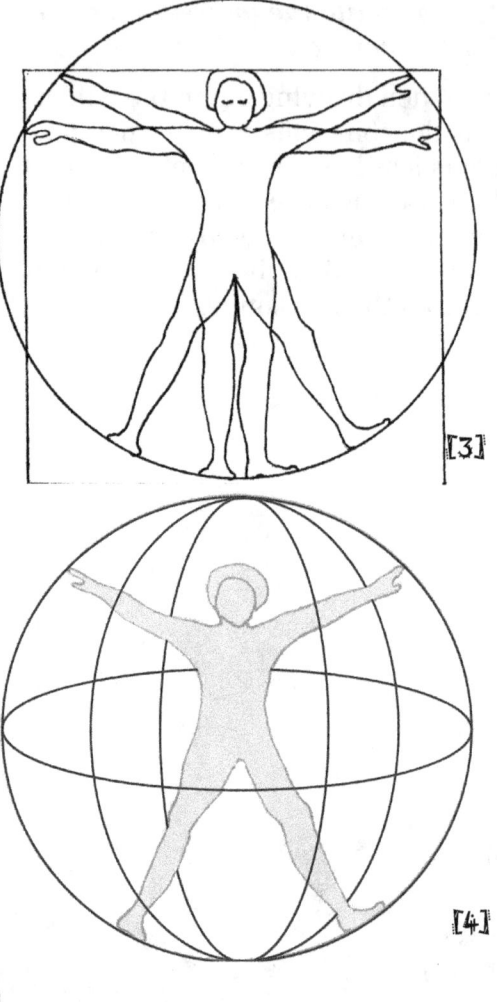

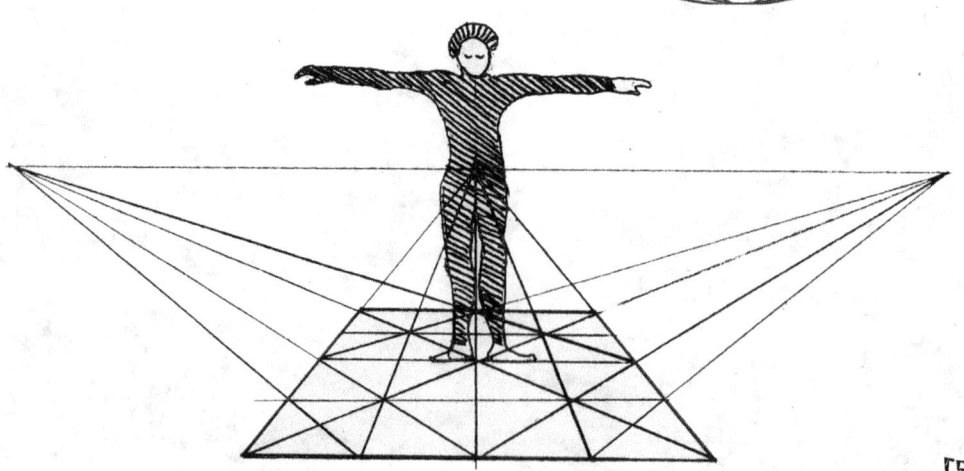

Leonardo da Vinci's Vitruvian Man and his experiece of space

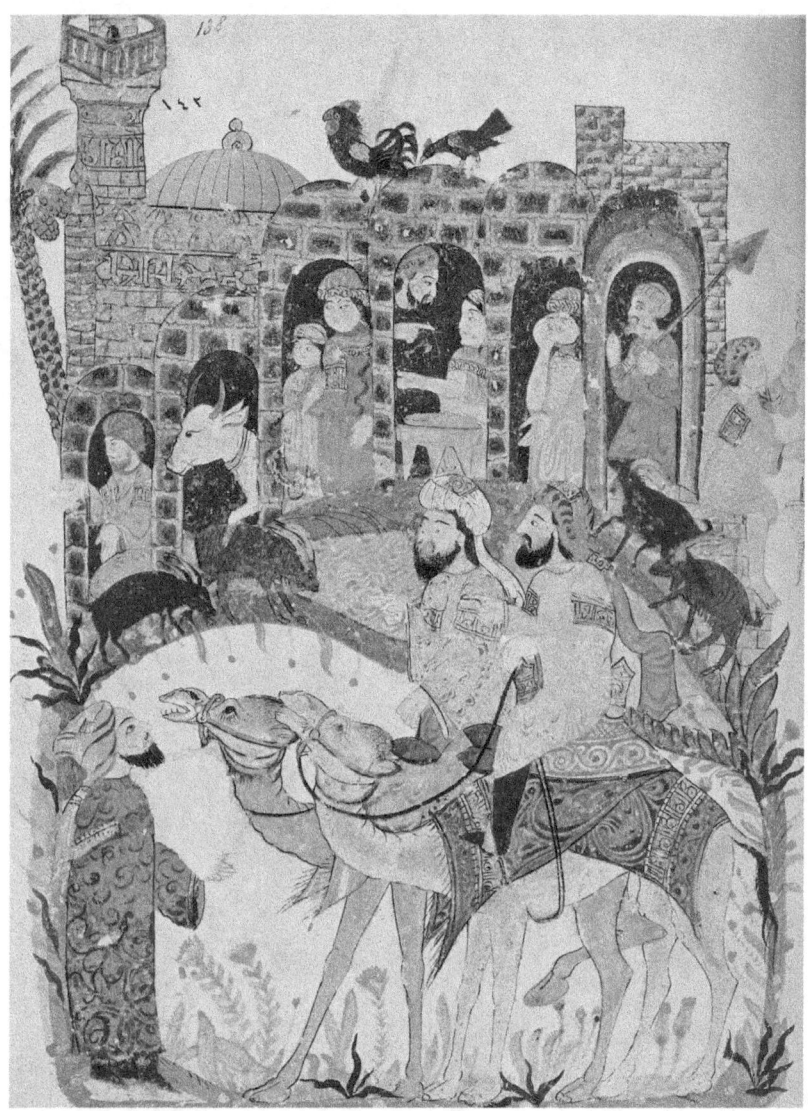

Village Meeting of Men, Arabic painting, 1280, Die Arabische Malerei, Klett Cotta

In the ancient cultures, for example Egypt or Babylon, painters did not use perspective. Everything was depicted flat, staggered or overlapping.

In the example [6] of a gathering in a village, you will see that the new people arriving in the foreground are drawn much bigger than the meeting place and the people who are already there. The timing of the events portrayed becomes quite clear – the more important and recent events are at the front and are larger. This was called 'vertical' perspective.

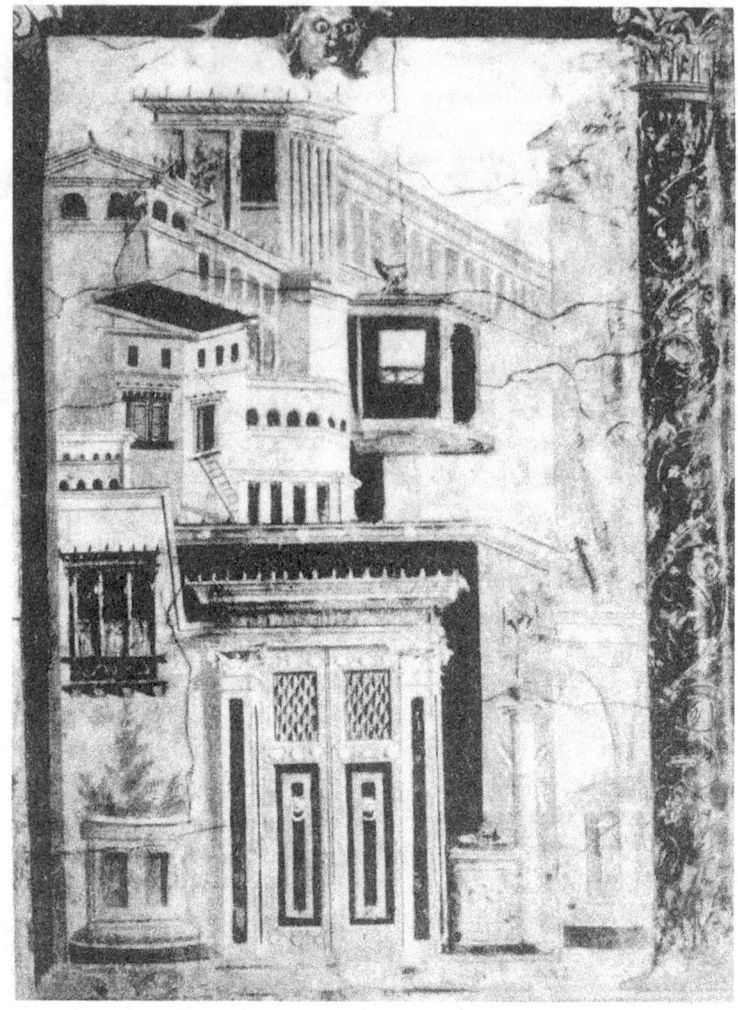

A stage set for a comedy (40 BC) [7]

The first evidence of systematic attempts to develop perspective appeared in Ancient Greece in the 5th century before Christ. There are not many examples left of these early experiments.

However, some vases show figures using foreshortening. There was also further evidence of early attempts in theatre props of buildings, houses, temples and pillars, which were devised to give an illusion of depth on the stage [7].

While artists were responsible for the invention of techniques for imparting perspective, there is some evidence that mathematicians also

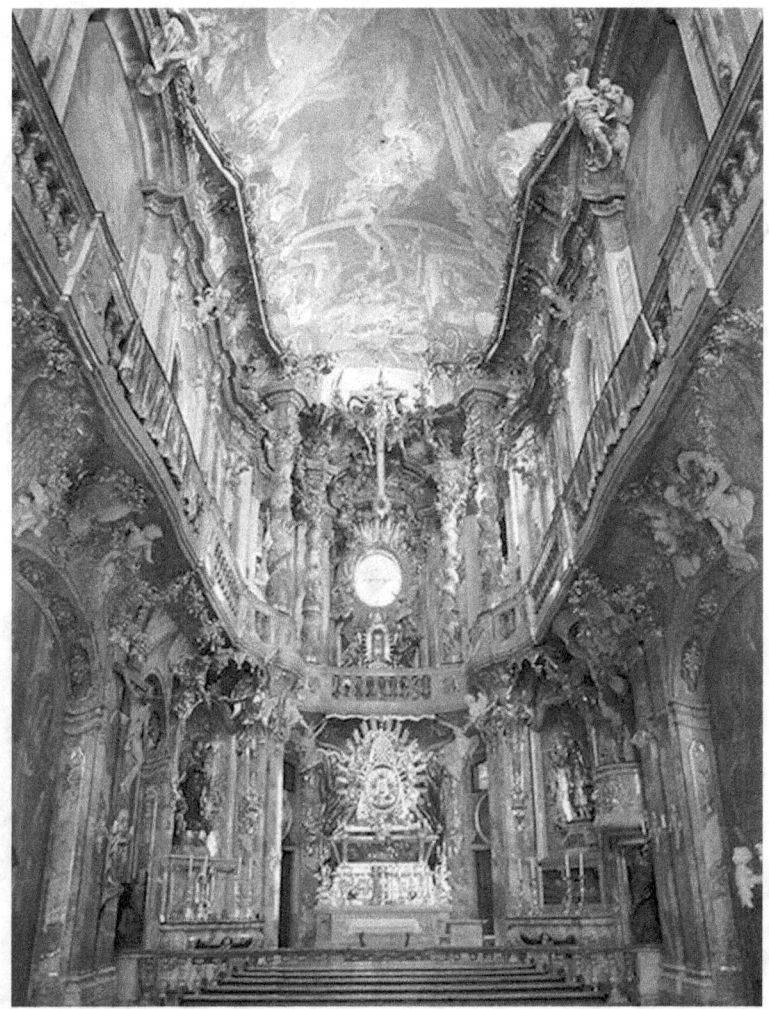
The Asamchurche in Munich [8]

took an interest in it during the later years of antiquity. In Pompeii, frescos were found that indicated the use of vanishing points. But it seems that most of this knowledge got lost during the Middle Ages when paintings telling stories from the Bible became two-dimensional again.

However, during the Renaissance in the 14th century, the techniques involved in creating perspective reached new pinnacles. The Italian, Philippe Brunelleschi (1377-1446), is regarded as the founding figure in the development of modern perspective.

He was also the architect who designed the dome of Santa Maria del Fiore in Florence, but it was his invention and use of the vanishing point in his paintings that was so important for following artists such as Leonardo da Vinci, Raphael and Michelangelo, to name but a few.

Knowledge about perspective reached another high point during the Baroque period, particularly in the flamboyant paintings on the ceilings of churches, which gave a perfect illusion of depth [8].

The modern era

Around 1900 abstract art began. Paintings no longer needed to give the illusion of depth because art was no longer a mirror of reality. Therefore, it was no longer necessary to trick the eye into seeing depth and space on a flat surface.

The impressionists turned space into light and colour [9]. Three dimensional space begins to disap-

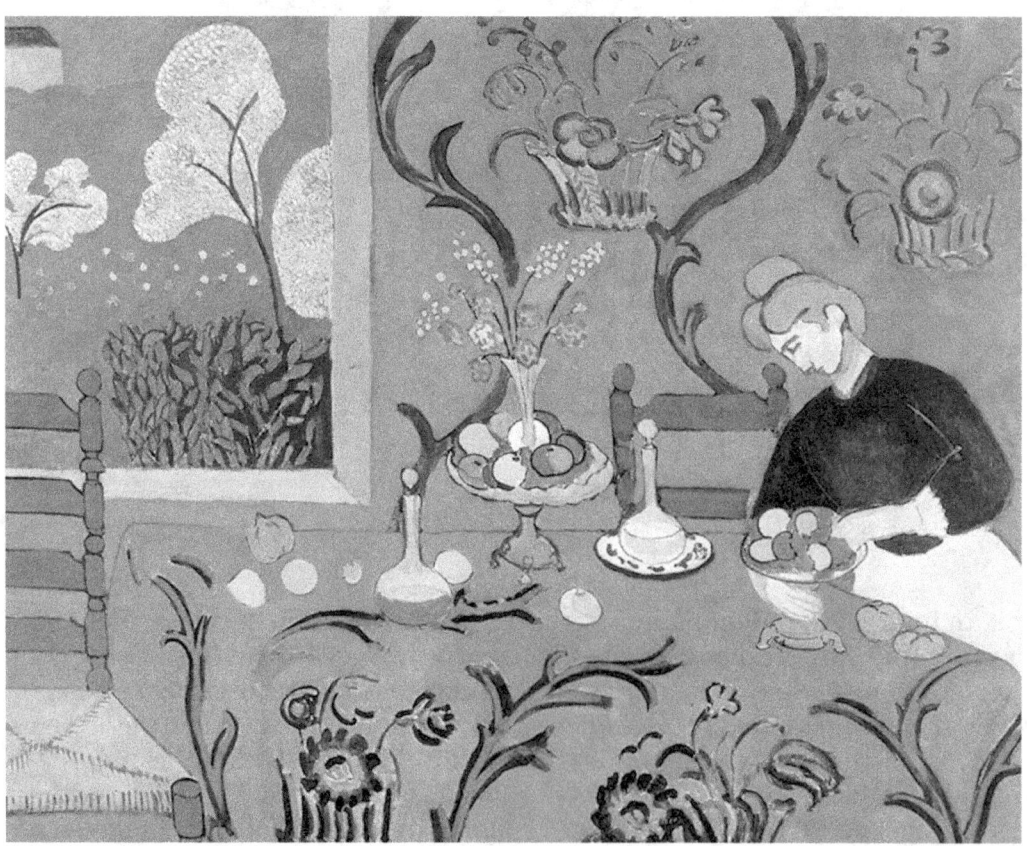

Matisse, La Desserte, 1908 [9]

pear from paintings and cubism fragmented all depth. Being able to look at everything simultaneously becomes the new viewpoint [10].

The problem for the artist is that while we can experience objects the way they really are, there is a discrepancy between the complexity of the object and the limited experience of it that we have when we look at it. A constructed perspective helps to depict things the way we see them. For this reason, perspective continues to play an important role in art and graphic design as well as in technical drawings.

An example of cubism in the style of Picasso [10]

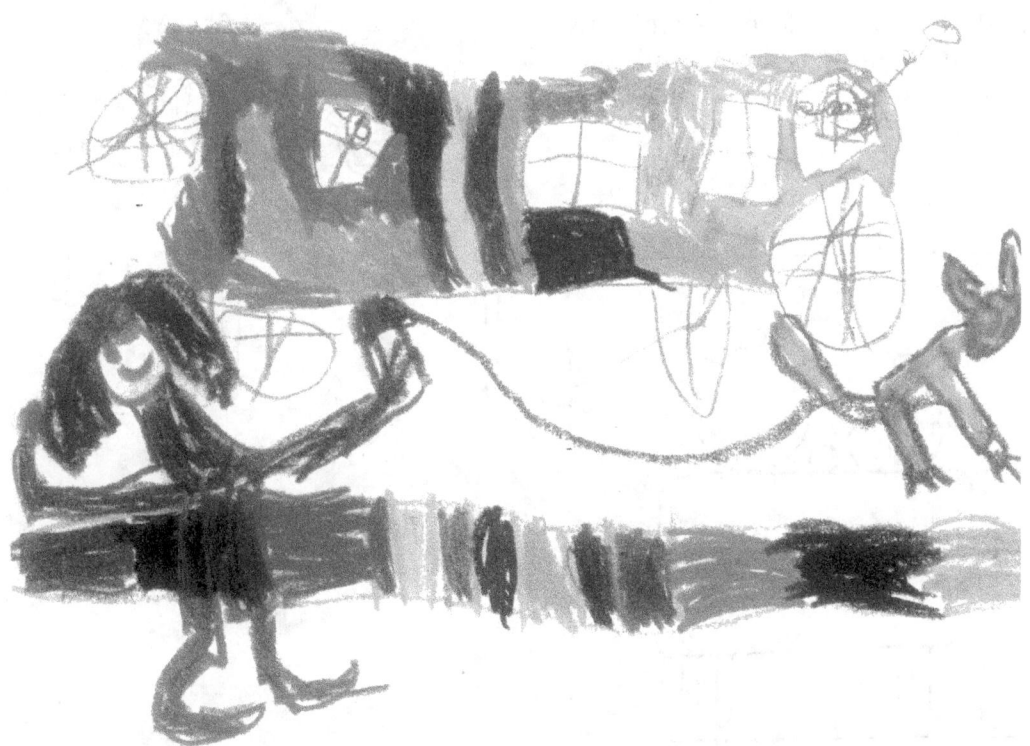

Maya, aged 5, is walking her dog across the zebra crossing; the car is waiting. [11]

Small children find all this very easy. They draw in only two dimensions. All objects are flat and things that are further away slip up into the top of the picture [11].

In Example [12] we recognize a flat table and its four legs. On top we see a teapot and a bowl with fruit. As children we learnt how things are by touching and feeling them. But an object can change its appearance [13]. It has many faces, depending on our viewpoint. If you sit under the table it looks very different compared to how you see it when you climb on top of it. We can only depict an object well when we understand its many aspects. In other words, we have to experience objects in the world around us before we can draw or paint them. You don't think pictures; you imagine them.

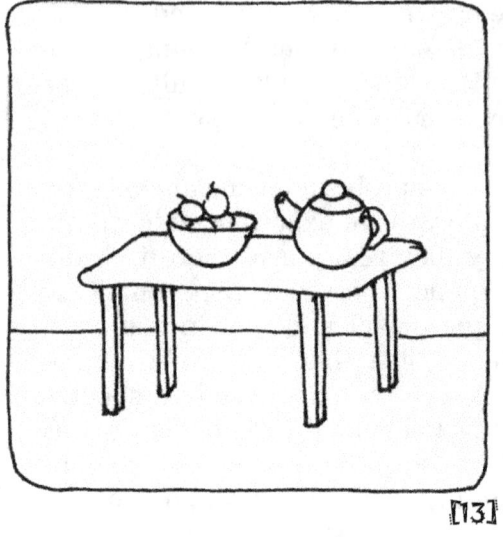

[13]

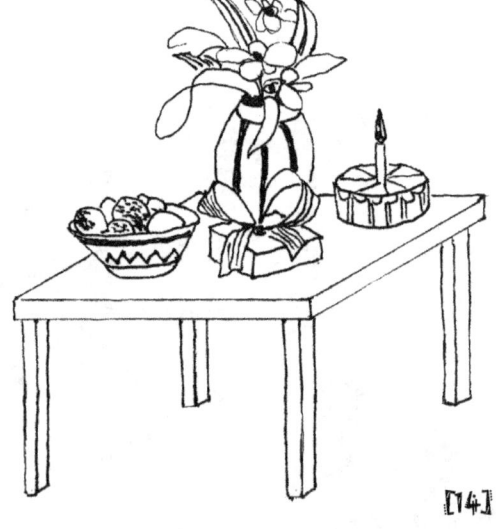

[14]

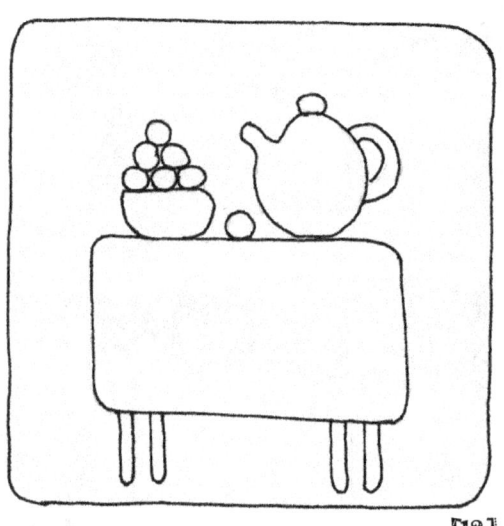

[12]

Space and perspective

Using parallel lines to create an illusion of depth

In the chapter about shapes you met the square. Frank turned the square into a cube with his diagonals. The result was a parallel projection. The diagonals, which are so important to giving the appearance of depth, do not have a vanishing point. This is how we depict objects that are not far away from us, as over a short distance we do not detect the foreshortening. You will often see this in still-life pictures, such as this birthday party table setting [14].

If you need a construction plan for a home, you can draw this yourself using parallel lines. A simple box forms the basis of your plan [15a]. You can see that everything in this drawing is parallel.

Now draw three big boxes and stack them on top of each other [15b]. On top of this staircase you draw the box for the house. Where the dotted diagonals cross, insert a vertical line. This marks the centre of the roof. Connect the top corners of the house with this vertical line and your roof is ready [15c]. Such an imposing building needs a portico. This also is a kind of open-ended box. Light grey shading accentuates the steps and the roof [15d]. I hope your construction goes to plan!

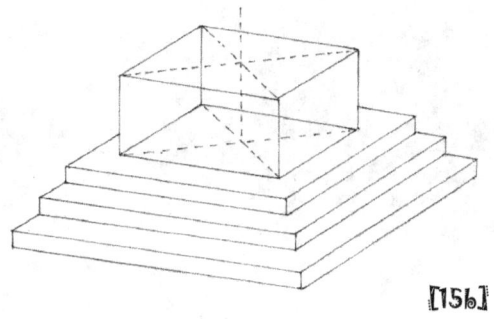

[15b]

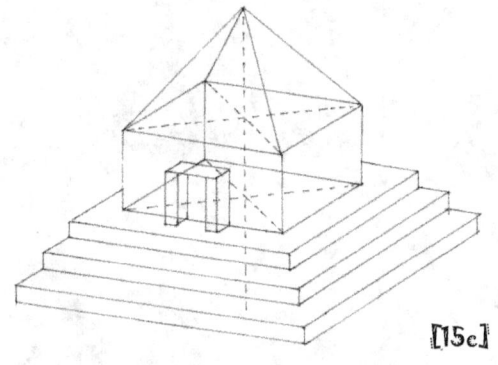

[15c]

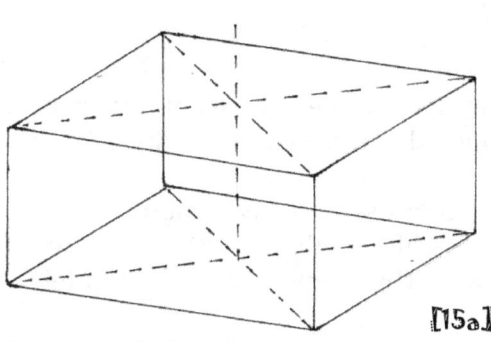

[15a]

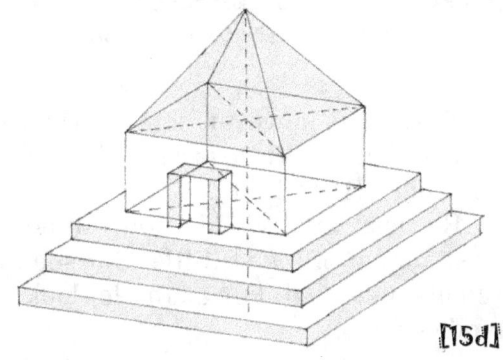

[15d]

Ingeborg Zotz – Fascination Drawing

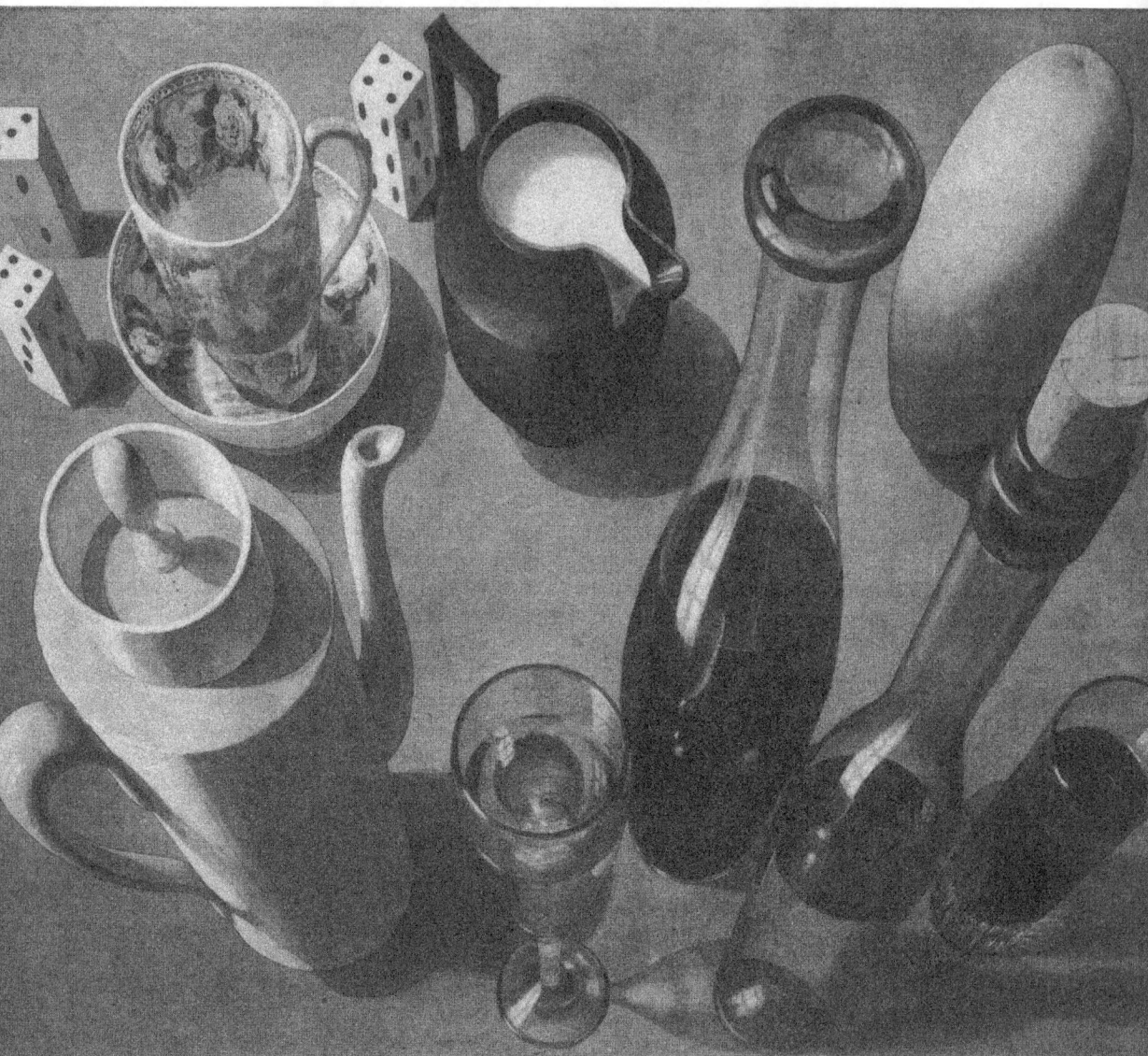

Still Life by Ludwig Adam Kelterborn (1811–1878)

There are, however, some curious exceptions to the simple rules we have discussed above. Here is a still-life using central perspective by Ludwig Adam Kelterborn (1811-1878).

He used an invisible point under the table as the central point for the construction of his still-life. But see how this has made everything look extremely distorted. For example, look particularly at the dice in the top left-hand corner.

Space and perspective

Finally, a little city

We have seen that by drawing parallel constructions you can develop a series of buildings.

Use your knowledge of parallel perspective construction in a playful manner to suggest a town view [16a].

There is no vanishing point; all the buildings are constructed by using parallel lines, diagonals and semicircles.

Start your sketch in pencil. You can either copy the picture or start just with a tower or a house and steps, walls and other buildings in an informal way. You should start the picture beginning from the bottom paved area, then set one building behind another, alternating large and small buildings.

When you are happy with your sketch, go over the lines with a black marker. The sun is shining from above, on an angle; this means the shadow hatchings are on the right-hand side [16b]. Chapter 6 will introduce you to the creation of shadows.

In 1600 Guido Ubaldi published a book called 'Perspectiva', which for the first time discussed the fact that parallel lines drawn from a point on the ground will converge at a point on the horizon. He called this point the 'punctum concursus'. We now call it the 'vanishing point'.

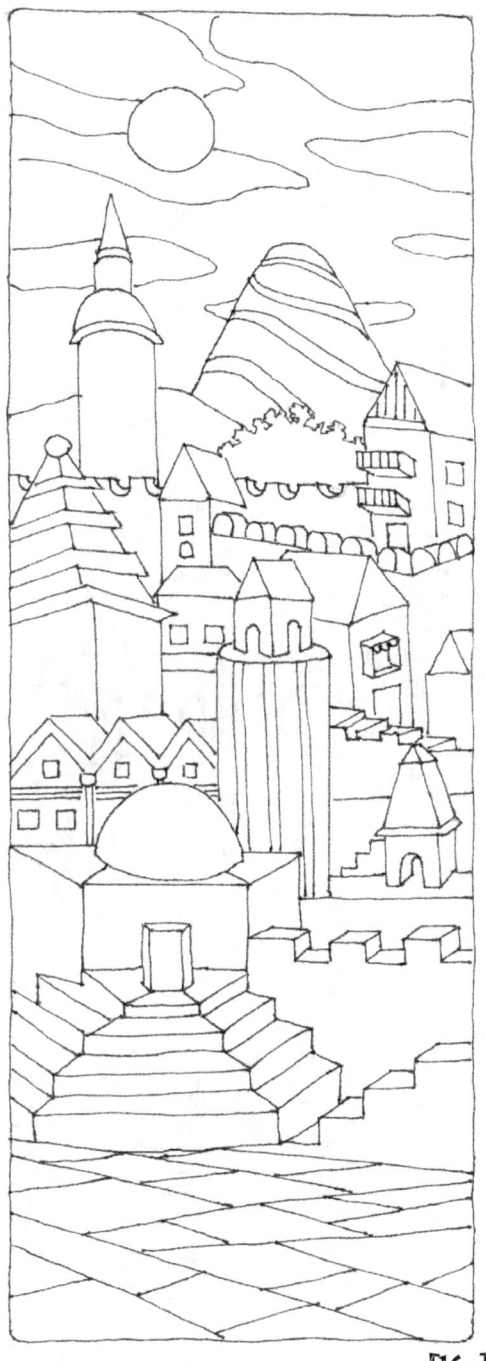

[16a]

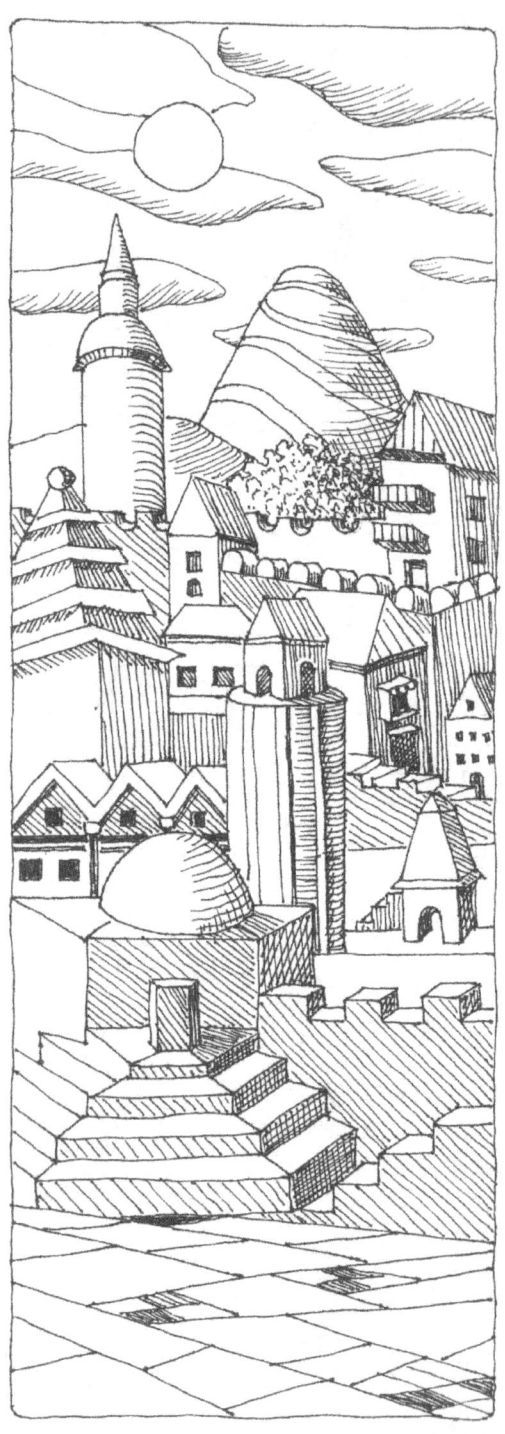

[16b]

Frank and the vanishing point

The sun is slowly setting. Frank takes a walk along a tree-lined avenue. He is followed by his long shadow. Exactly at his eye level lies the end of the path at the horizon. Each one of us has our own individual shadow as well as our own horizon. These two things we can never lose. The shadow is created by the incidence of light and the horizon depends on the position of the observer.

In the picture of Frank walking, all lines are leading to one point on the horizon. This is why that point is called the 'vanishing point'. It only becomes observable when we are looking at straight lines such as roads, canals, or buildings, as in the picture of Frank walking along the avenue [17].

We talk about 'central' perspective when only one vanishing point is used. As you will see later in this chapter, it is possible to have two or more vanishing points.

Spend a day observing your environment and where your horizon lies in relation to it. You may be in a shopping centre on an escalator, or you may have just taken off in a plane from the airport [17, 18, 19,]. Or you may find yourself in a bus, a car, or perhaps even weeding in the garden [20].

Space and perspective

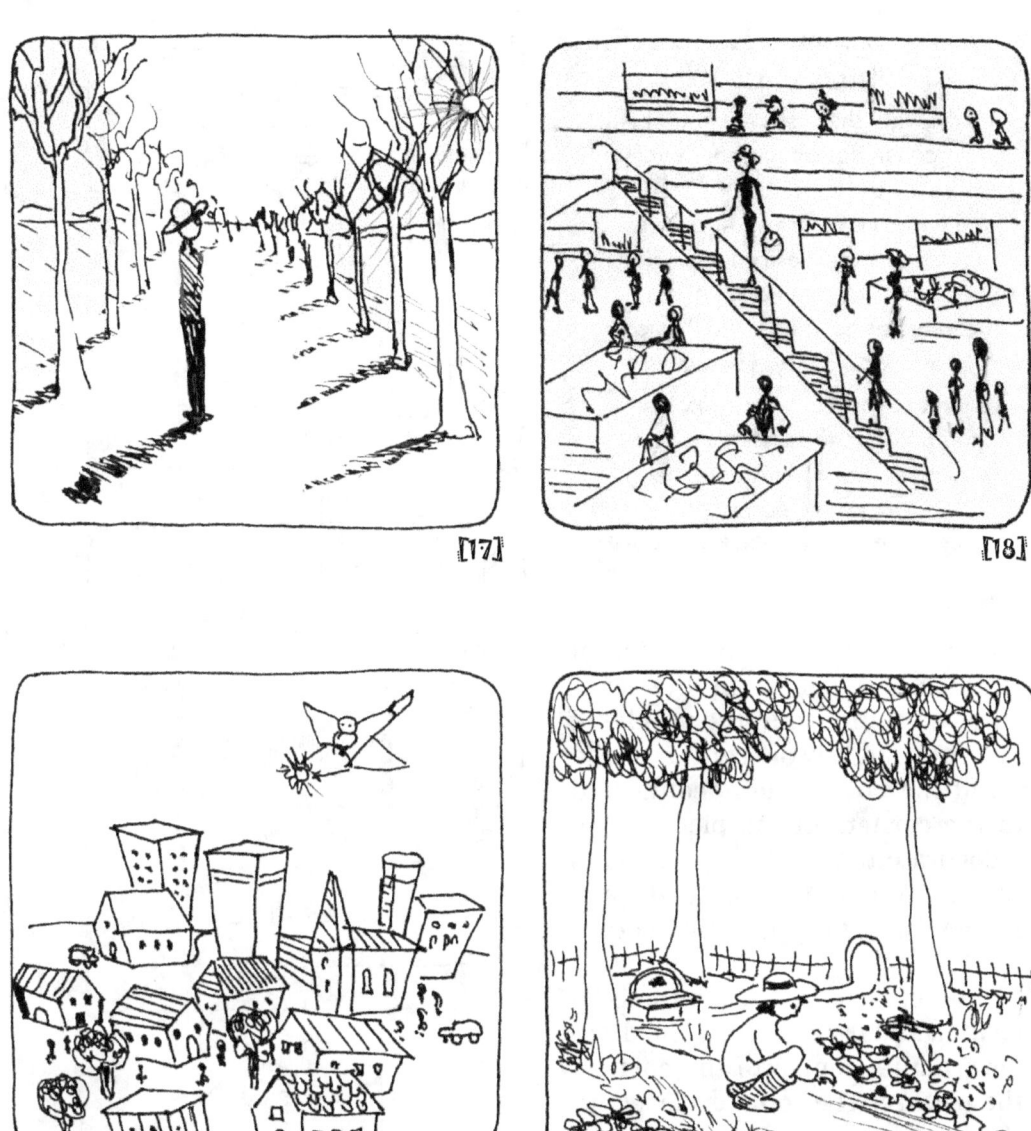

[17] [18] [19] [20]

Observe how your environment looks different when the horizon changes. The height of the horizon in a picture reflects the eye level of the observer. For instance, when you are on top of somewhere you look down on the things that are below you. The higher you are, the smaller these things will appear. If you are weeding in the garden your horizon may be just the neighbour's fence. So obviously what we see depends on where we are.

> **Important:**
> A drawing that uses alignments in its construction has to be very accurate. It takes a lot of practice and patience to draw these lines freehand to the desired vanishing point on the horizon.
> If this is not achieved, the illusion of depth is not created.
>
> You can use a ruler to help you position the lines that you draw freehand towards the vanishing point.

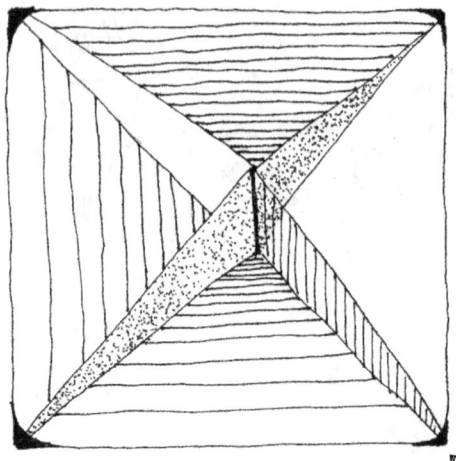

[21]

Perspective in practical terms

To help with the construction of the vanishing lines, Frank the vertical line is positioned in the middle of the picture, slightly off-centre. At the top and the bottom he is connected with the corners of the picture. We can decorate the resulting segments with horizontal lines of graded spacing. These lead deep into the picture [21].

Now replace the line in the centre with a square and draw the diagonals from its centre to the corners of the picture. The room is closed off at the back by a wall [22].

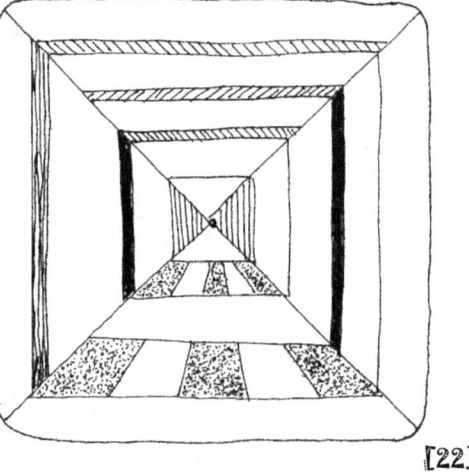

[22]

These are both examples of central perspective. With these examples I want to show you the diverse and interesting results you can get when you play with these elements. This is not intended as an exercise in technical constructions; rather, it is a journey of discovery into the illusion of depth in a drawing.

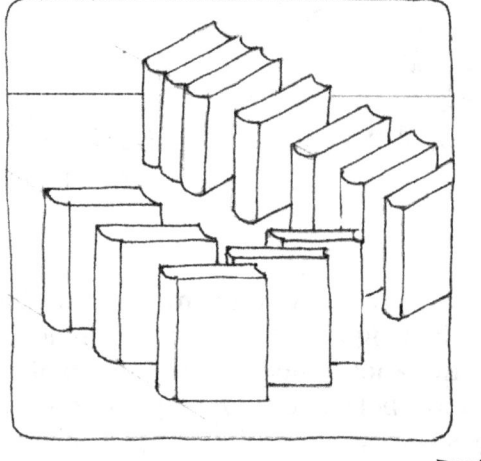

[23]

Space and perspective

In picture [23], the books are represented by cuboids. They stand upright on a flat surface, behind each other. Five of them are visible front-on and another seven can be seen from a side view. They seem to exist in a three-dimensional space. In this picture there are no vanishing points. It is a parallel projection. This is how you would draw things that are close, as in a still life.

The cubes in picture [24], however, do have a vanishing point. They represent houses along a street. We still have vertical and horizontal lines, but the difference in this picture is that the diagonals all lead to the vanishing point. They pull the viewer's eye into the picture and create the illusion of space. The closer the cube is to the horizon, the smaller it becomes.

In the next example, you will experience something new. You are standing at a street corner where two roads meet. This means that two

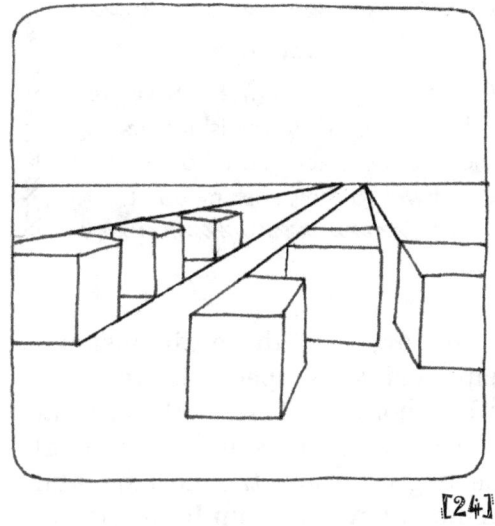

[24]

vanishing points lie on the horizon. The walls of the first house and of the houses behind it lead up to these points. This is so for all parts of the buildings that sit below the horizon. As the tall buildings rise above the horizon, however, the lines of the walls point downwards to the vanishing points [25].

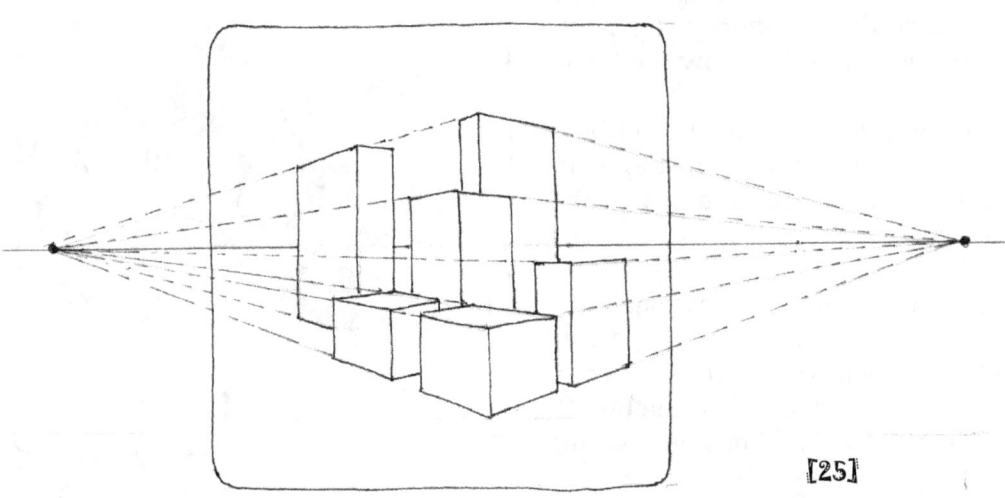

[25]

> **Important:**
> Objects below the horizon have lines that rise up to the vanishing point, and all objects above the horizon lead down to the vanishing point.

[26]

To draw a three-dimensional shape using perspective, we start with a horizon. This is the line at the eye level of the viewer. A vertical line begins below the horizon and extends above it. From both ends of this line we draw connecting lines to the two vanishing points that lie on the horizon. The edges of the object are placed along these lines. Now we also connect those ends to the vanishing points. The point where the lines cross each other is where the back of the object lies [26].

Here are some more cubes, also using perspective. The vanishing point lies on the horizon. The use of a ruler helps in the construction of such a drawing. It is important to understand the foreshortening. Note that all the cubes lie below the horizon [27].

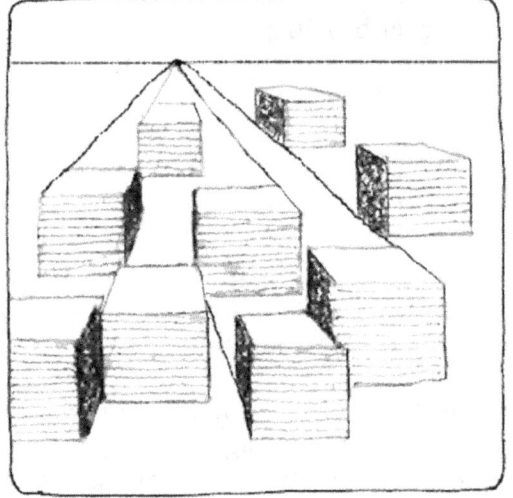

[27]

You can also scatter the cubes. See how the impression of depth is created by the staggering of the objects [28].

Now use what you have learned to draw a toy town made from blocks. Or visit an old town with a market place and sketch some buildings, with and without vanishing points [29].

[28]

Space and perspective

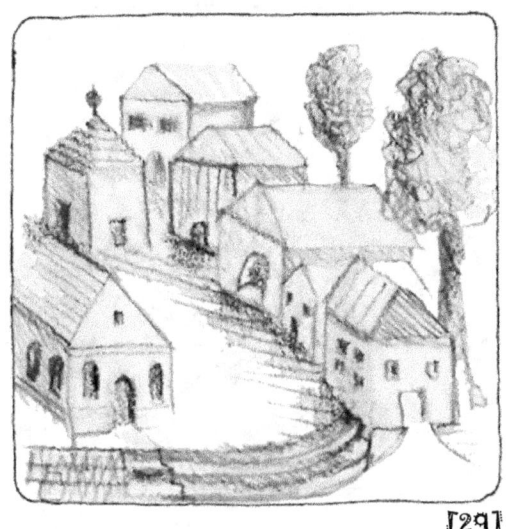

[29]

Fiona's curves become three-dimensional

It is quite clear that we could not build anything without Frank's straight lines or right angles. But how different would all our famous architectural buildings look without Fiona's arches, domes and other curved elements? These shapes make buildings look elegant and grand. Arches give a building stability and lightness at the same time.

A good example is this sketch of a Roman aqueduct which stands in the south of France [30].

Three different rows of arches give this construction a certain dynamic. The curves make the building flow like the water it carries through the undulating landscape. They give the building power and strength.

In the second example you can see how awkward it would look if the arches were replaced by squares [31].

[30]

[31]

83

Despite any architectural issues, however, it is Frank's horizontal line on top that is crucial to bringing the water to where it is needed.

You will not be surprised to hear that Fiona's circle also changes when we apply the use of perspective and introduce a vanishing point. Note how the circular surface changes into an oval when you direct the square to a vanishing point [32].

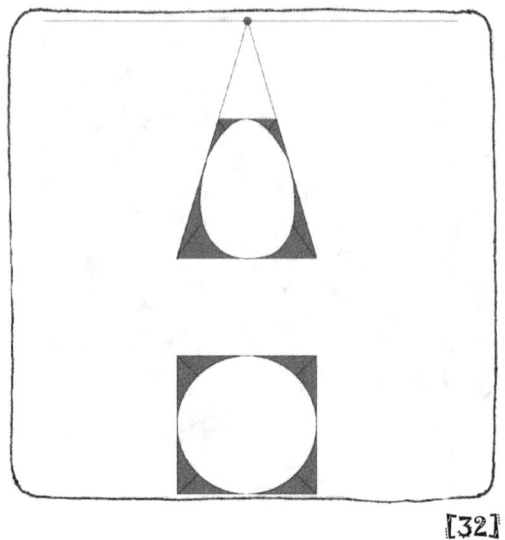

[32]

If you use a compass and draw circles along the lines that lead to the central point on the horizon, you will end up with something that looks like this [33]. The circles are all visible from the front. This way they do not become a pipeline that leads into the distance.

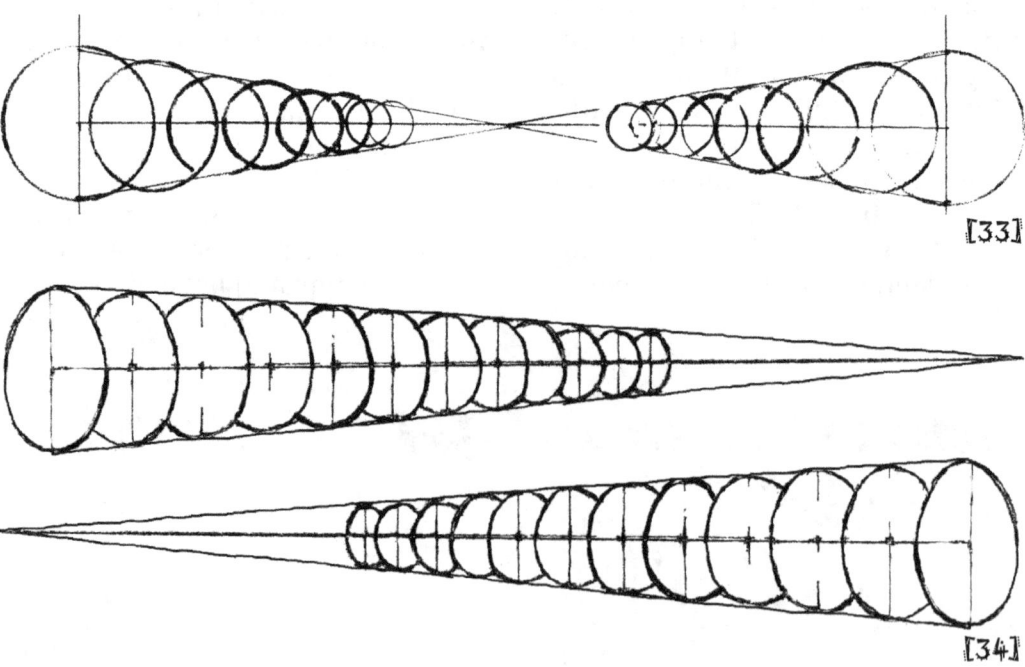

[33]

[34]

Space and perspective

[35]

All the circles have to change into ovals to look three-dimensional [34]. In addition, they are centred to the vanishing point and shrink continuously.

Stand them upright and they become pillars, as in this Greek temple [35].

Remember the spiral? It also has a three-dimensional quality [36]. It is very useful in the construction of figures [37, 38].

[36] [37] [38]

Constructing a dome above a tiled floor

Now it is your turn to help build a dome. You will need a pencil, a fine black felt-tip marker, a ruler and a compass. Once you are able to construct such a drawing on your own, you have understood the elements of central perspective.

First, draw the horizon [39a]. Divide this in half and use this point to draw a circle. This gives you two more points along the horizon. Below your horizon line, draw a second line of equal length. Now mark the points at which these lines would divide into four equal sections.

Insert three vertical lines. Divide the first and third vertical lines into eight equal parts and also the section of the lower line which joins them.

Connect the centre of the circle to the lower ends of the vertical lines, thereby creating an isosceles triangle.

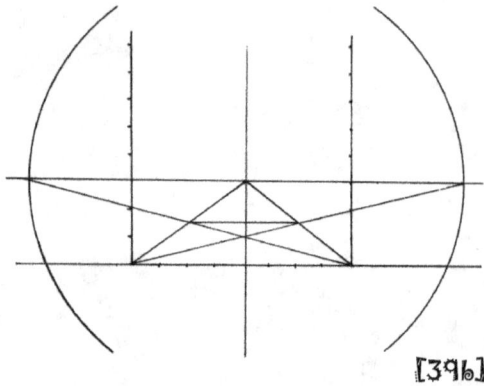
[39b]

Then connect the base points of the triangle to where the first line intersects the circumference of the circle [39b].

Now draw a horizontal line between the points where the diagonals intersect the triangle. The area below this line is your floor. Your foundation is now complete and is shown as the grey rectangle in Fig [39c].

From the points that divide the base you now draw diagonal lines to the left and right points on the horizon and to the centre. Each point on your floor now has two diagonals, one to the left the other to the right outer point on the horizon.

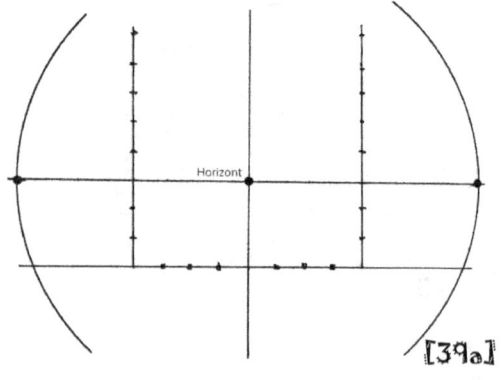
[39a]

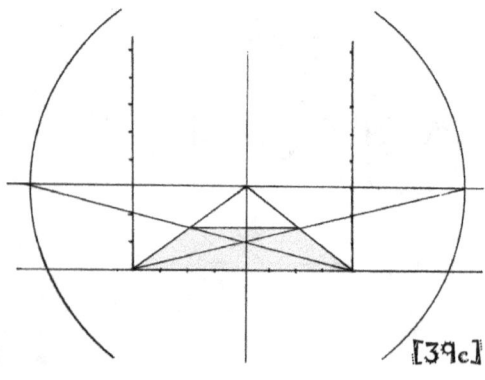
[39c]

Space and perspective

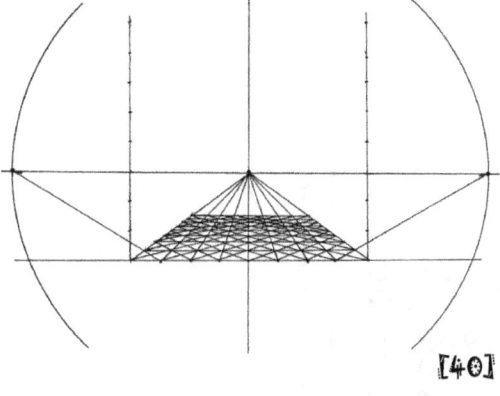

[40]

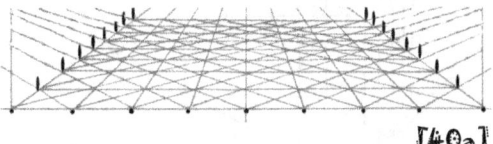

[40a]

Once you have drawn the lines in pencil, colour them in black, but only to the edge of the tiled floor [40].

In the enlarged version [40a] you can see the points where the lines cross. Through these points you now draw horizontal lines. These are marked at each end with black ovals. These lines dissect the tiles in the process of setting up the central vanishing point [40a]. Now the tiled floor is finished.

Next we need to build the dome. For this you need the three vertical lines you can see in example [41]. Connect the top of the outer left and right line above the horizon to the centre. Then add vertical lines to all the points that were marked with ovals in Example [40a].

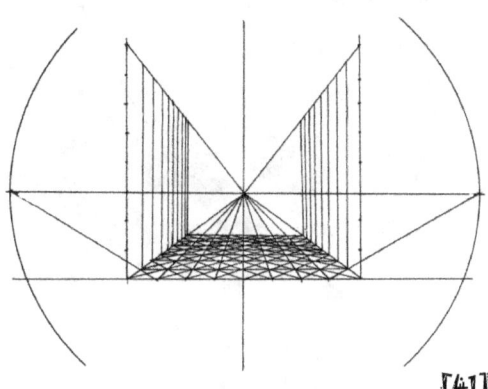

[41]

As they get closer to the back of the room, the vertical lines have less space between them and their height is also reduced towards the vanishing point. These lines could also be transformed into pillars.

Now we add vaults to make the roof of the dome. To do this you add half-circles to all the pillar uprights where they meet the horizon [42]. This is how it could look like if you were to add some detail [43].

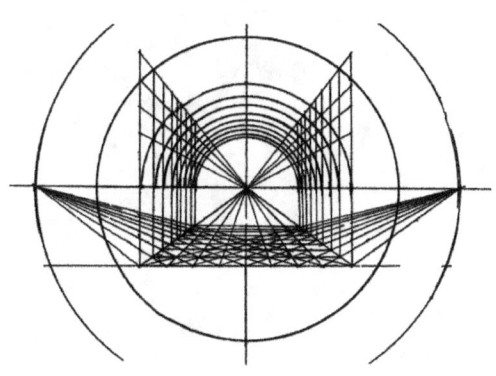

[42]

87

Congratulations!

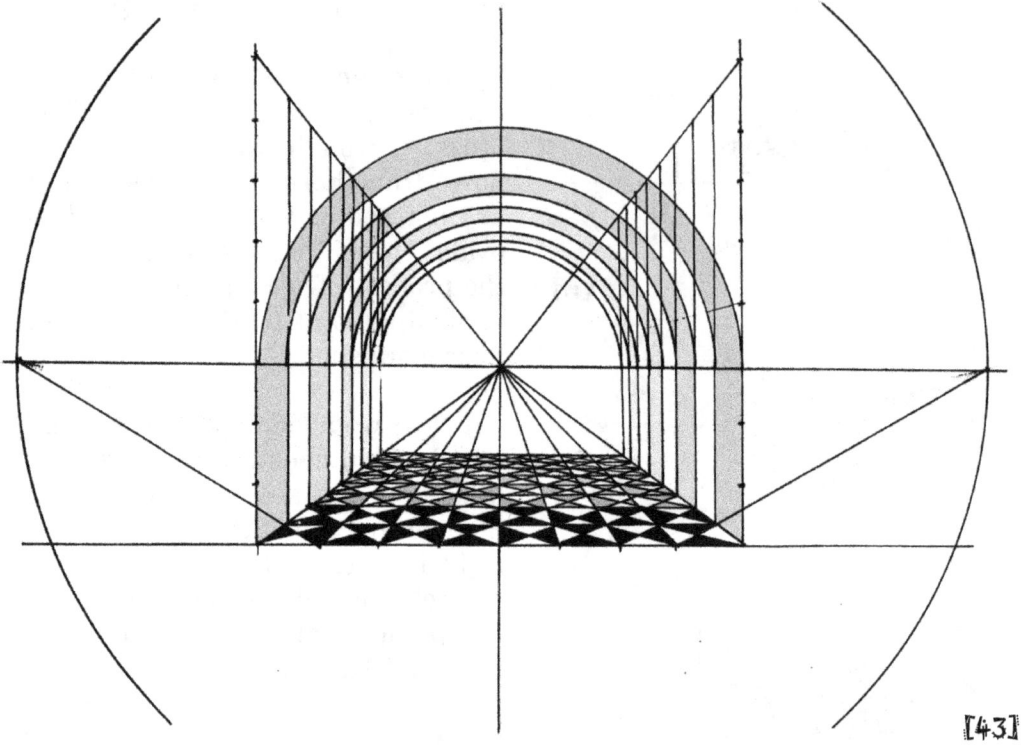

[43]

Space and perspective

While knowledge of perspective is important for architects, in general freehand drawing it does not play a major role. In sketching a marketplace or historical buildings it is more important to use your eye's sense of proportion and your pencil to measure.

How to measure with a pencil

If you want to draw a scene that includes objects of different sizes, you need to measure them to get the proportions right. Doing this by using your eye alone is not always enough. While the edge of your paper can be a useful guide for both horizontal and vertical measurements, the best way to measure an object is to use your pencil.

Hold it in your outstretched hand in front of your eyes against the object you wish to measure. Close one eye and use your thumb to measure the length along the pencil. Now transfer that measurement to your drawing [44].

Angles are also measured in this way by comparing them with a vertical or horizontal line in the picture. This way it is much easier to get the correct ratio between height and length. If the height of the house compares to the whole length of the pencil, then the width of the roof might amount to only two-thirds of the length of the pencil [45, 46]. By using your pencil to measure you can avoid making errors in the proportions between objects in your sketch.

[44]　　　　　　[45]　　　　　　[46]

Now it is time for you to enjoy using vanishing points to create your own abstract composition. Take an A4 size of drawing paper and position it horizontally (landscape). Divide it in half with a vertical line and then draw a line for the horizon. Around the centre, where the lines intersect, draw a freehand rectangle, 10 to 16 cm [47].

Crisscross this shape with lines, always starting at the outer vanishing point. Give some of the sections or shapes texture by colouring or crosshatching them grey with a pencil or black with your pen [47a].

Now turn them into cubes by adding verticals [47b]. Feel free to create as many as you like. The more texture and contrast you give them, the more architectural they look [47c].

If you now cut off the surrounding space only your original rectangle remains and you will see that you have created an exciting construction [48].

In your construction you have actually used three vanishing points – two on the horizon left and right and one in the centre. By using the point in the centre you have demonstrated the use of 'central perspective'.

The next chapter will introduce you to the space we live in, the landscape.

[47a]

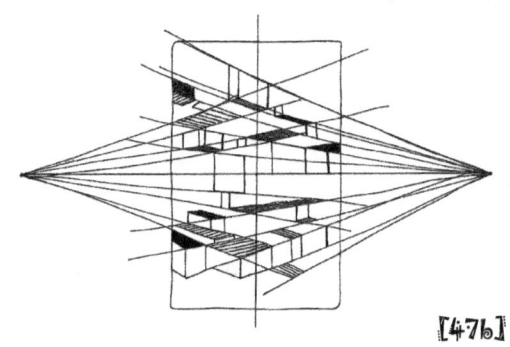

[47b]

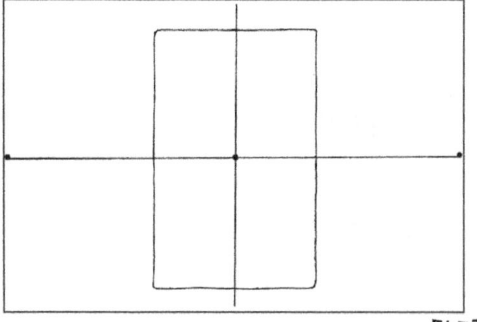

[47]

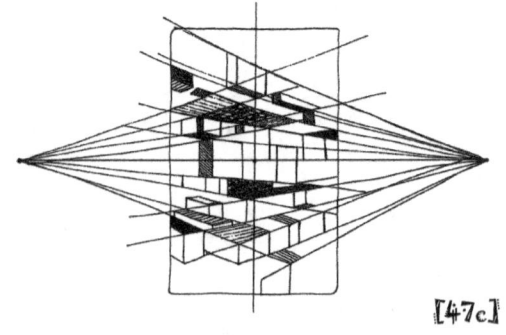

[47c]

Space and perspective

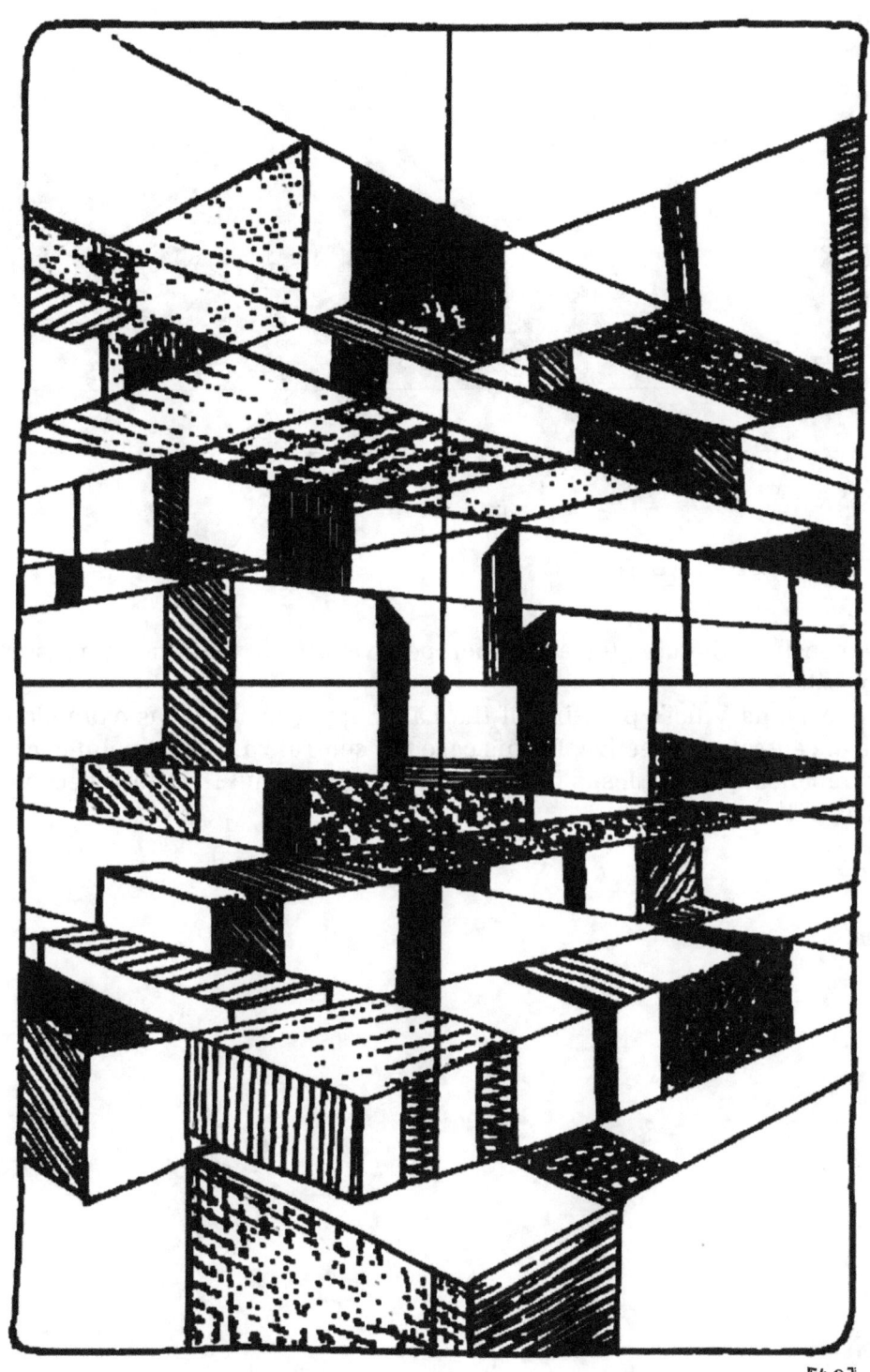

[48]

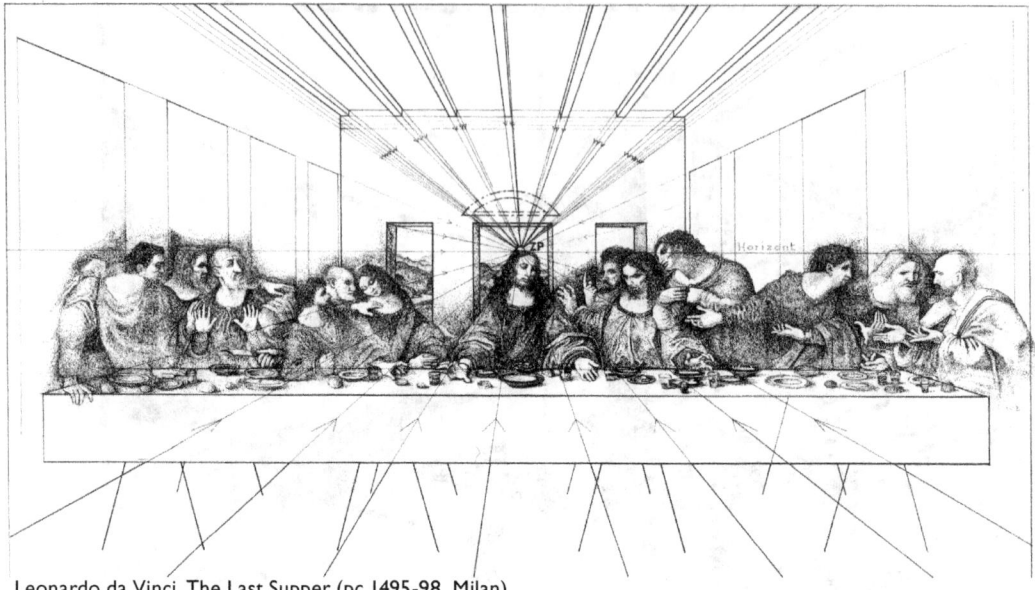

Leonardo da Vinci, The Last Supper (pc 1495-98, Milan)

We conclude the chapter about perspective with a well-known masterwork of art.

Leonardo da Vinci's painting of the Last Supper is a famous example of the use of central perspective. In this case the central vanishing point is also used symbolically since Jesus is placed at that point and therefore becomes the focus of the painting.

5
Landscapes

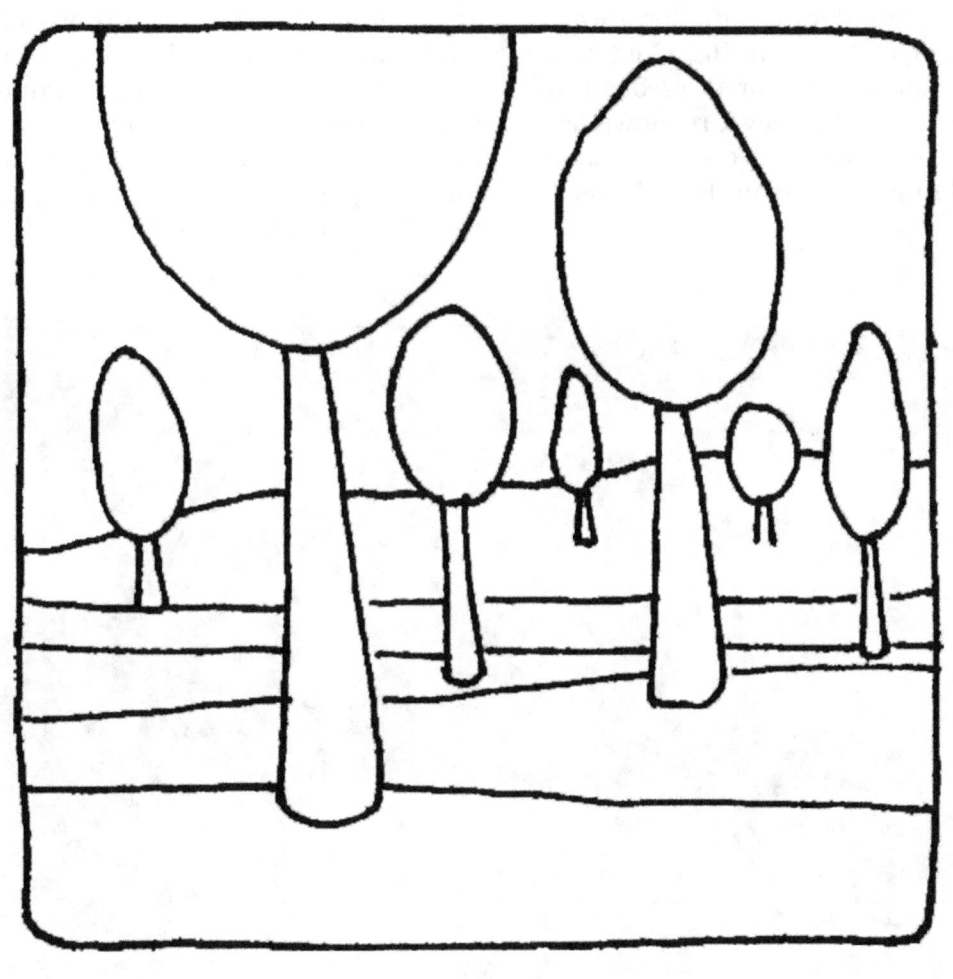

Painters love landscapes

The whole world consists of a landscape of unrivalled complexity. But landscape has not always been the subject of artists' attentions. In the paintings of the Middle Ages it served merely as a backdrop for the portrayal of religious figures. The impression of depth was achieved by the depiction of sections of landscape that get smaller and smaller towards the top of the painting. And trees were not painted for their beautiful appearance as they are nowadays, but as symbols of strength – this applied in particular to the oak tree.

It took until the beginning of the Industrial Revolution for painters and artists to discover landscape as a subject in its own right. This coincided with the beginning of the destruction of the natural environment when nature came to be appreciated as a refuge from the world of human activity. Cities were crowded, noisy and dirty. But out in the countryside one could feel free and at peace.

The Romantic period expressed a yearning for the natural world. Fairy tales and legends were often played out in beautiful magical landscapes, and since that time the depiction of the landscape has been an integral part, not only of painting, but of the arts in general.

Albrecht Dürer (1471–1528) Weidemühle [1]

One of the first artists to draw and paint landscapes was Albrecht Dürer (1471 – 1528). His watercolour paintings were inspiring for coming artists. He used watercolours because they were easy to carry while travelling in Italy. This made him a pioneer in both watercolour and landscape drawing [1].

A trip to the great outdoors with Frank and Fiona

In its most basic form, a landscape consists of three elements: the sky, the earth and the horizon that separates them. The marvellous diversity of forests, rocks, lakes, rivers, sea and mountains turn these basic elements into an adventure. The atmosphere also plays its part and includes light, shade, wind, rain, and even the sweet smells of nature.

To experience landscapes and to be able to draw them you have to immerse yourself in that landscape, not just sit in front of it.

Frank starts by taking the easy option. He draws a horizon across the picture and instantly creates both the sky and the ground below it.
The freehand lines that he adds get further and further apart until they end in the foreground. In this way a sense of depth is achieved. Fiona does the same with the clouds above. At the top of the sky they are large and then become progressively smaller and slimmer towards the horizon [2].

You have already learned this rule in the previous chapter: the bigger and further apart things are depicted, the closer they are to the viewer; when they are smaller and closer together, they seem further away.

[2]

But even after applying the rules of large and small, this landscape still looks quite flat. So Fiona thinks about a different kind of landscape. She builds large hills in the foreground. Then she adds smaller hills behind. Flat areas separate these from the mountains in the background. As in the first example, everything becomes smaller towards the horizon. The staggering makes the picture more dynamic [3].

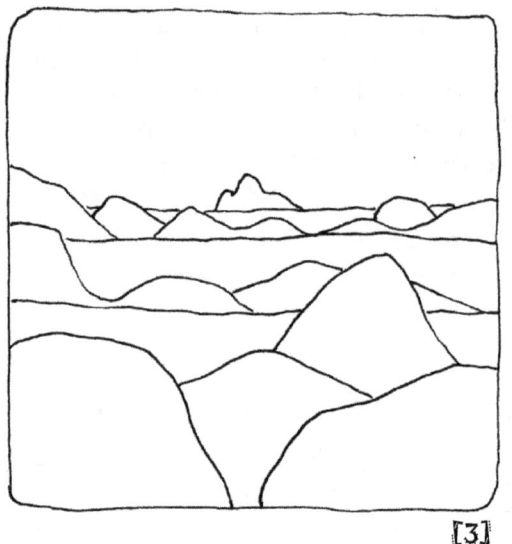

[3]

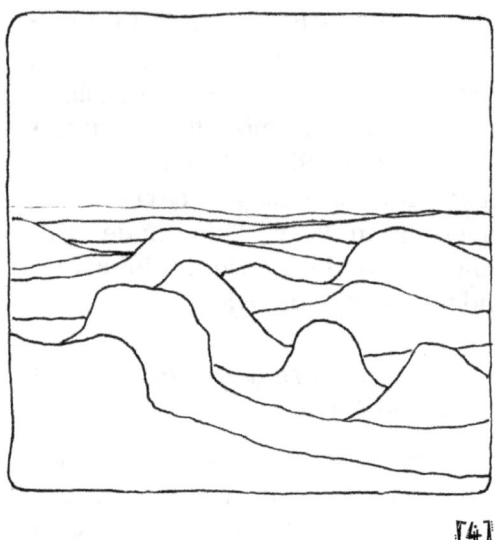

[4]

The landscape becomes even more dramatic if the boulders fall into vertical lines towards the valley floor [4].

To be able to view a landscape into the distance, you need to be in an elevated position. The horizon, however, remains at eye-level. Observe this for yourself next time you are outdoors.

A climb up a mountain is rewarded with the magnificent view of the surrounding landscape [5].

After your excursion, your dog needs to be taken for a walk [6]. Your horizon is now a lot lower. The next day you take a trip to the beach. While sunbathing you realize that the horizon is even lower [7].

[5]

[6]

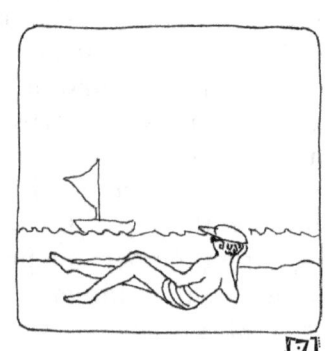

[7]

Drawing a landscape

When you draw a landscape you always include the position from which you have made the sketch.

A landscape that has been altered by humans is called a 'cultivated' landscape. Fences and different crops create a patchwork of fields of different sizes.

When viewed from above this can resemble a set of rectangles [8].

But viewed from the ground by someone walking or hiking, the shapes become more like rhombuses [9].

If you divide the area below the horizon with gentle diagonal lines that have increasingly larger spacing towards the foreground, you create a kind of grid. The different patterns can represent the different crops growing in them [10].

[9]

Next Fiona uses hemispheres and sets them into the grid. Now they look like hills. As with the rectangle, a circle also changes its form when viewed in a three-dimensional environment. It becomes an oval [11].

[8]

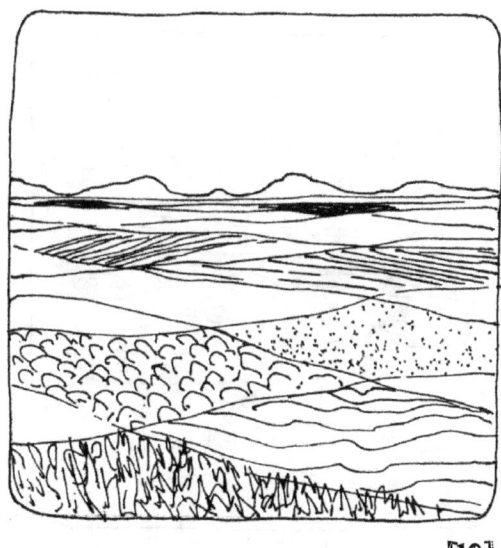

[10]

> **Important:**
>
> When you are drawing the details of a landscape, remember the rule that less is more.

It is impossible to capture with a pencil or a paintbrush all the detail that exists in a landscape. That is why you begin by just drawing the outlines, paying particular attention to the dark and shaded areas. Draw the dark areas to make the light ones more visible. This creates contrast in the picture.

At the core of all these drawings are the rules we have already discussed, which will help you to understand how a landscape is formed:

- Large objects seem close.
- The smaller the object, the further away it looks.

- If hills or trees are staggered, the picture achieves more depth.
- Flattish diagonal lines help to lead into the landscape for a more three-dimensional effect.

Once you have grasped these elements, it will become a lot easier for you to draw and sketch a landscape. Staggered shapes, layering, diagonal lines and using smaller shapes in the distance are all the elements you need to create a three-dimensional effect. There is no need for vanishing points or perspective.

Creating atmosphere

However, one other important element you need to consider is the atmosphere. The further away a hill appears, for example, the fainter and more muted the colours become. The amount of air that lies between the object and the observer causes this effect. It is called 'aerial perspective'.

To achieve these muted tones you use a soft pencil or charcoal. If you use charcoal you need a large piece of paper because charcoal is a robust medium. For a quick sketch, charcoal is a good choice.

Move quickly to capture just the outlines, their size and position in the picture [12, 13]. Do not add any details at this stage. Do a lot of these quick sketches for practice. Remember that if you use charcoal you need a fixative, for example hairspray, otherwise your drawing will smudge.

[11]

Landscapes

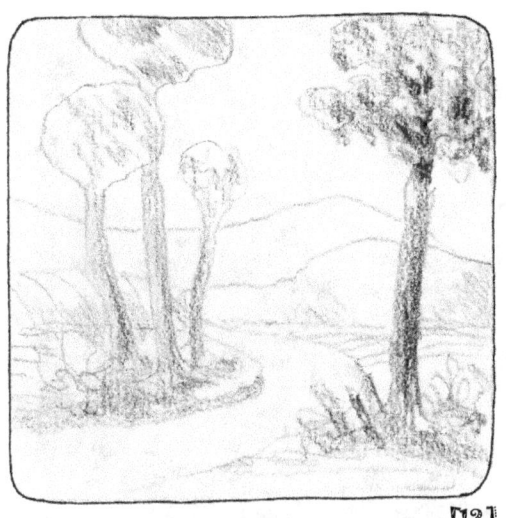
[12]

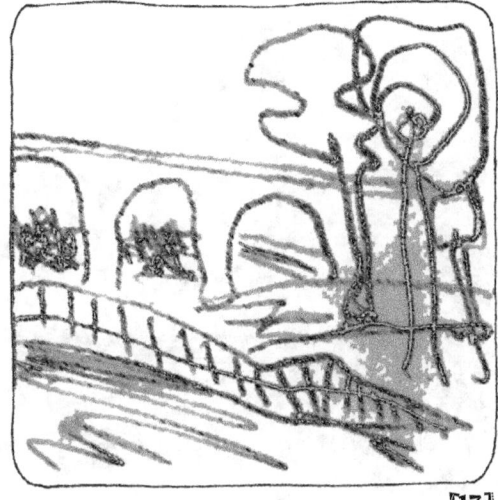
[13]

These sketches can be outlines of hills, trees or perhaps a lake, for example. It is always a good idea for sketching outdoors to bring along a viewfinder.

Using a viewfinder and putting it all together

A viewfinder is a cardboard frame that helps you find a suitable part of the landscape to draw. By using a viewfinder you won't get distracted by what exists past your chosen section of landscape [14].

To get the proportions right, measure with your pencil and outstretched arm, as explained in the previous chapter. Remember that your own position is also important because that is where your eye level is and this determines the horizon.

Remember also that you can alter a section of a landscape by omitting the parts that are unimportant.

[14]

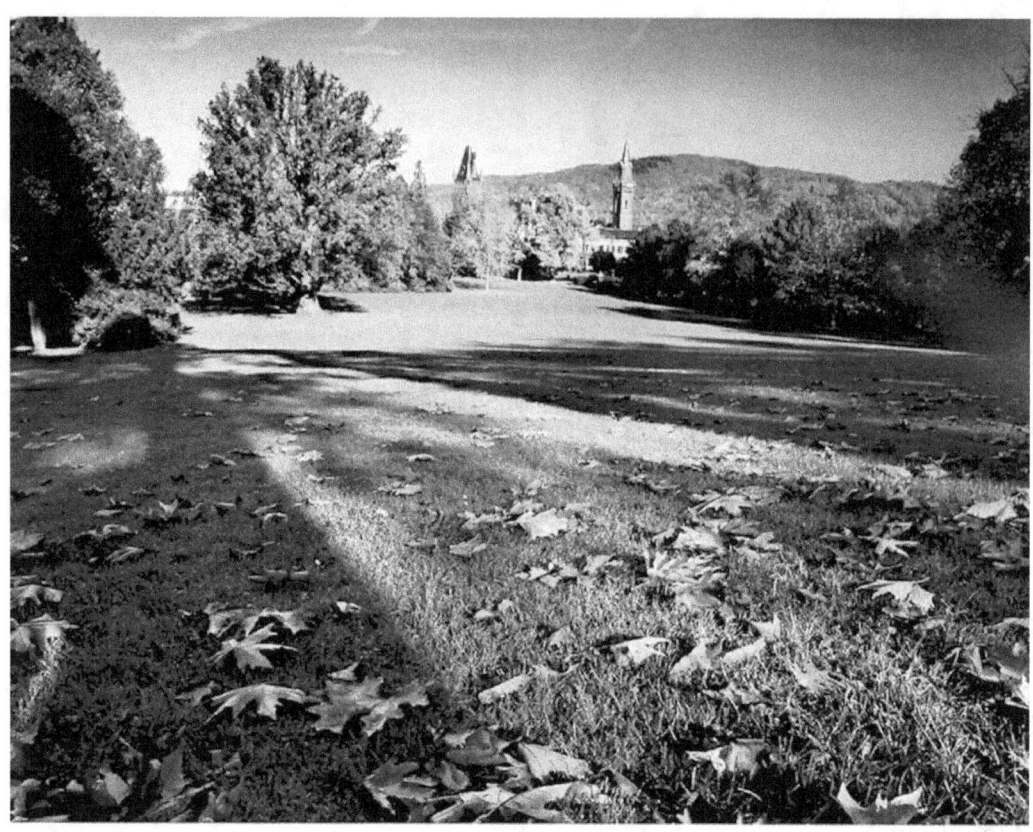

[15]

To put all of the above into action, find a park such as in the photo above [15]. Make a little sketch of it. Simplify the scene by sketching only the outlines of the main shapes: the trees, buildings and hills. Remember to include the shadows on the lawn by drawing their outlines as well [16].

Now use your viewfinder to select a new section of your landscape. You can vary the size, height and width, as well as the size of the objects included [17 - 18]. Choose a section that reflects the overall atmosphere of the parkland.

Use a soft pencil to add the grey tones of the shadows. Can you see how the long shapes of the shadows draw the eye to the centre of the drawing? This helps the observer to focus on the centre of the picture [19].

Important:

Make sure the horizon does not divide the drawing exactly in half.

This takes away the dynamic feel of the picture.

Landscapes

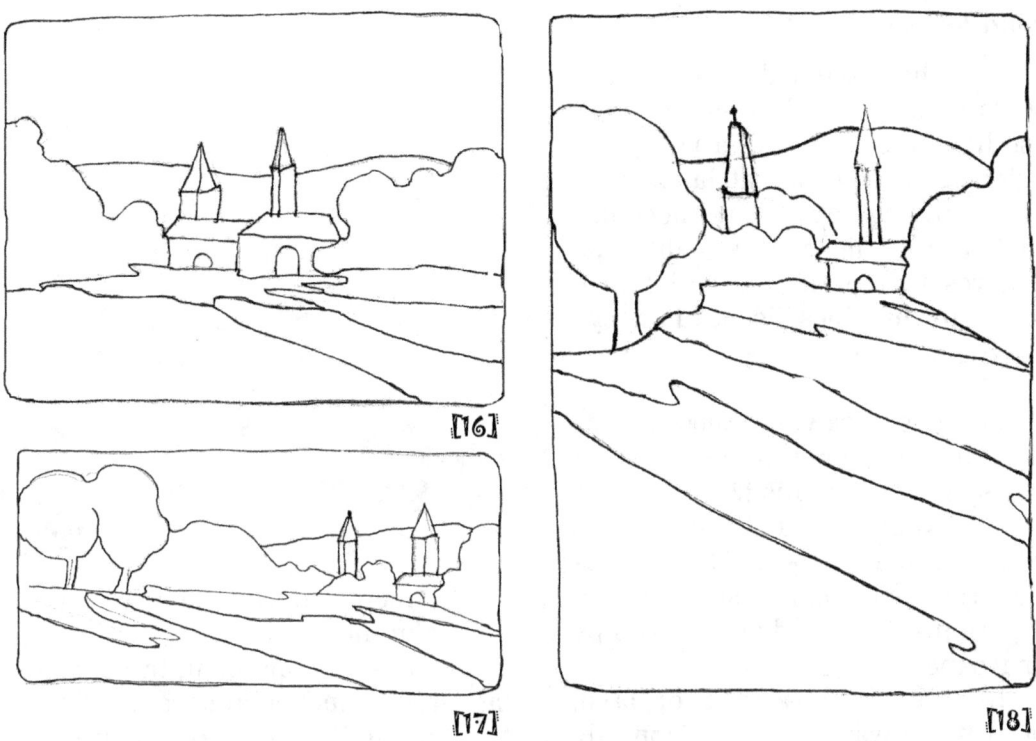

[16]

[17]

[18]

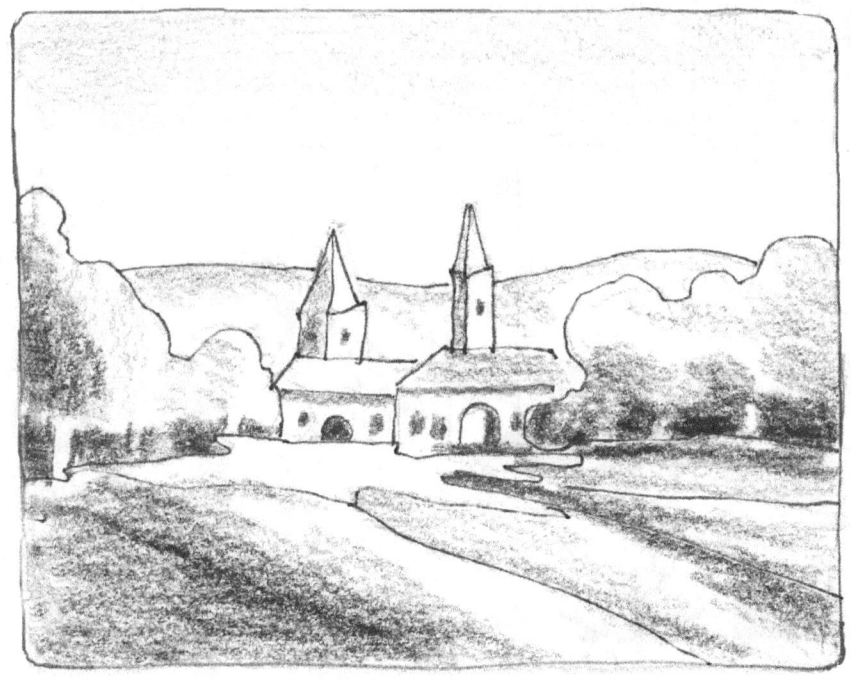

[19]

101

Fiona loves water

All the rounded waves and swirls make her feel at home. Fiona also likes the curves of a river meandering through a flat landscape. This winding waterway becomes smaller and the curves tighter as it moves further into the distance. These curving lines also lead the eye into the picture.

Practise drawing these lines over and over many times. It is not so easy to achieve this [20].

In Example [21] these curves have become shapes. The shapes could represent floating sheets of ice, or perhaps flat islands or a swampy landscape.

If hills frame a river or lake, the water always flows horizontally around them. You can see this by looking at the shadows on the water [22, 23]; they are all parallel to the edge of the paper.

[21]

The mountain rises nearly vertically from the shoreline.

Make sure the mountains are staggered in such a landscape.

Winding lines can also lead upwards, such as a path up a mountain, or fence lines that follow the line of the land. It is important to get the ratio right [24, 25].

[20]

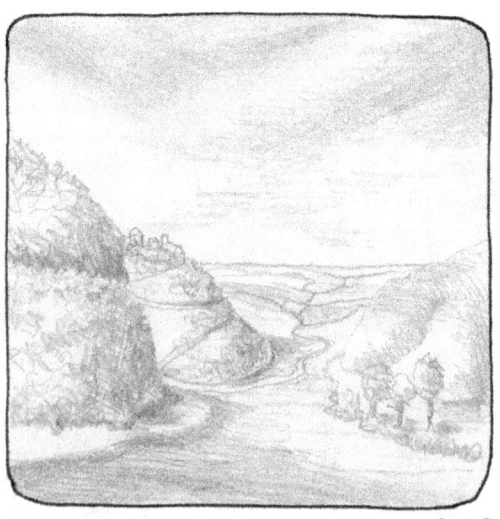

[22]

Landscapes

[23]

[25]

The closer an object, the bigger it is. Use this technique to give your picture more depth. It could be a tree, as in Examples [27, 28]. Similarly, a boulder or a fence have the same effect. Take care, however, that the shadows are all on the same side. In this example, the sun is shining from the right-hand side.

Important:

Everything in the landscape below the horizon rises up to it.

Everything above the horizon sinks towards the horizon.

Look at the line of the arrows in Example [26].

[24]

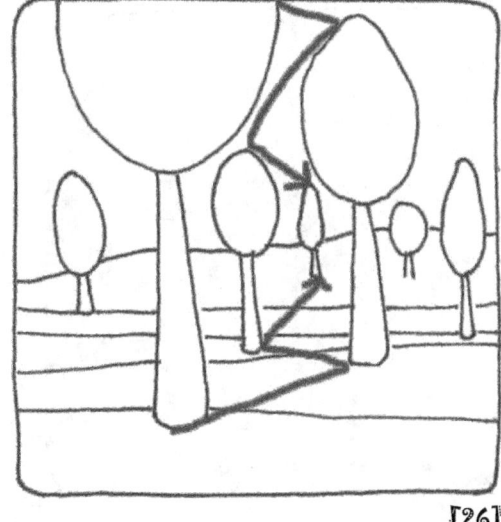

[26]

103

[27]

[28]

Now shape your own imaginary landscape out of flat and curved components. You can add patterns (as discussed in Chapter 2) to add interest to the surfaces. This adds extra texture and diversity to the landscape [29].

Here are two more examples of how free forms can become a landscape. The large irregular rock shapes become flatter and smaller as they move into the distance [30]. They then appear to rise up as their shape becomes more rounded, upright and bigger again.

Copy these examples and you will learn for yourself how through the use of these forms you bring movement and drama into the picture [31].

[29]

Landscapes

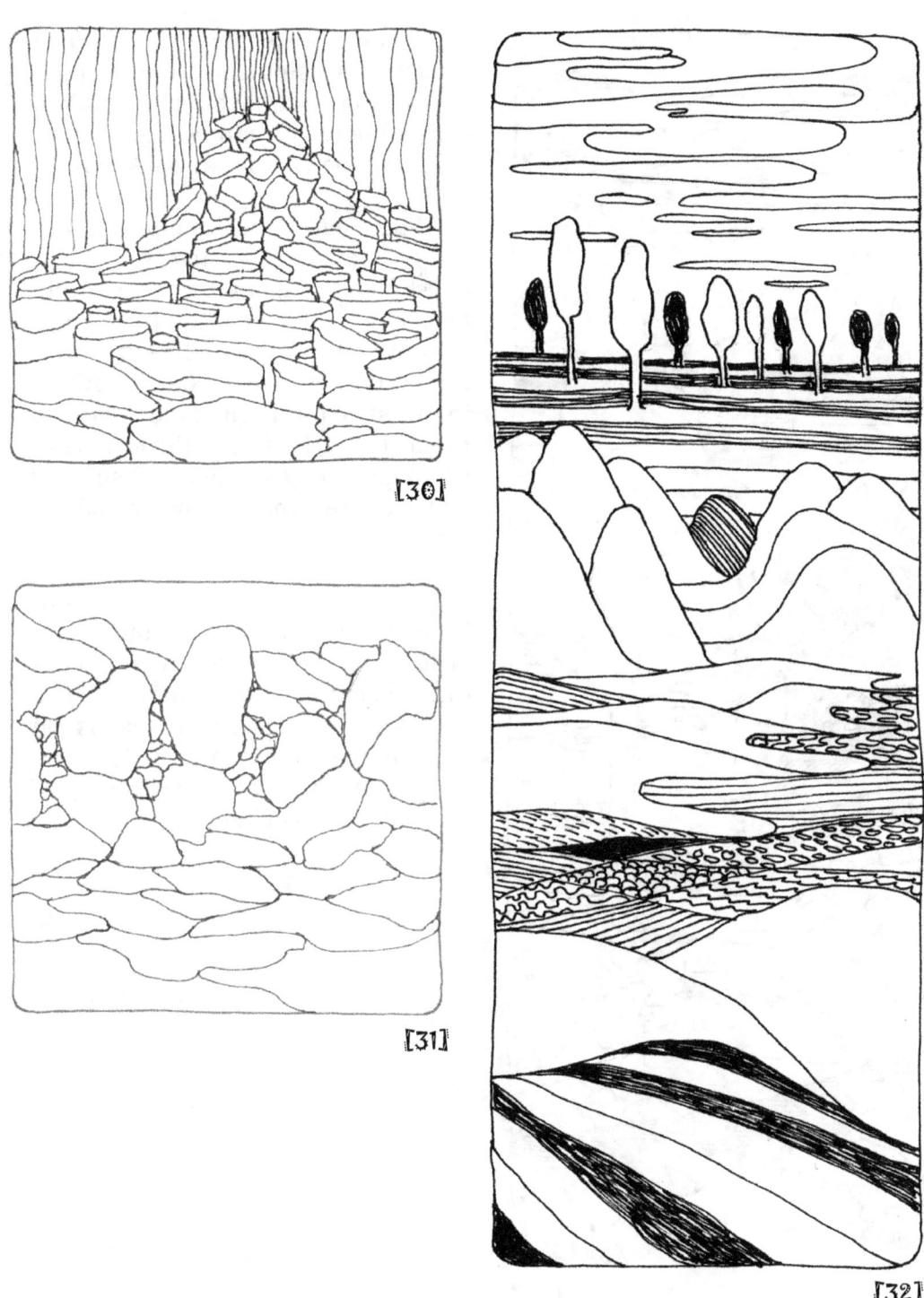

[30]

[31]

[32]

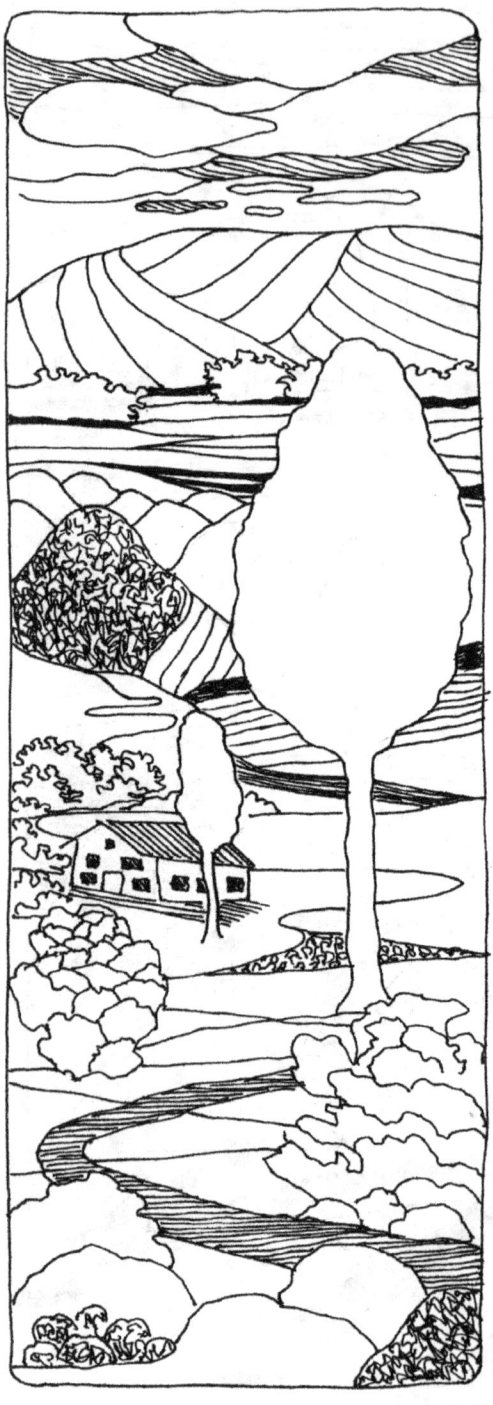

[33]

You can also compose your own landscapes using the basic components discussed in this chapter. You can see how this can be achieved by studying the two pictures [32, 33].

Start with large components at the bottom. Then sketch in a group of slightly diagonal and winding forms, with or without patterns. Put in some hills to make the surrounding landscape appear flat. Continue in this style until you reach the top of the picture. Make sure the forms become gradually smaller and smaller to retain the three-dimensional effect.

The sky arches above it all with large clouds at the top getting smaller towards the horizon. With the addition of patterns and dark areas you create a dynamic force that leads the eye into the picture. You will discover how to create and use these patterns in the last chapter.

Landscapes

Space for you to create your own landscapes

Space for you to create your own landscapes

6
Light and shadow

Light and shadow

Although Frank and Fiona have tried to do their best to fill the world of drawing with lines, shapes and objects, there is something important missing: the sun!

Without the sun Frank and Fiona would be left in complete darkness, having to feel their way. Light creates shadow and, when combined with Frank and Fiona, makes objects look three-dimensional. When you take a photo you make sure you get the right amount of light so your image does not look too dark or too flat. Ideally, the light comes from the top left or right.

In the examples below, this classical head has a different illumination in each photo [1]. You can see that, depending on the light, each one has a different facial expression.

Classical head [1]

Light and shadow

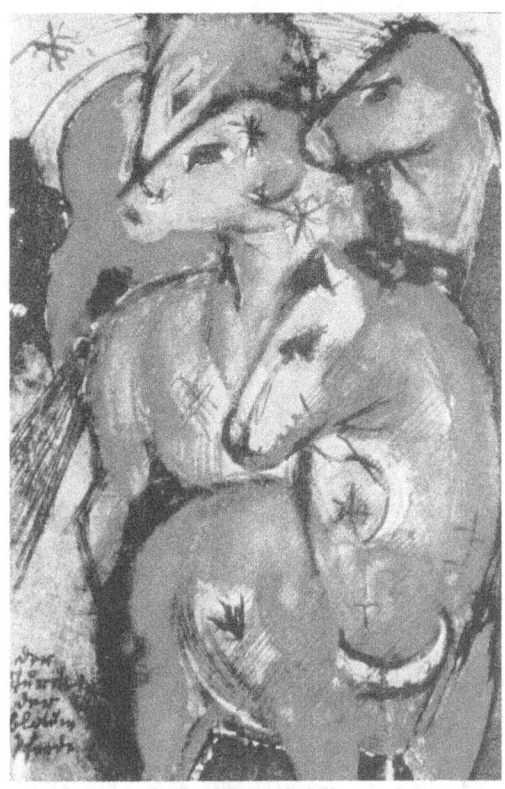

Franz Marc – The Tower of Blue Horses, 1913 [2]

In modern art, however, shadow lost its importance. Pictures became two-dimensional. *Impressionists, for instance, mostly used colour to achieve contrast in their paintings.* In Example [2], Franz Marc depicts his blue horses with a lot of contrast and divides the shapes with dark lines.

Grant Wood treats light and shadow in a very different way. In his work, Spring Turning in Iowa, we look into a wide three-dimensional landscape that is formed by light and shadow alone [3]. The curves of the undulating hills are achieved by the various shades of grey.

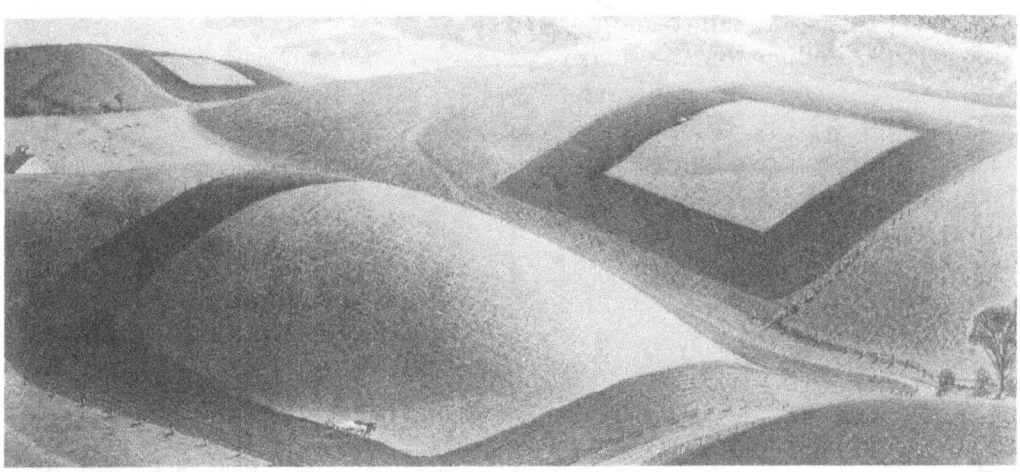

Grant Wood: Spring Turning in Iowa, 1936 [3]

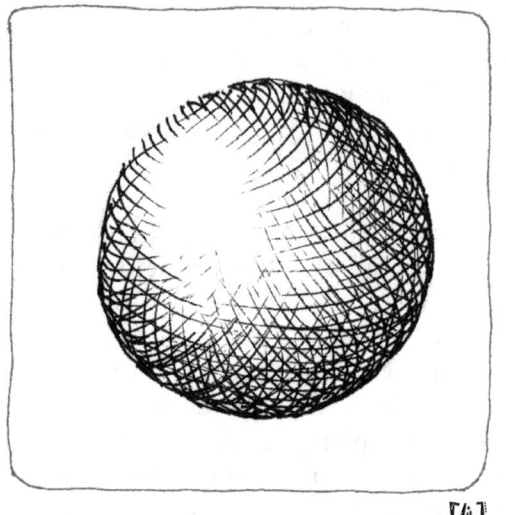

[4]

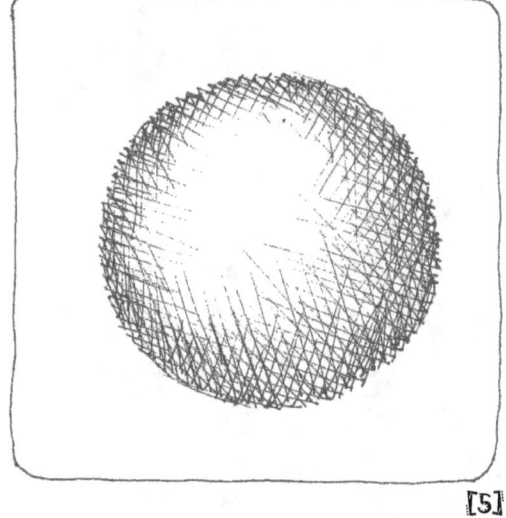

[5]

Fiona's sphere

Let's take Fiona's ideal, the sphere. To draw it you need only shadow, not an outline. Cover the form with curved cross-hatching [4], remembering that if you use straight lines, the shape will appear flat [5].

To draw a shadow, begin along the contour on the shadow side of the object. Starting at the edge bring the pencil along the outline before leading it in a curved line into the shape. Continue repeating the curved shape of the sphere. Reduce the pressure on the pencil as you lead it towards the centre of the shape. This is where the light falls. Now crosshatch in the opposite direction to complete the shadow. Round objects look round when the shadow is also rounded. This enhances the shape.

Using tones to create rounded forms

The roundness of things is expressed through the alternation of light and shadow.

Using a pencil, shades of grey from very light through to nearly black make shapes appear rounded.

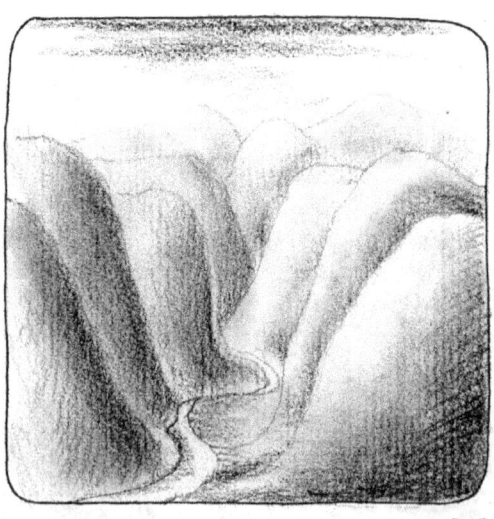

[6]

Light and shadow

In Example [6], a river winds its way, its surface reflecting the light. This picture has been drawn with the aid of tones – that is, a scale of subtle changes from very light to very dark shades of grey which are achieved by using a HB pencil.

The ten boxes illustrate the different tones of grey. Draw these for practice to get the feel of how much pressure is needed to get the desired tone. Hold your pencil on an angle and increase the pressure from box to box as you progress from left to right [7].

[7]

[8]

For the next exercise you will need a soft eraser. Fill an area with a soft grey tone [8].

[9]

Now use the eraser to work some light shapes without the use of lines [9].

113

Determine the direction of the light source in your drawing and crosshatch on the opposite side. You will see that the white shapes begin to look three-dimensional [10].

If you go over the crosshatching a second time, the effect becomes even stronger [11].

Underlay some dark shapes or add round buttons to achieve further depth [12].

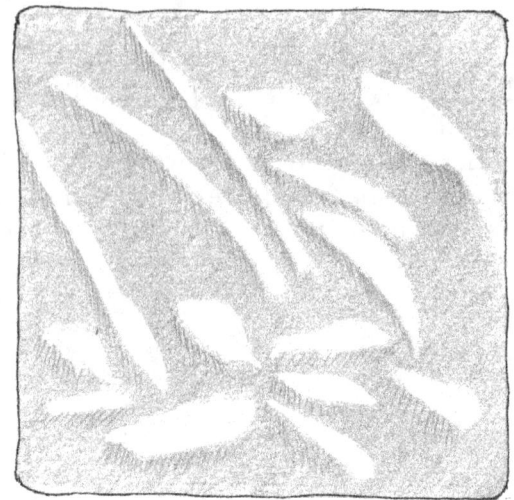

[10]

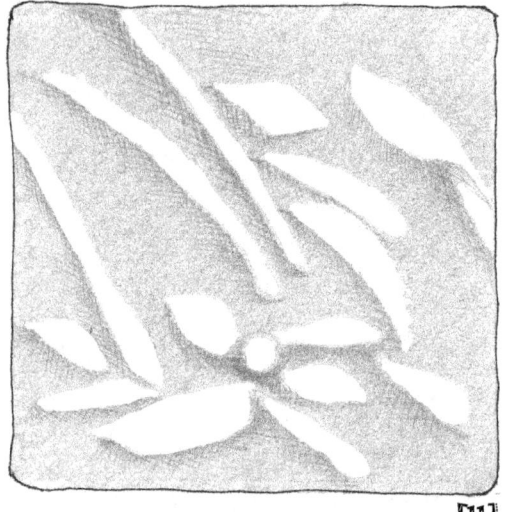

[11]

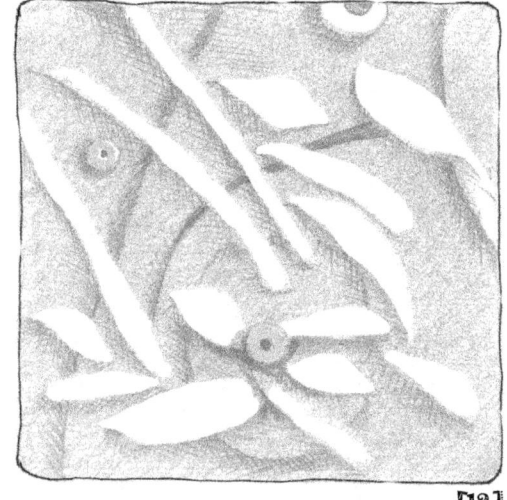

[12]

Light and shadow

The elements of light

Light consists of rays, which are straight and parallel. The part of the object that the rays hit is light and all the other parts that receive less light are darker. This means that the object is shaded. The closer the shadow is to an object, the darker it is.

Pay attention to the light when you are drawing outdoors. Light creates shapes by giving them a shadow. It is difficult to concentrate on the shaded areas because we are used to only looking at the light side of objects [13]. What did you see first in this picture – the dog Tito or the shadow of the two people?

[13]

Creating shadows

After the outline and construction of a form, the shadow is the next important factor for the artist, whether drawing a trunk of a tree, a shiny water surface or the foliage of a plant.

When you begin to draw, the light already exists in your picture in the form of the blank white sheet of paper in front of you. Therefore, what you need in order to create shape and depth in your picture are shadows.

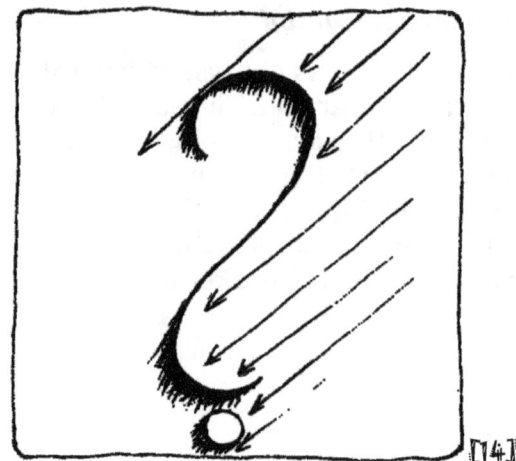
[14]

In the three examples Fiona and Frank are modelling the effects of shadows.

The curved line represents the question mark at the end of the sentence: Where is the light coming from? It should come from one direction only.

The shadow is the result of the shape and how broad it is. Fiona's line is narrow, so the shadow is also narrow [14].

If she is a wide ribbon, the shadow looks like this [15].

[15]

The arrow lines show the direction of the light. Frank contributes some sheets of paper that are blowing in the wind. They are shaded themselves and also casting shadows [16].

If you use this vase [18] as an example, you can follow the technique of shading from start to finish.

First, the shape is constructed from circles and ovals [17a].

[16]

Light and shadow

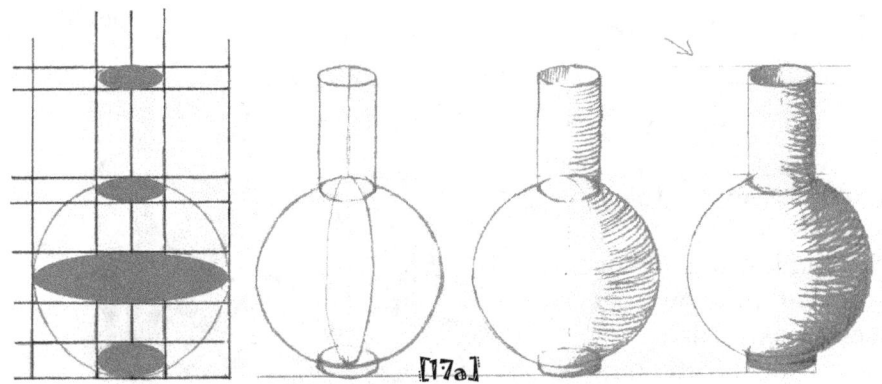
[17a] [17b]

With the light coming in on an angle, the shadow is created along one side using crosshatching [17b].

Looking at the finished vase, you can see a straight line running along the right-hand side. This is the first ray of light that passes by the vase. The point at which it hits the bottom is exactly the spot where he shadow of the vase ends [18]. In the open top of the vase the shadow lies on the left-hand side. Remember to do the crosshatching in the same rounded line as the vase itself.

Note, however, that an object has more than one shadow. Not only is there the shadow created by the form of the object itself, but also the shadow the object creates in the place where it stands.

The shadow of the object itself is called the 'form' shadow, and the shadow it creates is called the 'cast' shadow. At the place where they both meet, diffused light creates an illuminated area. This line divides the two shadows. This is an important fact to remember in the world of drawing.

The two shadows should not be lumped together.

Practically no light reaches directly beneath the vase so this is where the deepest shading will occur. It is called the 'complete' shadow.

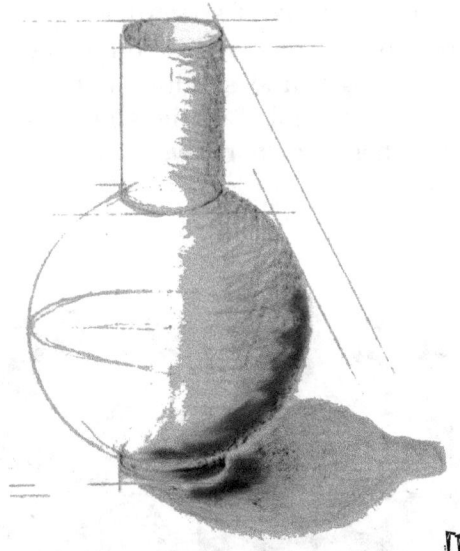
[18]

Important:
If two shadows touch each other there appears to be a light reflection on the edge of the shaded object.

117

Seeing the light, and shadow

To sum up, then, we see light and draw the shadow. One causes the other, as expressed in the saying: 'Where there is light, there is shade'. But the shaded side is not always easily noticed. Shadows really do lead a shadowy existence.

Now try to concentrate on the shaded areas of a shrub. It does take a lot of effort to keep focusing on the dark parts [19].

If the contrast is stronger, such as in an overexposed photograph, it becomes a lot easier [20].

Once you have practised studying the shaded areas, you will discover a multitude of structures and figures that are caused through the impact of light and shadow. For instance, in Example [21] the shadows of branches cast a network over a field of clover.

[19]

[20]

[21]

When there is more than one source of light falling onto an object, it is quite amazing to see the resulting shadows. See, for instance, what happens at night in your living room where the different lamps and lights create a wild mix of crossing shadows from table and chair legs. If you draw these patterns without the object they belong to, you get completely abstract figures. This is a useful exercise if you want to come up with new ideas.

Now let's think about sunlight. The position of the sun determines the direction and length of the shadows. You have probably observed with your own shadow that the lower the sun, the longer and more absurd-looking your shadow becomes. On the other hand, using an artificial source of light at night you no doubt know the game of holding your hands in front of the light source and casting animal shapes onto the wall.

Many cultures have developed plays that involve the use of shadows. In China these go back to 2000 BC [22]. Puppets made from leather are brightly coloured. Sticks attached to the limbs are moved to interpret the story that is being told. Their shadows are cast onto a light curtain. In Europe shadow theatre became popular during the Middle Ages. This is a fascinating form of theatre because the shadows seem to be disembodied and floating. Nowadays shadow theatre is regaining its former popularity as new techniques of lighting open up a lot more possibilities.

[22]

If you look at a black and white drawing you can see many shades of grey. These replace colours. Without colour, pictures gain a certain power, caused by the contrast of light and dark. In Example [23] many shades of grey are used. The picture was begun with a small white circle in the middle. Example [24] shows a close-up of this. With the addition of crosshatching more and more circles were added in all directions. Shading helps to define the shapes.

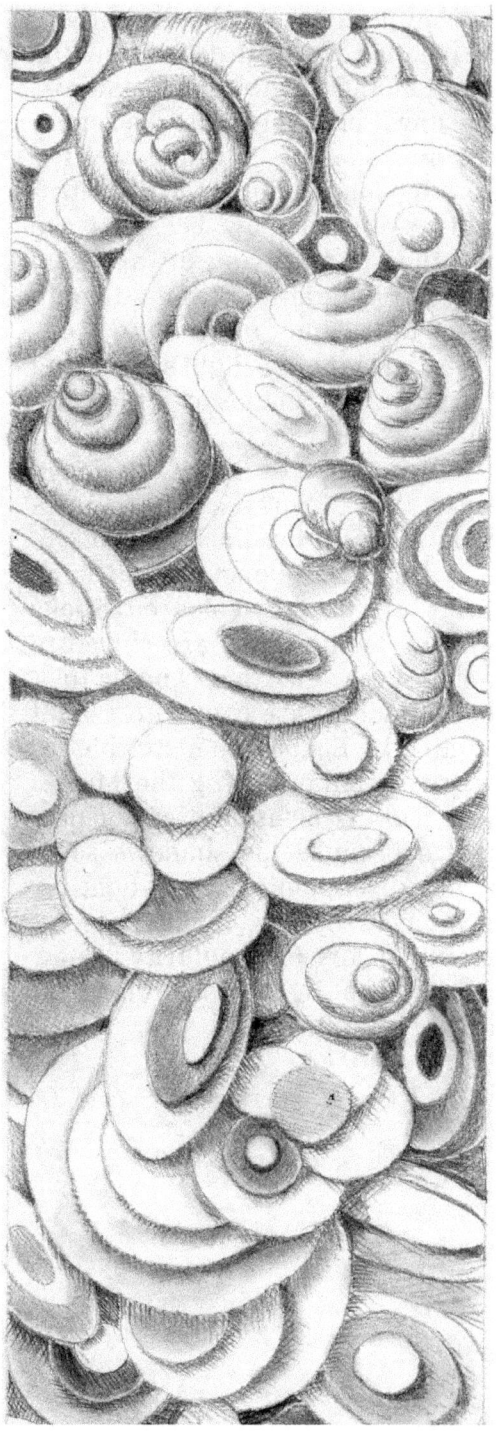

[23]

[24]

Light and shadow

[25]

In Example [25], the tree is drawn solely by using crosshatching. Its shape is organic and dynamic. In the detail you can see that the dark areas are constructed from layers and layers of shading and crosshatching [26]. When trying this yourself, keep the lines very loose.

The next page shows you different ways of drawing a surface with patterns in different sizes and intensity [27 - 32]. To do this yourself, start with quite a large movement, but do not at first put much pressure on your pencil. Continue by intensifying the pressure and shrinking the movement. The result is a pattern that appears roundish.

This leads to the last part of the book where we talk about surfaces and patterns.

[26]

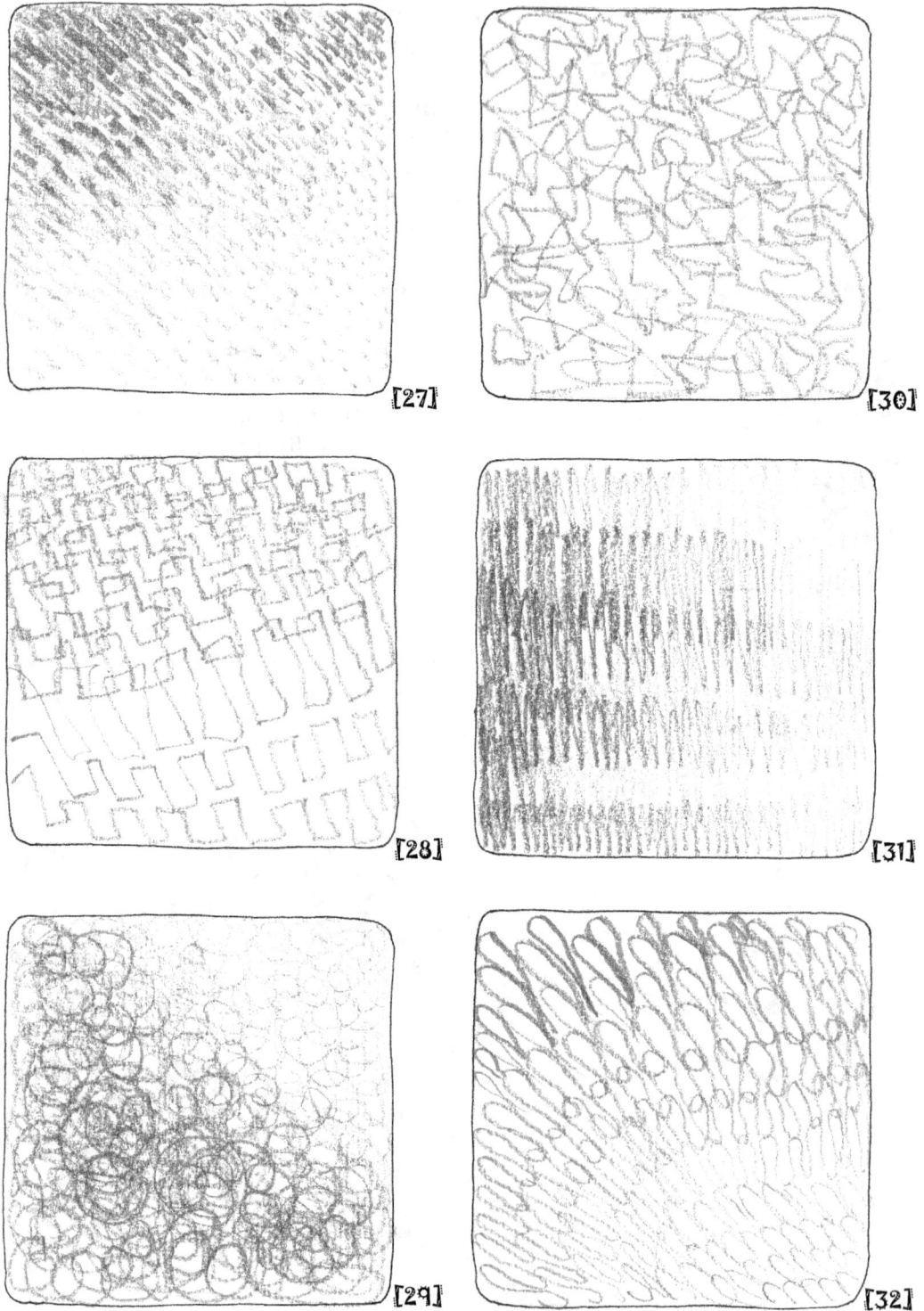

7
Patterns are everywhere

Patterns are everywhere

We started this book by talking about dots and how they were able to form patterns. Then we discovered that lines can do the same. This chapter is about many types of patterns, not just the decorative prints we find on tablecloths.

The term 'pattern' is not exclusive to the art world. It is used in many varied fields. For instance, there are language patterns, behavioural patterns, flight patterns, design patterns, landscape patterns, thought patterns, and many more.

In a book about drawing, of necessity lines take centre stage. In a drawing a pattern is a component of the surface of an object. It can be decorative and ornamental, or it may typify an object. With the help of the whiz kids, Frank and Fiona, you can have fun exploring the world of patterns. Whether you use straight or curved lines, you will find that the

[1]

possibilities for construction and decoration are endless.

Typically, a pattern is two-dimensional and repeats itself many times. Identical elements form a rhythm, or may be combined with others. The important thing is that a pattern is at the same time harmonious and interesting. A boring pattern will not draw attention and be noticed.

Patterns also define many objects, such as stones, spotted shells, striped leaves and so on. Try to create a pattern using just one design element – for example a circle [1]. As soon as you group many circles together, you create a pattern. Admittedly, it is a simple and plain pattern, but if you keep working with the circle, using the principles of drawing you have already learned you will achieve a more varied result. The circles may become large or small, they may be layered, or they may form rows or radiate from the centre. The effect can be two-dimensional, three-dimensional or with a central focus.

Patterns as building blocks

Science has taught us that the whole world consists of patterns. The smallest particles group together to form larger ones. These make up structures according to a specific plan. These structures are not static; they are dynamic and can change and adapt. Lots of individual forms group together into systems. These are also interconnected, ultimately building the complex world of which we are a part. Through a microscope we look into a foreign world of molecules, cells and atoms. It is an infinite variety of structures that seem very abstract.

Structure and texture: Internal and external patterns

The two terms 'structure' and 'texture' can be easily confusing. When we refer to 'structure', we mean the internal design and construction of an object. But 'structure' can also be used for the outside texture. For instance, the pattern formed within a honeycomb or the blossom of a sunflower is both the

Structure of a tree [2]

underlying structure and the surface pattern that results from it.

However, this is not always the case and mostly there is a clear distinction between the two terms – 'texture' and 'structure'.

To take this a step further, the inner construction is the structure and the surface appearance is the texture. For example, the trunk, branches and twigs make up the structure of a tree [2]. Each has special characteristics, depending on the type of tree. This is clearly visible in winter in deciduous trees. Other trees are evergreen. Their structure (trunk, branches and twigs) has the additional texture provided by the leaves [3].

Texture of a tree [3]

Frank builds a house

Frank has decided to build a house. The inner structure is provided by the walls and the façade provides the outer texture. To build his house Frank needs lots of straight lines. He joins these with right angles and diagonal lines, following his architectural plan. The structure for his house started with a floor plan. This was divided into rooms, hallways, windows, doors and staircases. Frank adds a second storey and finishes with a steep roof [4].

Let's stand in front of the finished building and admire the beautiful façade. Can you also envisage the internal design of the house?

[4]

While you can count the number of windows and try to guess how many rooms the house is divided into, only when you inspect the house on the inside do you understand how it is set up – in other words, you experience its structure.

It is not easy to imagine the external texture and the internal structure at the same time. These have to be explored, but we know that the inner structure will determine the external appearance and form.

On the outside of Frank's house you can see part of the foundations made from bricks that form a pattern. The façade is made up of beams and rendered surfaces. It is a Tudor-style home with a very decorative façade.

A lot of houses make a town. The town consists of a network of streets, and interconnected water pipes and electricity lines. It is a system that functions because of its connections. Most of us live in such an environment and infrastructure and we are further connected by the World Wide Web.

The net – nature's design

Nature also has its own web of connections which can be found in many forms – for instance, the blood vessels in a body or the veins of a leaf. They are all built on the same principle. The branching out creates a pattern of networks which are organized. Some are regular patterns, such as in a tree or a spider's web; others are irregular patterns such as in the flow of water. Try to imitate one of nature's networks by copying the examples below. Two lines branch out to form many more lines, all pointing upwards. The first example gives the impression of a tree [5]; when viewed horizontally it resembles a river delta [6]; and when turned upside down it looks more like the root system of a plant [7]. The idea is simple and you can find a multitude of examples of this kind in nature. The veins of a leaf or of our nervous system both have the same origin – a structured net. Structured nets may be regular, as in spiderwebs, or chaotic, such as we see in wild swirling waterfalls.

[5]

[6]

[7]

A spider's web

Waterfall

The following plant examples are all taken from Peter Heilmann's book, Nature as Printer (Harenberg, 1982).

The oak leaf [8] and the lady's slipper orchid [9] are examples of some of nature's delicate networks. It should be noted that both these pictures are prints.

Oak leaf [8]

Lady's slipper orchid [9]

Peter Heilmann: Nature as Printer, Dokumente des Naturselbstdrucks, Harenberg: Die bibliophilen Taschenbücher, Dortmund, 1982.

About 300 years ago, doctors and pharmacists developed this type of nature print to obtain realistic images of medicinal plants. Plants that had been treated with a dye solution were pressed onto moist paper or, in a later development, into soft metal plates, in order to make multiple copies. Unfortunately, this method is all but forgotten these days. The accuracy of these reproductions is amazing and unrivalled to this day.

A leaf is made up of large and small veins – this is its 'structure'. The veins give the leaf support and supply it with nutrients. The surface or texture of the leaf can be smooth and shiny or rough, hairy, wavy, spotted, green or colourful with stripes. In the tropics there are even leaves with a pattern of holes in them to make sure the rain can run through them and prevent the leaf from getting damaged.

Every object has its own typical structure and surface – for example, bark, moss, stones and so on. When we draw an object, it is important to show both its structure and surface texture. It is exciting to choose the right lines and patterns to represent the image of an apple, for example – this is what makes drawing such a great experience!

Now draw a branching network in different shades of grey. Example [10] is a brush drawing.

Try copying this by using a watercolour brush size 8 and black or coloured ink. Hold the brush vertically over the paper and draw a line. The more pressure you use, the thicker the line. If you alternate the pressure as you draw the line, you will end up with a lively thicket of lines with different breadths. To achieve a three-dimensional effect, draw the first set of lines with diluted ink.

[10]

[11]

Now add a second layer of darker lines and a third using an even darker tone. This gives you depth: the light lines move into the background and the dark ones into the foreground.

In Example [11] the lines are two-dimensional in their appearance but interest is added by filling some of the gaps in different shades of grey, and in Example [12] straight and curved lines combine to build leaf structures. The lighter forms surrounding these give depth.

The way we see things depends on our own individual interpretation. For instance, Example [13] looks like a network, but it could also be a group of rocks.

In picture [14] we see a pattern that could have originated from an animal: zebras, tigers, leopards, giraffes, and even frogs, have skins

[12]

that could be represented by these kinds of net worked patterns. Nature invents patterns that help animals to camouflage themselves and, depending on the colour, also to warn others that they are dangerous or poisonous.

[13]

[14]

Example [15] is a wonderful illustration from nature – a pincushion flower or scabiosa. The networked patterns adjust in size to cover the rounded surface of the flower head. The pattern changes as it is viewed in a three-dimensional environment, as in this photograph by Karl Blossfeldt.

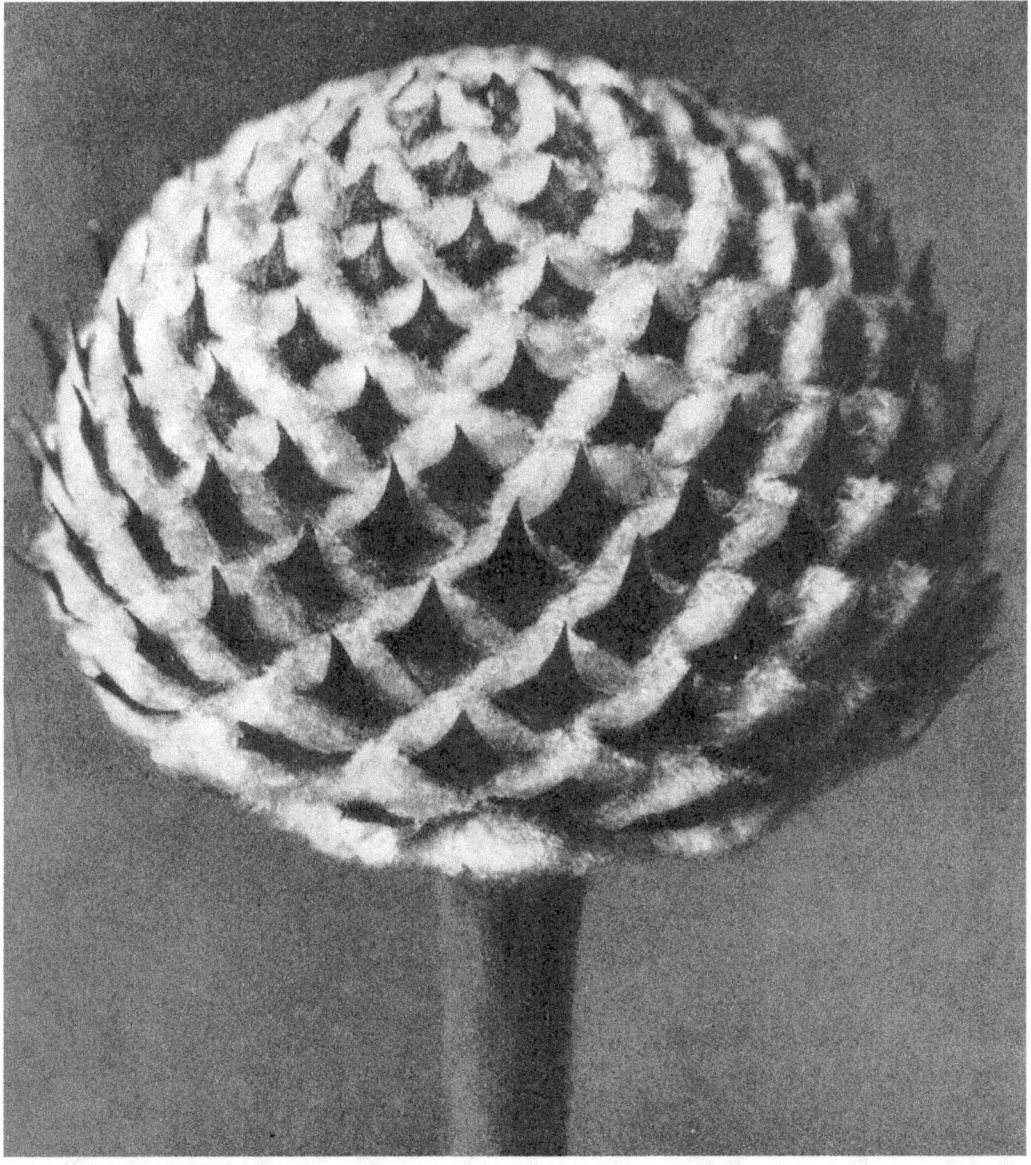

Cephalaria, Karl Blossfeldt, Art Forms in Nature, Harenberg, 1928 [15]

You can draw patterns to cover all kinds of rounded shapes.

Examples [16 - 17 - 18] show how this might look on standing or sitting figures. Even in an undulating landscape they enhance the rounded shapes [19].

> **Important:**
> The closer the patterns, the more they distort and shrink.
> The patterns should adapt to the roundness of the shape.

[16]

[17]

[18]

[19]

Patterns are everywhere

To practise your patterns, trace the outlines of figures in newspapers or magazines.

This way you will learn how the expression and movement of figures is achieved without the added difficulty of sketching a shape [20, 20a, 20b, 20c].

Make sure the patterns follow the shape of the objects.

Where there is a curve you need to adjust the pattern and make it smaller and tighter. You can also use distortion to get a sense of depth and curvature without the use of cross-hatching or shadows [20c]

[20]

[20a] [20b] [20c]

The first patterns in art

Humans have always been fascinated by patterns. The oldest patterns made by humans are perhaps at least 10,000 years old. They are mostly simple geometric patterns on pottery and tools found in caves. Because these patterns consist of mostly straight lines and circles they belong to the 'geometric' style. Historians can often date objects by examining the patterns used as they were specific to certain periods in history. In some cultures patterns were also used symbolically.

The Maori people of New Zealand come from Polynesia. This is where tattoos originate. These are a unique form of body decoration

Meander pattern [22]

which is achieved by cutting the skin and introducing pigments to form geometric patterns. In the portrait below [21] you can see that the abstract patterns run over the face in a very elegant fashion and adapt perfectly to the shape of the face.

We are not certain why the early patterns in art history were geometric. It could be that early humans invented patterns when weaving and plaiting. In other words, the type of craft determined the patterns. On the other hand, perhaps straight lines fascinated early humans because they are so rare in nature.

The meander pattern [22] was first found in Greek art in the 9th Century BC. It is very well known and popular and a great example of the strict geometric style of the early Greek period. To this day it is used in many applications. The right angles are arranged in a way that attracts the eye. It is simple yet interesting, which is just the right combination for a classic pattern.

Maori tattoo decoration [21]

Endless options

A lot of that what you have learnt in the chapter about lines you can now turn into patterns of the geometric style. There are endless options.

If, for instance, you follow a simple rhythm – for example, straight line, right angle, curve and so on but change direction every so often – you will also create an interesting pattern.

[23]

If you enjoy drawing patterns, you could start your own pattern book. Use an A5 sketchbook. Choose a simple shape, for example a rectangle, and arrange this in all the different ways you can think of.

You will find that while it is fun, it is not always easy to create effective patterns. Make sure you repeat the pattern at the same intervals [23-28].

Draw a series of right angles and then add a curve, all in a continuous line. Create intersections, to the left or the right. Make some small variations along the way.

If you keep doing this, new ideas will emerge as you progress.

[24]

[25]

[26]

[27] [28]

The patterns in Examples [29 – 32] are more varied than the previous examples. They use the same elements but do not repeat with the same regularity. You may find more inspiration in Chapter 2 – the intersecting lines, for example, or the alternating of straight and curved lines, as well as using a variety of angles, can all make great patterns.

When creating your patterns, stop and pause as little as possible because, as you know, the best results come from the flow and momentum of your drawing. Using rhythm makes drawing easier and more fun.

[29] [30] [31] [32]

Ancient patterns relating to nature

Nature is full of patterns. But while nature's patterns can be similar, they are never the same. No leaf, no snowflake, no fingerprint is exactly the same as another. We have been able to benefit from nature's patterns by transforming them into ornaments and decorative repeating patterns.

A pattern turns ornamental

Decorative ornamental patterns can be found not only on buildings (pillars, vaults, walls, facades and balustrades) but also on textiles, wood, masks, vases, tiles, carpets, wall hangings, wallpapers, stone floors and so on. Wrapping paper relies on them and jewellery even more so.

Lace is a type of ornamental fibre pattern and mosaics and patchwork are constructed patterns which often use straight lines and are mostly geometric using a system of repeats and alternating light and dark sections.

Ornaments and decorations can make an ordinary object into something special. They give an object distinction. While ornaments are an ancient form of decoration, they have been copied and varied many times over by all cultures throughout our human history. Nature is an inexhaustible treasure trove for their inspiration.

For instance, an abstract depiction of papyrus or a lotus flower was very popular in Ancient Egypt [33].

In the examples below, the leaf and flower or bud have been joined to form a garland. They are then mirrored and some lines and spirals are added to connect them. Animals, people and hieroglyphs were also often used as decoration.

When visiting historical places in Europe, it is very likely that you will encounter a 'bucranium' [34]. This stylized head of an ox had its origins in the sacrificial offerings to the gods in ancient Greece. This form of decoration was then perpetuated through the Roman Empire, then the Renaissance as well as the Baroque

Lotus plant and its variations [33]

A bucranium decoration on a rotunda on the Greek island of Samothraki [34]

period, and even has endured to this day. We may have forgotten the origins of these motifs as they are passed from generation to generation but they are still found in rural areas, for example, where you can still find ox skulls suspended over barn doors. Similarly, rosettes, lilies, spirals, ivy leaves and tendrils are also part of the repertoire of ornaments that have been around for centuries.

The source of art is nature

In 1928, the photographer Karl Blossfeldt published his book, Art Forms in Nature [35 - 39].

Blossfeldt was convinced that all of human creation takes its inspiration from nature. He compiled his collection of natural forms over a period of 30 years and, to this day, architects, sculptors and painters use his book for ideas. You will recognize the shapes in the examples below. It will be evident that nature is used as the model for most of our creations because we love the aesthetically pleasing forms that we find there.

Patterns are everywhere

[35]
Equisetum hyemale, Horsetail rush

[36]
Abutilon, Chinese bellflower

[37]
Adiantum pedatum, Northern maidenhair fern

[38]
Saxifraga willkommniana, Rockfoil

[39]
Campanula alliariifolia, Ivory bells

The boom and bust of ornaments

While patterns and decorations have always been components of creative ideas, there were times when such decorations reflected and influenced the lifestyle of society.

For instance, the 16th and 17th centuries were times when people did revel in decoration and embellishment. The periods known as the Baroque, Rococo and later, in Germany, the Gründerzeit, were times when grandeur, exaggeration and exuberance defined the artistic style.

Flamboyant ornaments were everywhere and, in fact, such embellishments became symbols of wealth and power. As a consequence, the masses, who could not afford these riches, despised the scrolls and flourishes. Decorations and embellishments became regarded as outdated and decadent as society rebelled against the excesses and decadence of the rich.

In Vienna, a particular street became the symbol for such excesses because all the façades of the houses were covered with stucco and decorations. It was where the privileged lived. Workers' unions were founded to combat the power of the factory owners and eventually the monarchy of the Austrian Empire ceased to exist. All these factors led to the demise of ornaments as rationalization and mechanization became of increasing importance.

However, there was a short period of time, between 1890 and 1910, when ornaments gained in popularity again. This was the period of Art Nouveau and Art Deco. Art Nouveau was a movement that tried to unite craft, architecture and technical advances into an art form that could be applied to everyday objects.

It was during this time that Japanese woodcuts with their elegant flowing forms and lines had a big impact on Western art [40].

In this example you can see how elegantly the patterns shape the body of the man and the dragon while the contrast of black and white creates a swirling movement.

Patterns are everywhere

Woodcut by Utagawa Kuniyoshi, 1797

Gustav Klimt: Hope II, 1907 [41]

William Morris is very well known for his colourful plant designs. These were printed on wallpapers and textiles [42] and are still popular today.

Aubrey Beardsley, an English artist, also became famous at this time for his black and white illustrations [43].

Compare this picture with the Japanese woodcut on the previous page. The relationship between the two can clearly be recognized: swirling lines, exotic patterns and the decorative use of large and small areas of black moving from the bottom to the top of the picture.

One of the most notable artists during the Art Nouveau period was Gustav Klimt. His ornamental paintings on gold backgrounds epitomize the Art Nouveau style [41].

In his work the pattern dominates the whole space and the figures are attached to it. Big and small shapes alternate with each other, making it seem as though the pattern is moving.

William Morris: Tulip and Willow Design, 1873 [42]

In stark contrast to the Art Nouveau movement with its swirling decorative designs, there was a countermovement called 'realism'. The artists who were representative of this movement omitted all the swirls and decorations of Art Nouveau in favour of depictions of people from all classes of society in situations taken from everyday life.

You can find this strong realistic approach in Egon Schieles work [44].

Aubrey Beardsley, The Peacock Skirt, 1893 [43]

The ethos of Realism was further extended by the development of another new movement with a no-frills approach and emphasis on functionality. This was the Weimar Bauhaus school, founded by Walter Gropius in 1919, which developed the International Style of design and architecture. This was the era of mass production and mechanization. Consequently, for a period of nearly 40 years ornaments were banished from the artistic movement.

Egon Schiele, Standing Male Nude with a Red Loincloth, 1914 [44]

The ornament in Islamic art

The Alhambra is one of the buildings that stands as a monument to the wonderful use of ornaments. Islamic religion forgoes real-life depictions. Instead, patterns and ornaments are used.

These are extremely imaginative and innovative. They are fascinating to look at and consist of a mix of geometric shapes and natural forms. The patterns and shapes appear to be static and dynamic at the same time. The eye travels from one point to another and continues to find new patterns, connections and relationships between the various shapes.

Example [45a] shows a section from a mosaic located in Pompeii. Can you find the circles, the vertical stripes and the many diagonal lines that travel across this pattern?

This is a geometric construct where shapes are created by crossing lines, which in turn create new shapes [45b, 45c]. It becomes a mosaic where white and dark squares and triangles alternate.

Mosaic from the Temple Isis in Pompeii. [45a]

Its composition in lines [45b]

Its composition in lines with circles [45c]

Patterns are everywhere

A modern mural from Istanbul [46]

Nature is very important in oriental ornaments. Together with animal shapes and scripts they make breathtaking examples of the wealth of ideas in their art [46].

An arabesque is an element that mainly exists in Arabic art. It consists of many different shapes that are joined, layered and mirrored to make a larger ornament [47a, 47b, 48].

Individual components that make up the mural [47a]

An ornament made from stucco in Cairo [48]

Details of the mural [47b]

145

All forms can become patterns

This picture, *Sky and Water II* by M C Escher, seems very complex [49].

Escher begins using fish as his motive but slowly and cleverly transforms them into birds. The dark background that surrounds the fish changes into the outlines of the birds above on the white background. It is astonishing that these spaces turn into birds so easily. How did he do it? It is magical!

When developing your own patterns, start with something less complicated. Look at shapes in your environment and turn these into simple patterns. They can be based on plants from the garden or abstract forms that you combine freely using curves and straight lines.

Here are some examples [50 - 55].

M C Escher, Sky and Water II (woodcut, [49] 1938)

[50]

[51]

Patterns are everywhere

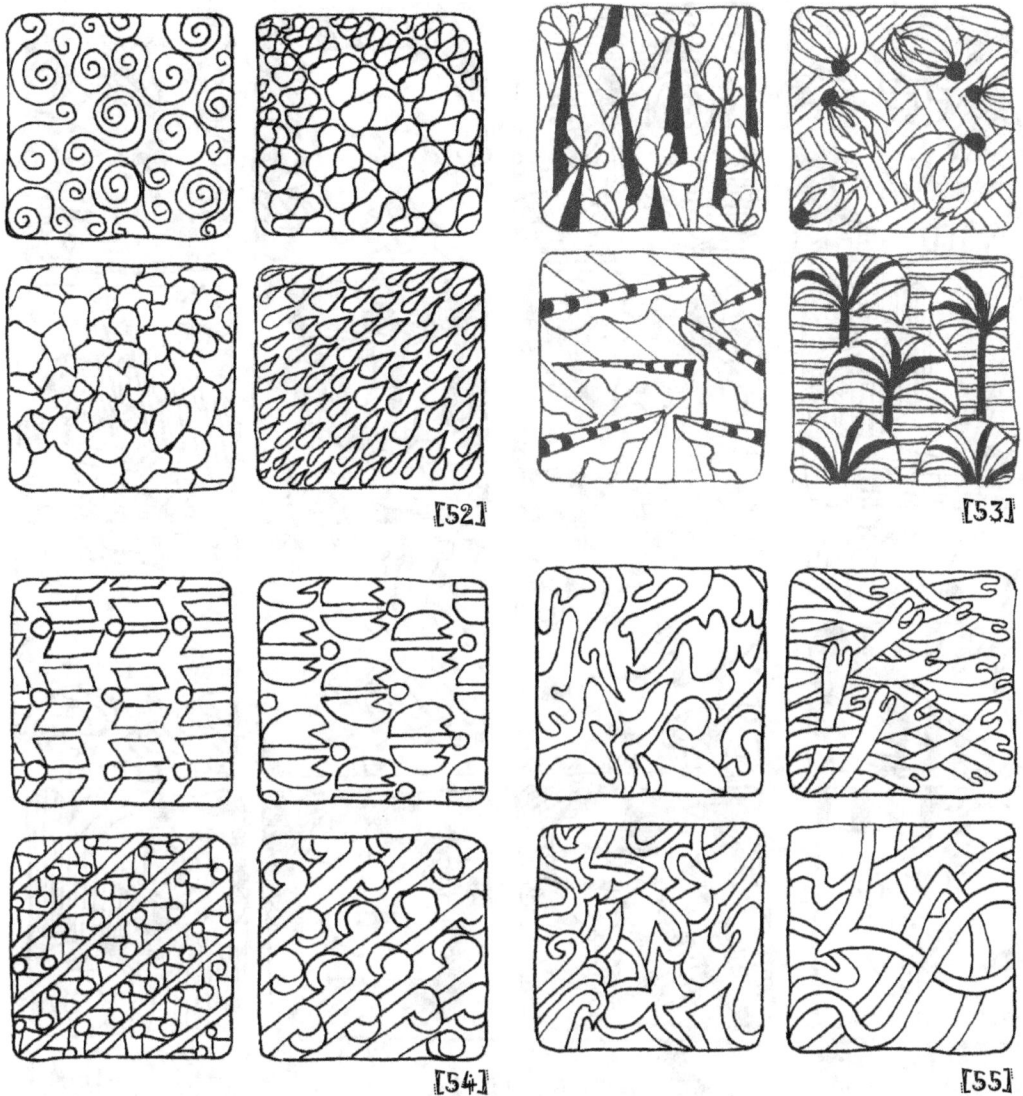

[52] [53]

[54] [55]

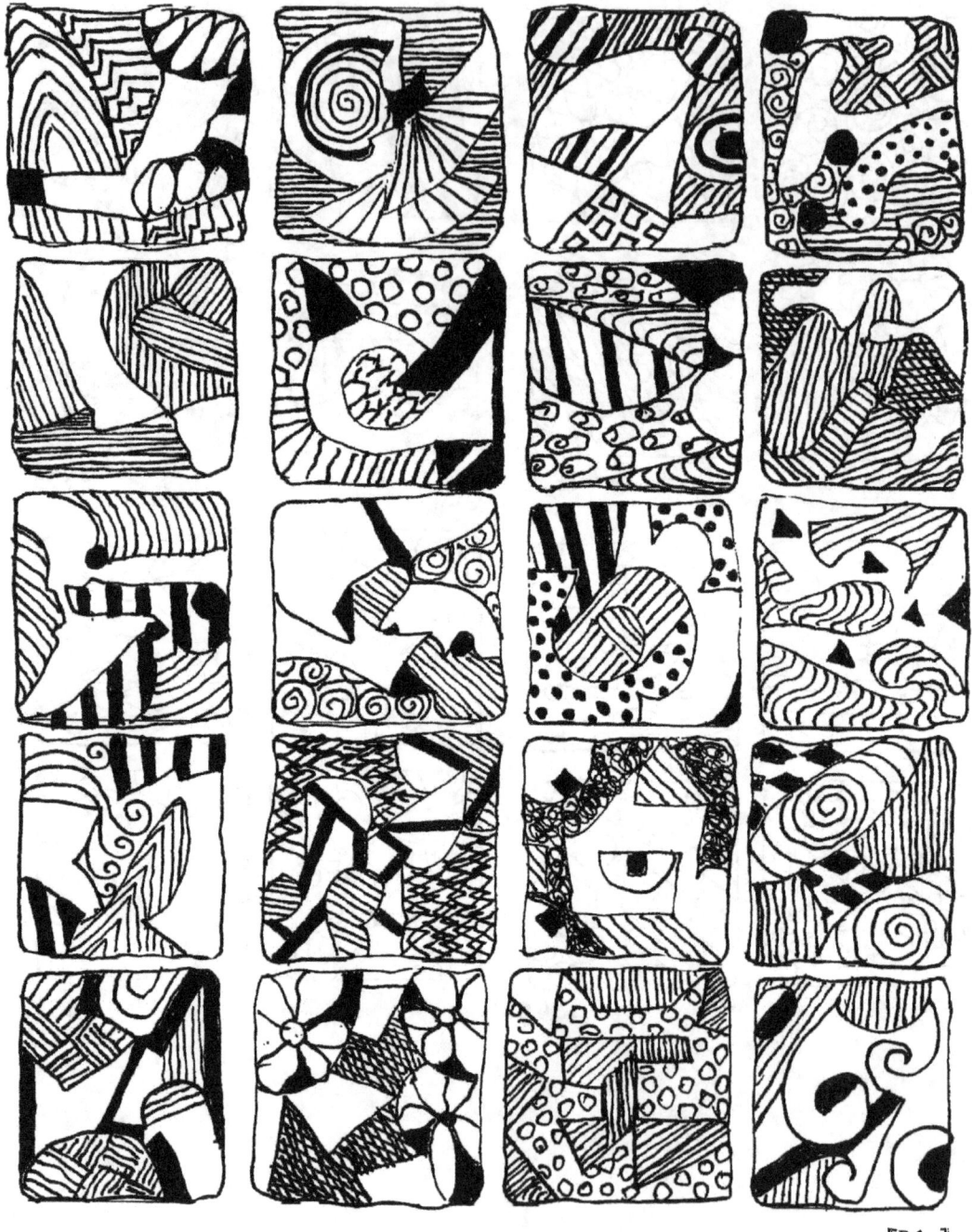

[56a]

It is not necessary for patterns always to be regular. Example [56a] consists of 20 squares. Every small field is divided by lines that are drawn freehand.

This creates abstract shapes that are then filled with a variety of patterns. Example [56b] shows first lines and shapes which fill the rectangles. The paired set of squares show what happens when you fill the shapes with patterns. Note how the rhythm of the pattern affects the way it looks.

The patterns, such as dark lines or black circles, are often used three times in the same square. The resulting rhythm gives the design harmony and stimulation.

Try this yourself using quick strokes.

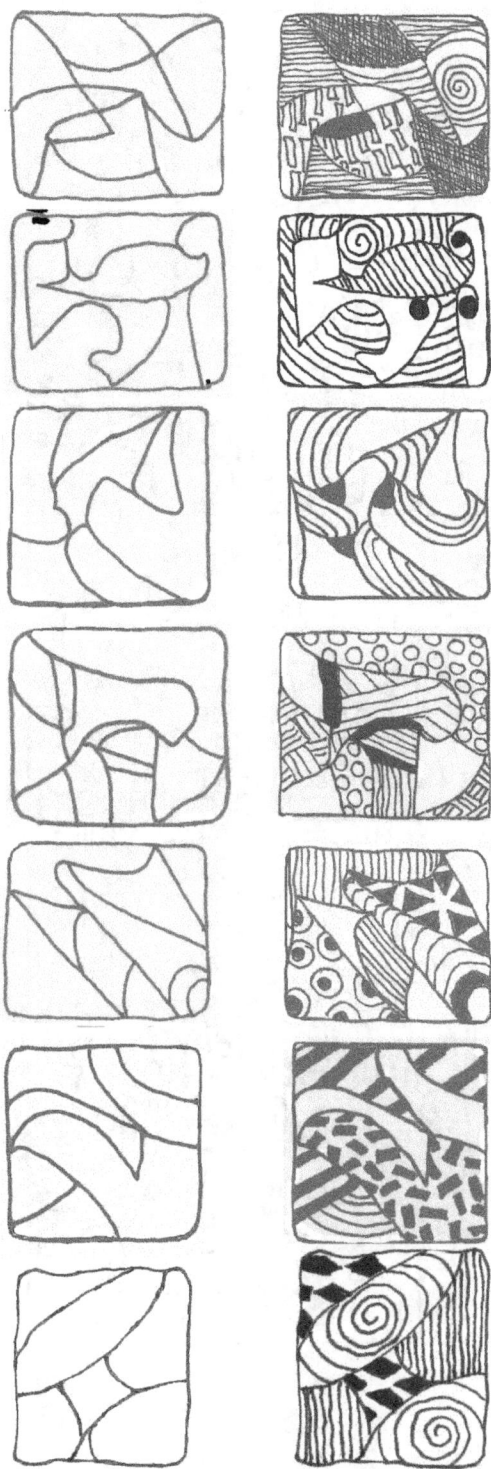

[56b]

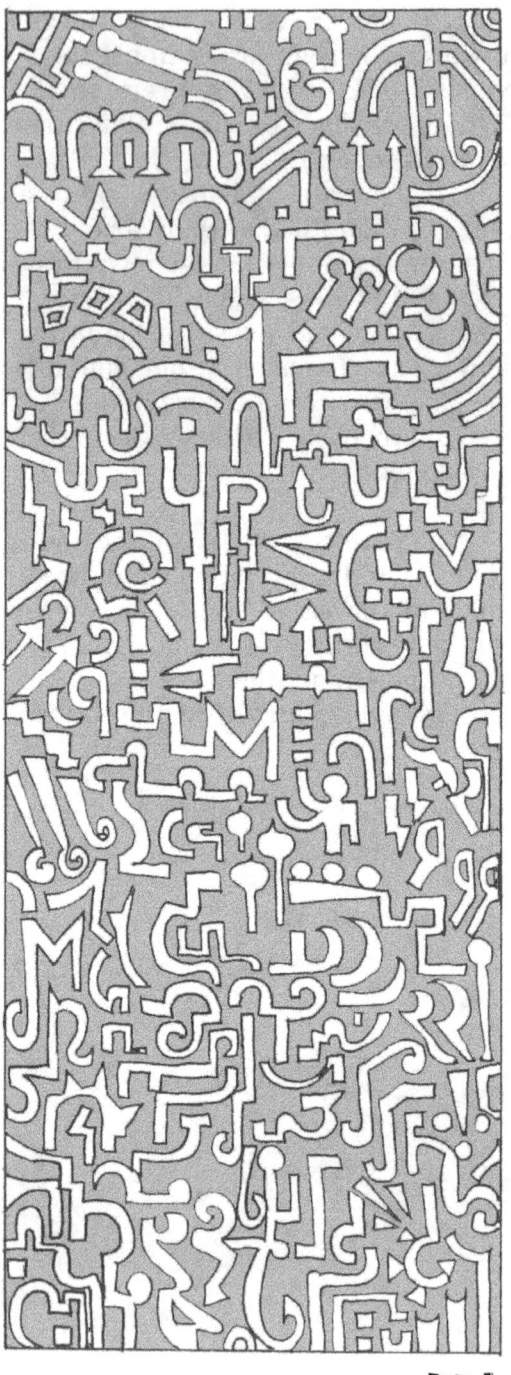

[57] [57a]

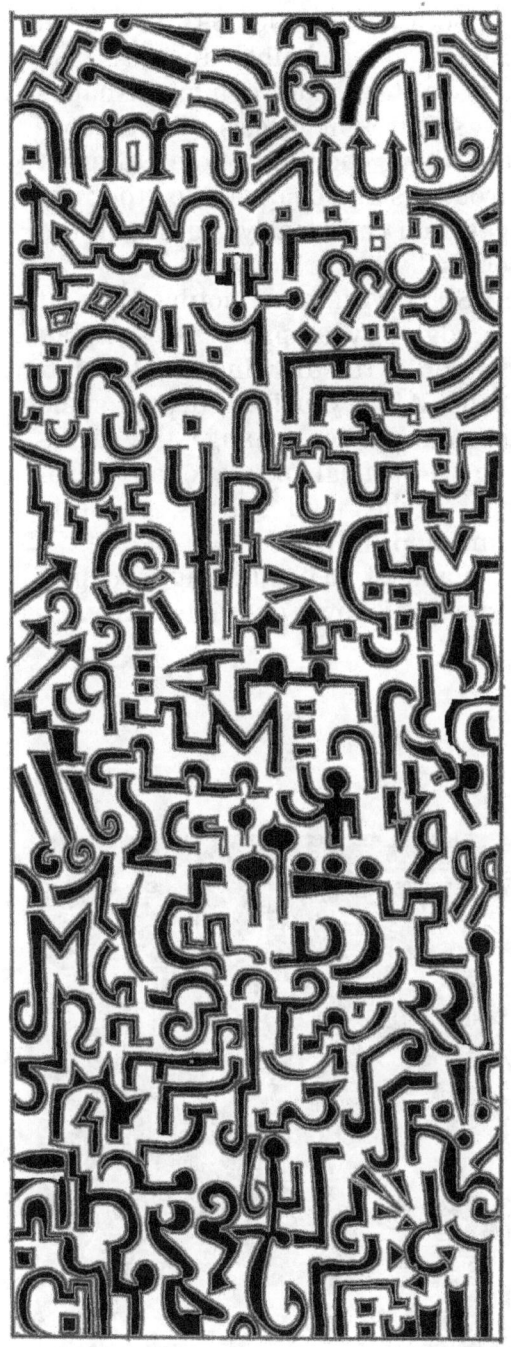

[57b]

Random patterns and variations

In patterns [57, 57a, 57b] there is no strict order or constant repetition of shapes.

As we saw in Example [46], the motif of the arabesque pattern is repeated, but not in an orderly fashion. The pattern is seen in three different variations. At first they are positive, then on a dark background and finally in black.

Such patterns are the result of the irregular interplay of similar shapes. The shapes themselves, the width of the lines and the switching between curved and straight components are the common features of these patterns.

There is no focal point; the eye wanders freely over the elements of the pattern.

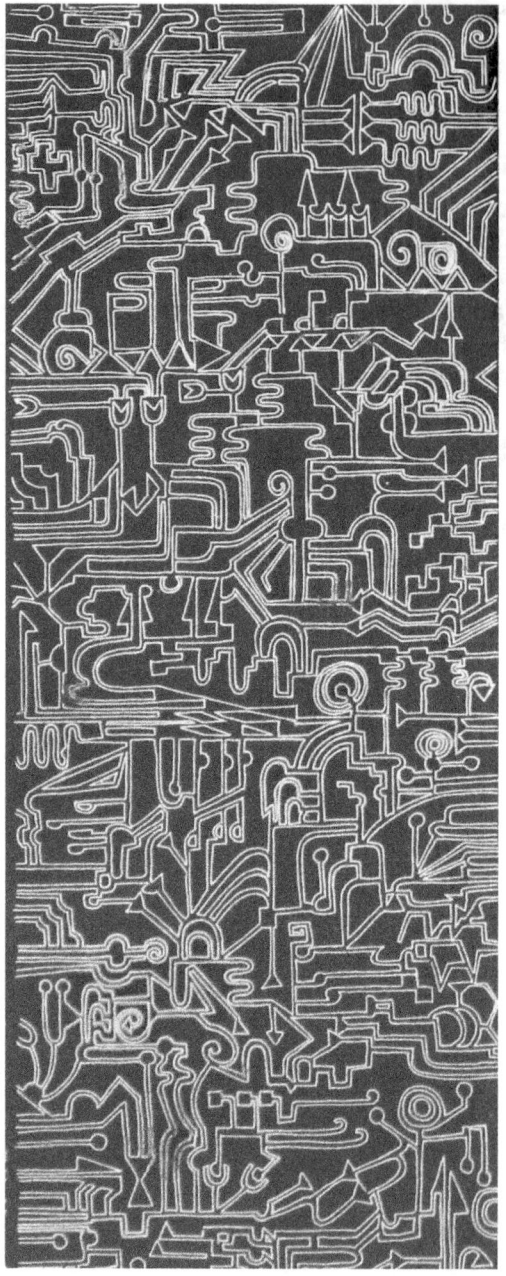

[58]

Both patterns [58, 59] have been created using double lines. As you can see these lines can form shapes like squares or circles. If you separate them they can take different directions and change into other images. You can clearly see this in the detailed version [58, detail].

Start with a few double lines at the edge of your paper. Do not plan ahead. Let the drawing develop naturally. After you have drawn some horizontal lines, change the direction to vertical or diagonal. Introduce arches and spirals, or build some steps into it.

Each of the following two patterns has its own characteristics.

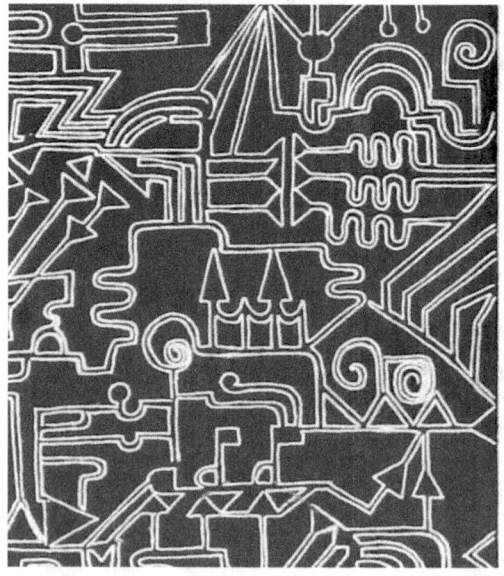

This detail from [58] shows its technical appearance

[58, detail]

Patterns are everywhere

Pattern [59] has also been drawn using double lines. This creates a more organic look because the lines are not straight and there are no right angles or squares. The curves and flow of the pattern combine to create the impression of something floating or growing.

Be careful while you are drawing to focus your thoughts fully on the plant like expression of your lines. Your hand expresses your thoughts and intentions.

These kinds of drawings have no crossing lines – they are patterns and so their appearance is essentially flat.

[59] The detail is organic, plantlike. [59, detail]

153

The world is full of patterns

Have a look around. You will find many amazing patterns on a small scale. For instance, here are two examples of patterns that have resulted from frosty conditions – tyre tracks in the snow and a frozen puddle [60, 61]. One picture looks geometric. It is a pattern which would be to Frank's taste because it comprises straight lines and it looks technical.

The other example, the frozen puddle, looks organic. It consists of Fiona's curved lines which create a natural effect.

Take a camera and go on a journey of discovery! Use similar impressions to create your own patterns

[60]

[61]

Patterns are everywhere

Two frames for you to fill with patterns

About the author

I was born in Munich in 1941. Because it was a safer place for a child to grow up, my mother moved to the small town of Kaufbeuren. At 16 years of age I finished school at a convent school for girls. While I was interested in drawing and painting it was not possible for me to study art at that time. Instead I became a banker. However, after I moved to Weinheim an der Bergstrasse I started to learn woodcarving and began to study at the Art school in Mannheim.

During that time I learnt etching and printmaking, which for many years were my preferred subjects. The paintings of the Renaissance particularly fascinated me, so I taught myself this special painting style.

Because I wanted more contact with people I started teaching Art at a school for adult education in Weinheim and continued there for many years. I also had many exhibitions in this area of Heidelberg and Mannheim, as well as in other parts of Europe.

In 2000 my husband and I moved to Australia where I continued with my work as well as teaching.

After 40 years of working as an artist I decided to write this book about drawing.

If you want to learn more about my work please visit my website:
www.ingeborg-zotz.com.au

www.ingramcontent.com/pod-product-compliance
Lightning Source LLC
Chambersburg PA
CBHW080959170526
45158CB00010B/2843